Ralph STEADman

EXTINCT BIRDS BOIDS

COMMENTARY by
CERI LEVY

BLOOMSBURY WILDLIFE

LONDON · OXFORD · NEW YORK · NEW DELHI · SYDNEY

BLOOMSBURY WILDLIFE
Bloomsbury Publishing Plc
50 Bedford Square, London, WC1B 3DP, UK

BLOOMSBURY, BLOOMSBURY WILDLIFE and the Diana logo are trademarks of
Bloomsbury Publishing Plc

First published in the United Kingdom in 2012
This edition published in 2020

A catalogue record for this book is available from the British Library
Library of Congress Cataloguing-in-Publication data has been applied for

ISBN: paperback 978-1-4729-8537-8; eBook: 978-1-4081-9079-1
The Gonzovation Trilogy box set: 978-1-4729-8664-1

2 4 6 8 10 9 7 5 3 1

Design by Pete Hodgson & Paul Beer

Printed in China by RR Donnelley Asia Printing Solutions Lmited

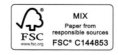

To find out more about our authors and books visit www.bloomsbury.com and sign up for our newsletters

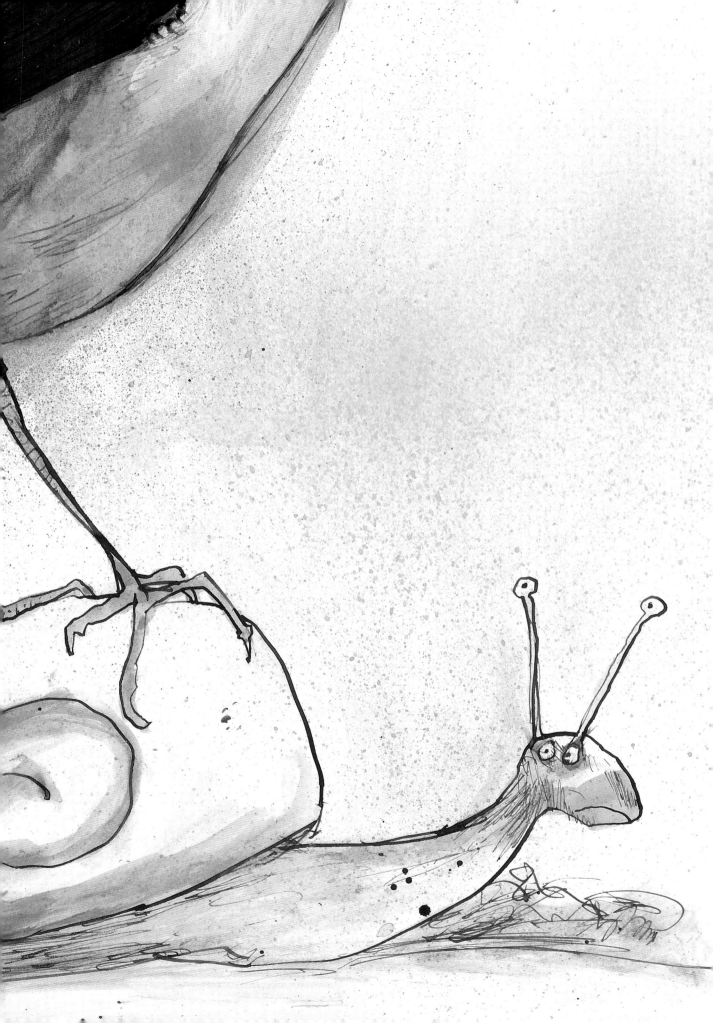

A commentator and an illustrator
Got together as creators
Not just of any old potatoes
But became extinct Boid perpetrators.

Though thinking they were bird-haters
They discovered they were bird-raters
They loathed the job but never mind
They had not realised they were so kind

To re-create all of these birds
Required a mass of art and reams of words.
Finally it would disprove a lie
That none of these birds again would fly.

By Levy/Steadman

His Nibship in the Midship

1st April 2012

It all started with a mistake. I asked Ralph Steadman to create a drawing of one extinct bird for an exhibition and he created a book's worth. And his first bird wasn't even an extinct one. That was how this book of boids began, and the course it followed and the paths it veered through from that first moment led us on a journey to strange places, WEIRRD conversations, odd creations and a voyage through the beautiful mind that belongs inside Ralph's head. In fact *voyage* is a very apt term, because it does feel that we have been sailing through the bird world together for this last year, discovering it anew and learning of extinction and all that the world has lost. As Ralph would say, "it's funny how things begin".

So how did this all begin? I had been making a documentary called *The Bird Effect* about how birds inspire and affect people, from birdwatchers and scientists to artists, writers and musicians. The more I learned about birds, world the more I realised that there were some serious conservation issues at stake. Consequently, I had been approaching artists to take part in our show *Ghosts of Gone Birds*, created by Chris Aldhous and myself. Its purpose was to highlight the risk of extinction that is faced by many bird species in the world today; the premise of the show was to get artists to represent an extinct species of bird, and to breathe life back into it. We felt it would be more powerful for *Ghosts* to engage with an audience through creativity as opposed to telling all and sundry how awful humanity is and how dreadful we are as a species. We all know this; a sure way to alienate viewers is by ramming this kind of message down their throats. By using art as the medium for the message we hoped to engage and forge a lasting connection with our audience. The exhibition was also designed to promote the work done by BirdLife International's Preventing Extinctions programme, with a percentage of monies raised going toward their projects.

It fell upon me to approach some of our favourite artists and ask them to participate in the show. Ralph and his work had been part of my life from the moment I first discovered his art in *Alice in Wonderland*, and through the years I always enjoyed his line, his wit and his cutting, creative spark. I felt that if there was someone who could work really well with the show's dark subject, it was Ralph. The only drawback was that I knew of nobody that could introduce me to him, and I had vowed not to approach people cold without some sort of an 'in' to them – it can be a soul-destroying process battling through the iron curtain of managers, agents or other protectorate states.

But serendipity played its part along the way, connecting me with the right people at the right time, and Ralph would prove to be no exception. It's just a matter of noticing when a window of opportunity opens, and then taking advantage of it.

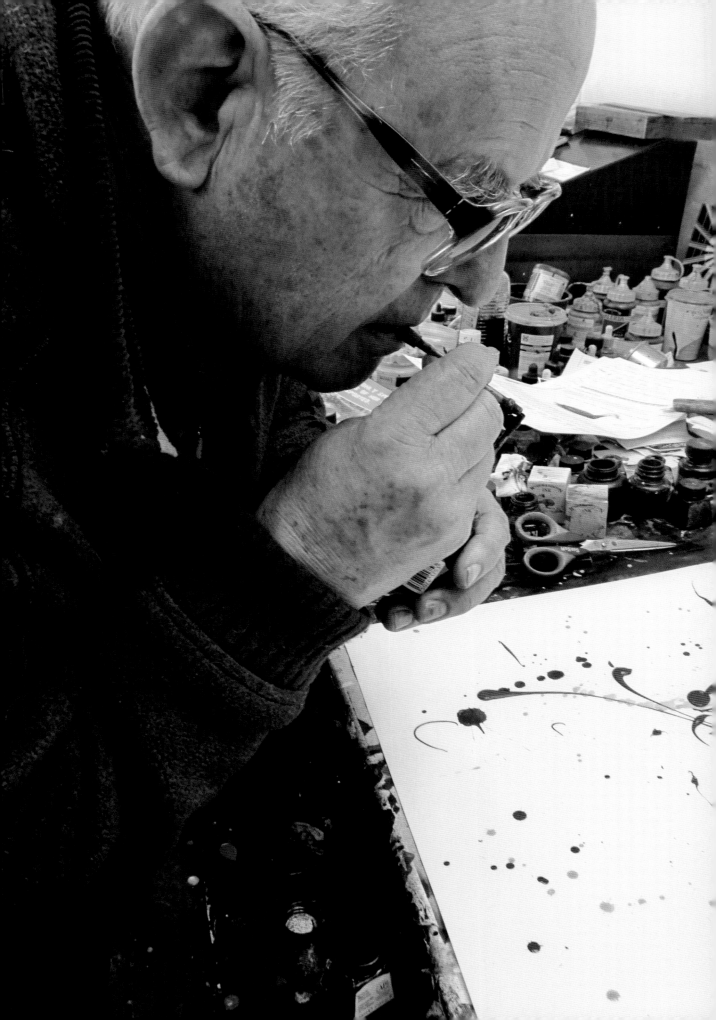

HMS Steadmanitania

At the 2010 Port Eliot Festival, I was invited to host a series of talks about birds and their effect on people in Jeff Barrett and Caught By The River's music and literary tent (for whose website I write a diary, about the making of my film). As I entered the site I saw two massive doors, unmistakably adorned with a Steadman logo for the festival from a previous year. The daubing of these gates by Ralph had proved so popular that the logo remains on them to this day. It was a sign, literally. I mentioned to Jeff that I really wanted to find a way to connect with Ralph and involve him with *Ghosts*. He spoke to the festival organisers, and Lady Catherine St Germans, who organises the Festival with her husband Lord Peregrine Eliot, passed Ralph's email address to me. She suggested I send an email to Ralph, but warned me not to expect an immediate response. She also said that just when you've given up all hope of any response, the chances are that suddenly, out of the blue, something wonderful will drop into your inbox. For me, any kind of a reply from Ralph would have been wonderful. I sent the email. And then one day, just when I had indeed given up all hope of any response, something glittered in my inbox. It was an email from Ralph, and once I had read it, I knew the world would never be the same again. Things had changed forever.

This book is set out in a chronological fashion, utilising snippets of conversations, emails, entries from my diaries and memories of phone calls to record the period of creation of this extraordinary collection of birds, or boids, to use the name Ralph gave them when they first came into view; *boids* is what they have remained ever since. The artworks are presented in the order of their appearance in my inbox. Each time Ralph's name appears there, I still feel a thrill of anticipation at what might be contained within the email. It could be a thought, an idea, a promise of something miraculous to follow in a future message, but mostly it has proved to be an unfurling roll call of the birds that we have lost over the centuries. Both of us have discovered how humanity has destroyed so much of the natural world around us. Ralph's work has allowed us to glimpse the subject of extinction from a unique vantage point, for never before have these creatures been depicted in this way. In his search for the extinct birds, Ralph has uncovered an array of facts, realities and desperate stories, and through these pages we hope we can impart a little knowledge and a lot of great art to you. This is Ralph's representation of extinction.

Like confused Victorian explorers we clambered on board the HMS *Steadmanitania*, manned only by Ralph and myself. Confused as to which direction we were facing, let alone how to unfasten our moorings from the quayside, we managed to set sail on the imaginary seas of invention, which we knew would lead to the lands of extinction. On the way we would discover birds that through the pen of His Nibship would turn into boids. A world I thought I knew became something else altogether. One minute our craft would be setting sail for Mauritius and the next we would be in Australasia. Ralph's world does not follow the normal rules of geography. After all, with Ralph, Rodrigues would become a person and not an island. We steered our path to the distant horizon and beyond.

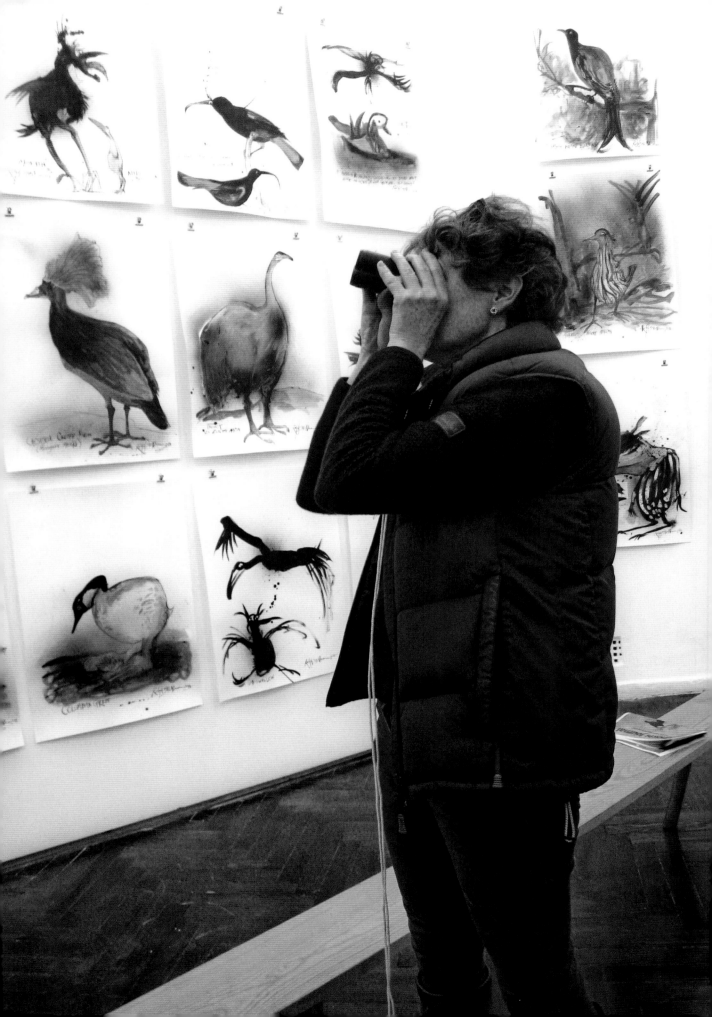

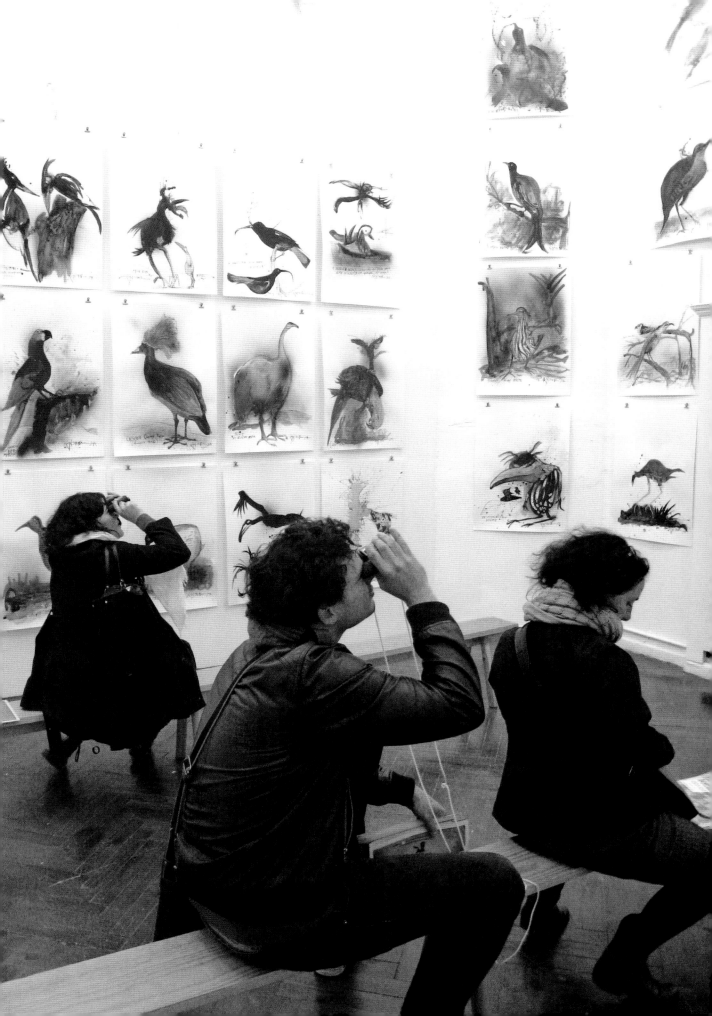

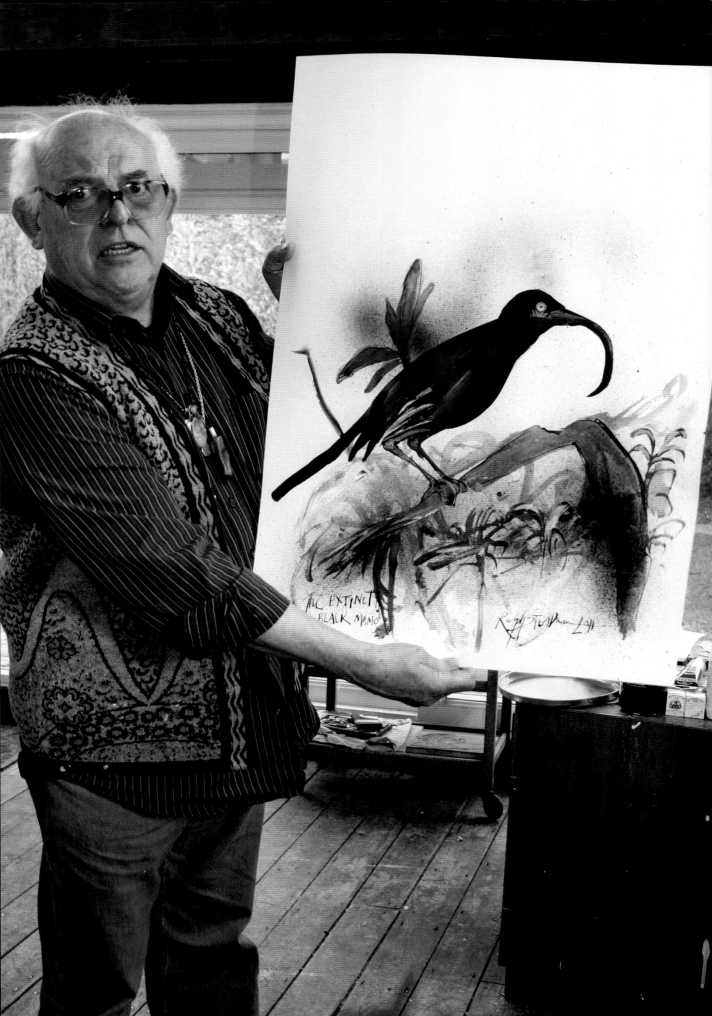

Ghosts of Gone Birds

What we found were tales of woe, misery and the death of numerous species, many of which disappeared from this world thanks to humanity and its desire to progress and reach a supposed higher state of civilisation. Often the potential of an economic nirvana brought about the decimation of alien habitats in the name of the God Cash. Brutal stories would appear as we looked over the sides of our boat. Auks destroyed as witches. Habitats burned and their inhabitants smoked out of house and home. God knows how many shot in the name of sport, and as for platefuls of food? Too damn many to count. The more we discovered, the more we realised we needed to document our journey together.

I have been at sea for more than a year with Captain Ralph on the *Steadmanitania*, seeking out new boids and discovering older, extinct ones. In bird-watching parlance we have done a Big Year. This is when one chooses to see as many birds as possible in a twelve-month period, with sightings recorded as a list. This we have done as we have criss-crossed the waters of the world; I think we have probably covered ground that has never been touched on before. Over the course of this year, Ralph has populated a complete aviary with his creations, and boids that spilled out of his mind have flocked into the imagination of all that have seen and come into contact with them. We have documented all of our findings, which we now present here for public consumption.

Ghosts came into existence in the material world in November 2011. It took place at the Rochelle School in London's über-cool district of Shoreditch, amongst the hip and trendy art communities camped out in the east end of town. Little did we know as this relationship came into the light that *Ghosts* would be right royally received. More than 100 artists exhibited, with music and poetry nights in abundance, creating a general sense of well-being as we brought the issue of extinction to a wide audience. The diversity of artists and the diversity of birds chosen created a unique atmosphere that allowed people to absorb just what we have lost from the natural world. But one of the most surprising areas of the show was the room that we dedicated to Ralph's work. His collection of more than 100 birds lined the space from floor to ceiling. There was an amazing echo in the space that almost felt church-like; this hallowed room of Ralph and his boids had a power that entranced the visitors. Many sat and contemplated the rows of art, often using the binoculars that we had placed in the room to see even the highest row of boids. Each piece connected with the whole, creating a body of work that signified extinction. The end result for Ralph's big birding year was a perfect finale for him, his boids and for *Ghosts*. As I have often said throughout my year with Ralph… things would never be the same again, again.

These are the boids of discovery.

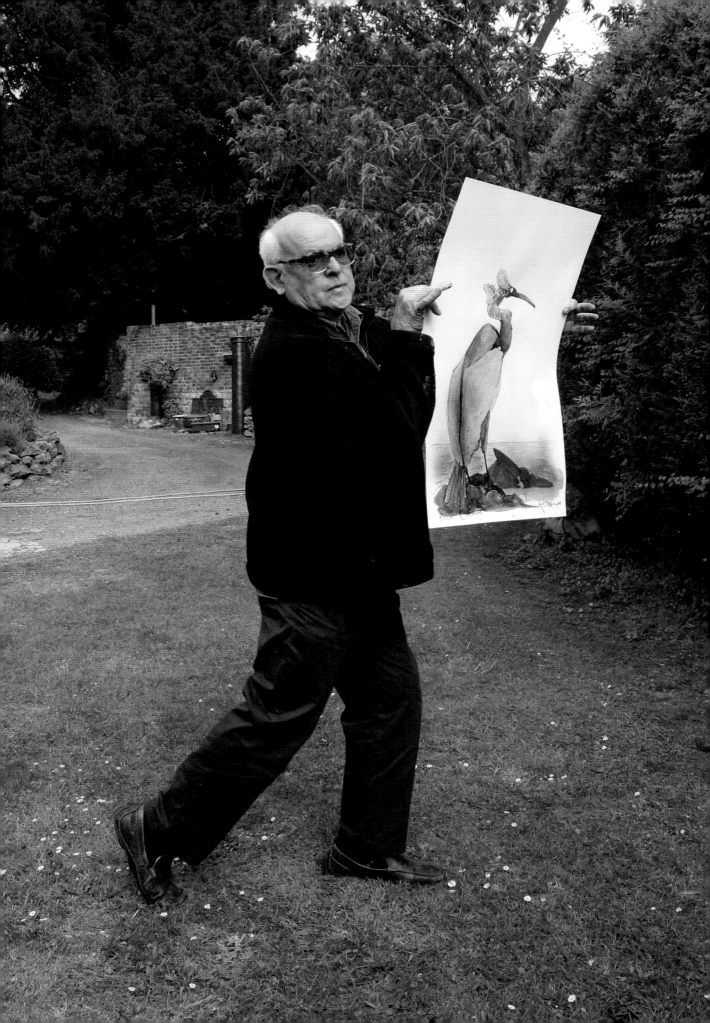

So I said, then he said, then...

On 25th February 2011, Ceri Levy wrote:

Dear Ralph,
Lady Catherine Saint Germans passed on your email to me, as I would love to involve you in an exhibition we are organising about bird extinction and the dangers that face birds today. It is to raise awareness for BirdLife and their work to save critically endangered birds in the world, of which there are 192 species. The show will be in London in November and is called *Ghosts of Gone Birds*.

Artists are representing an extinct species of bird from the list that I have attached. I really hope that you will join the throng, as we also have musicians and writers on board and *Ghosts* is becoming a truly creative voice for conservation.

I have attached an outline to the show as well as the list of extinct birds and a list of all the birds that have already been chosen.
All best wishes
Ceri

On 10th March 2011, Ralph Steadman wrote:

I'm not sure quite what you want from me and the bird notion of yours puzzles me a little – I think WEIRRD is so much more intriguing. Man has always wanted to fly... perhaps we had wings once...

Ceri's Diary: This seems like an enigmatic start to our relationship, to say the least, but contact has been made. I am not certain that Ralph totally understands what I want from him, and perhaps he hasn't seen the brief that I attached to the email. I have just written again to ask whether he has read the brief, to which he has just replied: 'Not as yet...'. This has led to him sending me images of all sorts of work he has done relating to flight, including hot air balloons, flying machines, angels, strange winged creatures, but no birds.

12th March, Ceri's Diary: Today, two days after first contact, Ralph phoned me for the first time. We began to talk about the project, but Ralph seemed keener to read me something he has written recently, and in those initial moments of hearing the storyteller begin to narrate, I lay down on my couch, relaxed and inhabited the same space as Ralph's vocal tones, listening to the timbre of his voice and his accent, which altered from line to line of his writing. Part-Welsh, part-Liverpudlian, part-gruff narrator, accents abounded, as his creativity crackled down the line and veered straight towards my cerebellum. I knew in that instant that I hoped that he, as much as anyone else I have spoken to so far, contributes a bird to *Ghosts*.

After the story was read I explained the purpose of the project and the need for him to study the list of extinct birds I have sent him, and to choose one to represent for the show. The thought of extinct birds as a subject seemed alien to him. So alien that he kept pondering the fact that I wanted him 'to draw creatures that don't even exist. It's madness really'. I agreed, but suggested that it might be possible to breathe life back into them. It's all down to him as to whether he can find a way into the subject. I have no idea what will happen next, but what I do know is I thoroughly enjoyed our conversation, and hope for more.

At 18:30, Ralph emails:
I don't know why I was doing it but I have done four birds today. Extinct too!!

Ceri's Diary: Four birds? Extinct birds? What is going on? I am so excited at the thought. I want to call him and find out what he has done – I want to see these birds. Am I really to believe that Ralph has created more than one bird? After all, only one is required. But we can make an exception in this case, can't we? Has he done four for a reason? Are three not very good? Does he want me to choose only one of them? So many damn questions and no answers until... I don't know when. I hope later tonight or tomorrow, who knows? I am now stuck inside Ralph's time. I sent an email stating my excitement but there's no reply. I am just going to have to sit and wait. Tomorrow will bring what tomorrow will bring.

I have tried to imagine what type of birds he will have done. I can't guess, but I reckon that he won't have picked an obvious bird to start with, like the Dodo.

I feel like I did as a child on the night before Christmas. My mind is racing and I can't wait to fall asleep, so I can wake up, sit down at my computer, and discover what birds have materialised. Here's to sweet dreams of extinction.

13th March – First Official Day Aboard the *Steadmanitania*

At 11:52, Ralph emails:
I will photograph my suite of extinct birds today and send them to you late...
OK RALPH

Ceri's Diary: The tension is too much for me. I can't think of getting on with anything else, other than waiting for Ralph to photograph his suite. **Four** birds! A suite! All of which I presume we will be able to include in the show. Come on, Ralph. Quench my thirst and let me see your work.

And then...

Japanese Egret

Egretta ralphartum falsartum

13th March, 12:43. Ralph emails:

Extinct BOIDS!!

I am sending you some pics I did yesterday... OK
RALPH

Ceri's Diary: And with this email that contains
attachments of the following three birds, life has
changed forever. We are on our way, afloat, and
Ghosts has a new member of the team. I am so
utterly excited by these pictures. I can't believe that
we have not just one but three birds to use in the
show. The Japanese Egret rising into the skies is a
beautiful sight, but it is wrong. This is a *notion* of an
extinct bird. It doesn't exist as a species, and never
has. There are egrets in Japan but there is no specific
Japanese Egret. But this is such beautiful chaos.

This is the mistake that started us on our adventure.

The egret is a very good place to start this collection.
It has never become an extinct species, but the egret's
modern tale is that of a dance with death as it has been
persecuted for its plumage, especially in the breeding
season when its feathers are at their most magnificent.
Plume hunters would kill entire colonies of birds to
procure a desirable fashion accessory for many a
milliner. At the turn of the 20th century, the desire for
egret feathers, especially those of the Snowy Egret,
led to the price of feathers soaring to more than twice
that of gold. There are many records from this time
of feathers from hundreds of thousands of
egrets being sold in auctions across the globe, from the
United States to London, as the fashion trade
demanded more and more decoration for their outfits.

Protests against the cruelty meted out to the birds by
hunters and the changing mores of fashion allowed the
egrets to strengthen their numbers, as fashion moved
onto grebes, terns and albatrosses. Thanks to a new
conservation movement, the RSPB, set up by a group
of determined people who preferred birds to hats, the
trade in feathers was outlawed in the early 1900s.

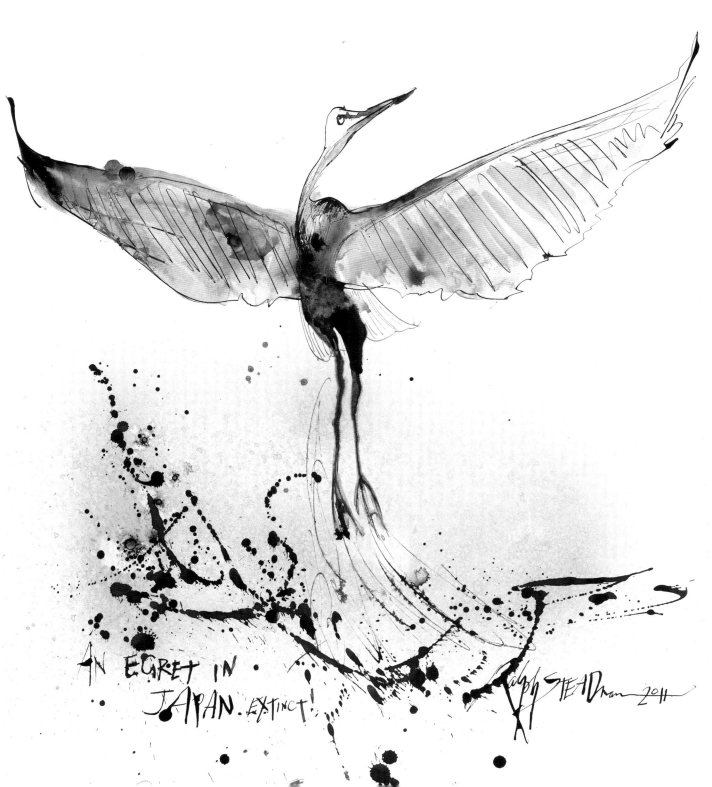

AN EGRET IN
JAPAN. EXTINCT!

Great Auk

Pinguinus impennis

Ceri's Diary: I stare in amazement at what is appearing before my eyes. This is sorcery! Here are birds, sorry, *boids*, created by Ralph bloody Steadman. Only his hand could have created these drawings. His style and voice comes through loud and clear. I am gobsmacked. I love this painting. The line is so assured, and the piece is fluid and simple. It is so easy to read things into this picture. The auk's eye is black and looks shut, perhaps not wishing to see the path ahead. It moves its left foot uncertainly forwards. Is it feeling for its future? Is the ground solid enough for it to continue onwards? Unfortunately this was just about the end of the line for the auk. How I would love to have seen this bird.

The last Great Auk to die on British soil was captured in 1840 by two men from St Kilda, west of the Outer Hebrides of Scotland. Their job was to find and collect birds from the surrounding rocks for the pot, or to make shoes or hats with. They discovered a large sleeping bird on the rock Stac an Armin and brought it back to St Kilda. There was a terrible storm, the auk was blamed for it, and so it was supposedly killed as a witch.

The Great Auk is second only to the Dodo in the extinct bird familiarity stakes. This large seabird populated the wide expanse of the North Atlantic. The largest of the auk family, it stood just a little shy of three feet tall in its stockinged feet. It most resembled a penguin and was equally as flightless, which didn't help it in its fight or flight from extinction, making it easy prey for hunters. But like a penguin, it was a true creature of the sea. In the water its wings would have proved to be powerful oars steering it on its course, and it would have proved to be a bird of agility, a surging swimmer, and a devourer of fish.

There was a dreadful acceptance of the demise and imminent disappearance of the Great Auk, and frenzied specimen collection before it became extinct was a bizarre additional pressure on the last of the birds. The last known pair of Great Auks were both killed on Eldey Island, off the coast of Iceland, on 3rd June 1844. Some fishermen discovered this last pair, with the female sitting on a single egg. The birds were strangled and sold as museum skins, while the egg was smashed. The last solitary sighting of a living bird was made off the Newfoundland Banks in 1852. The bird was never seen again.

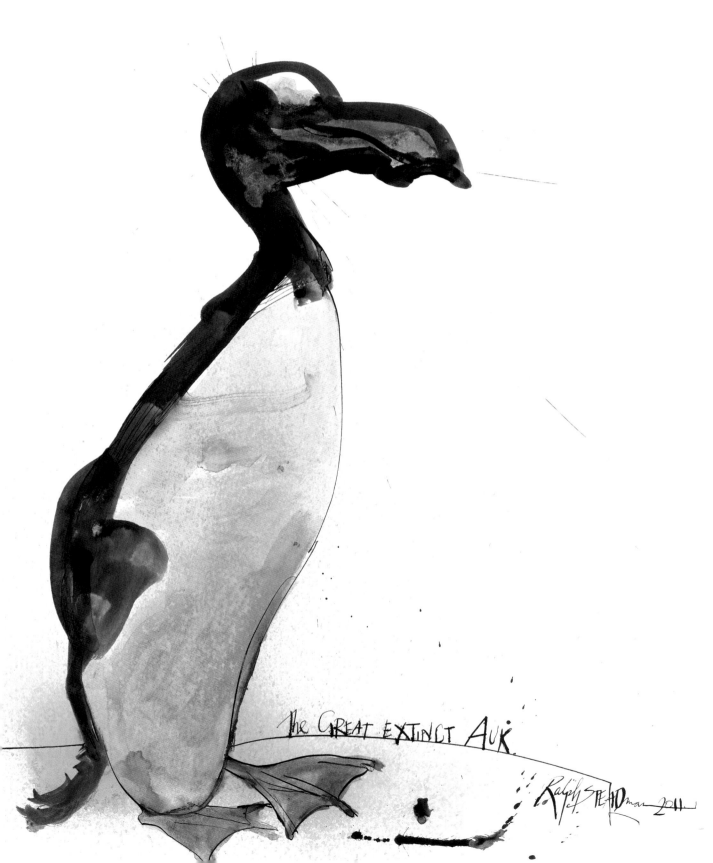

The Great Extinct Auk.

Ralph Steadman 2011

Ceri's Diary: I have been thinking about the word that has appeared with these first images. BOIDS. Ralph's use of this word intrigues me. I like the sound of it. It seems somehow apt. These are not scientific, textbook illustrations. These are Ralph's take on the subject. He has stamped his persona upon them, and given them their own unique identities.

I am delighted that we have not just one but three pictures for the show. I love what I'm seeing before me – *Ghosts* will be a better exhibition with these additions. I feel that we are home and dry, with Ralph becoming a part of the diverse roster of artists joining the creative army for conservation that we are assembling.

Ralph has managed to superbly capture the moa's look of revulsion at his imminent placement on the extinction list. A resigned pride crosses his beak. I look at the moa and wonder – how do you end up losing a bird of this size? Stupidity, that's what. To not notice such a large creature disappearing from view is more than extreme carelessness, it is negligence. Or maybe people just didn't care if a species fell by the wayside. Do we care now? I am doubtful that many people do, but I hope that is not the case. This is one of the main purposes of *Ghosts* – to point out the array of birds that have been lost, and to remind ourselves that species loss continues today, and that there are things we can do about it – by supporting the people who are out there fighting for the lives of our defenceless avian neighbours. I hope *Ghosts* can bring the subject to a new audience, which is why we have approached such a varied list of artists. This way we can engage with people who may never have been interested in conservation, ever. Whatever happens, I am sure that everyone who sees them will enjoy Ralph's pieces.

North Island Giant Moa

Dinornis novaezealandiae

The moas are ratites – the tribe that includes ostriches, emus and cassowaries – but they are different enough to be placed by ornithologists in their very own order, the Dinornithiformes. There were several types of moa, all of which lacked any hint of a wing (unlike the other ratites mentioned above). The moas were endemic to New Zealand. They had all gone before the European discovery of New Zealand in 1642 by Abel Tasman. Reasons for their extinction included hunting and loss of habitat.

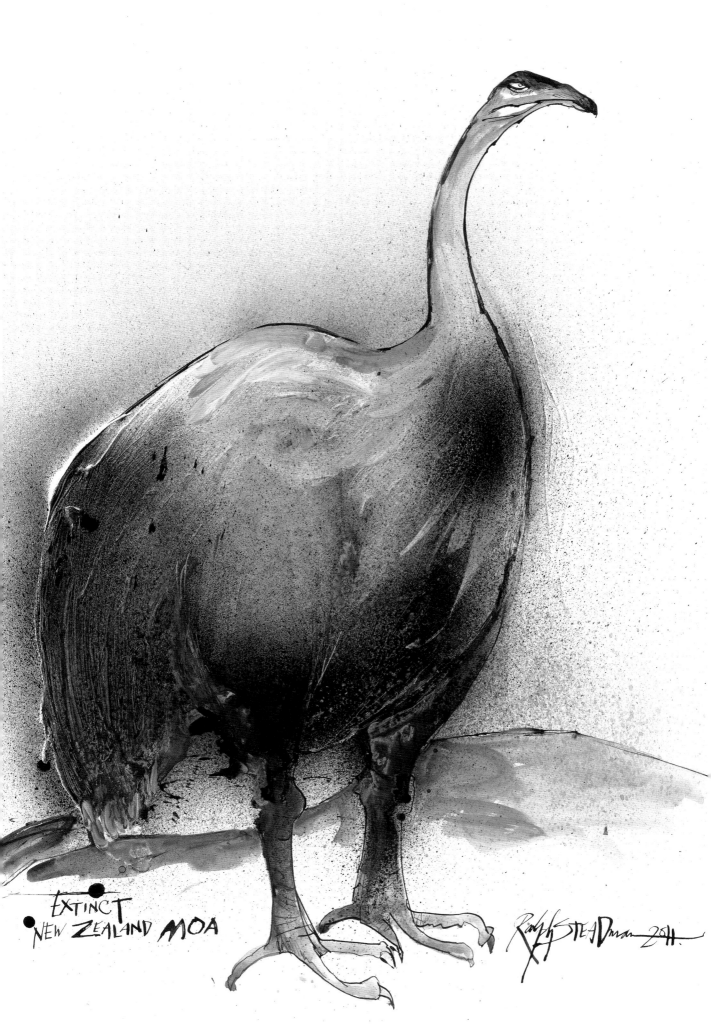

EXTINCT
NEW ZEALAND MOA

Ralph STEADman 2011

13th March, 19:12. Ceri emails:
Oh Ralph, these are extraordinary! These boids are no longer extinct. *Ghosts* will be a better place thanks to their existence. One of your previous emails said you had done four birds, but I only have the egret, the auk and the moa. I don't mean to be greedy but is there another one to come?

Ralph replies:
Glad you like my efforts. There is one more boid, the Choiseul Crested Pigeon, which is not quite finished. It should be done this morning and I will send it over. I may do a few more – they are rather fun to do!

Ceri's Diary: Time passes slowly as I wait for a FOURTH bird to appear. How good will it be?

And then…

14th March, 13:09. Ralph emails:
Here is the fourth one – any good??

Ceri replies:
I should say. The pigeon has an air of baleful resignation... it works exceptionally well. This bird looks way too hot to continue on its way, especially with that hefty looking, but pretty bonnet on. The burning ground it stands upon seems to scorch the bird's feet, and it seems such a meltingly hot day for it to try to survive. Really amazing, Ralph... thank you, from me and from *Ghosts*!

Ceri's Diary: What I find interesting is the setting that Ralph gives to these birds. They all have a sense of belonging to the landscape that surrounds them. These are not simple sketches. These involve time, thought and a sprinkling of Ralph's magic. I wonder how long it takes for him to do each piece, how much preparation goes into them, and if he makes preparatory sketches? I would have loved to have seen how he creates these boids. I would have enjoyed filming the creation of these boids – I love to capture the creative process. Ah well, can't have everything. But if he continues to paint birds then we may eventually do some filming together. That would be fantastic – fingers crossed.

Choiseul Crested Pigeon
Microgoura meeki

The Choiseul Crested Pigeon was endemic to Choiseul in the Solomon Islands. The skins that survive in various collections don't really give a clue as to how the bird's crest would have appeared when erect, but Ralph's interpretation is what counts. The pigeon has not been seen since 1904, and is considered extinct. Its disappearance from the record was probably due to predation by dogs and cats.

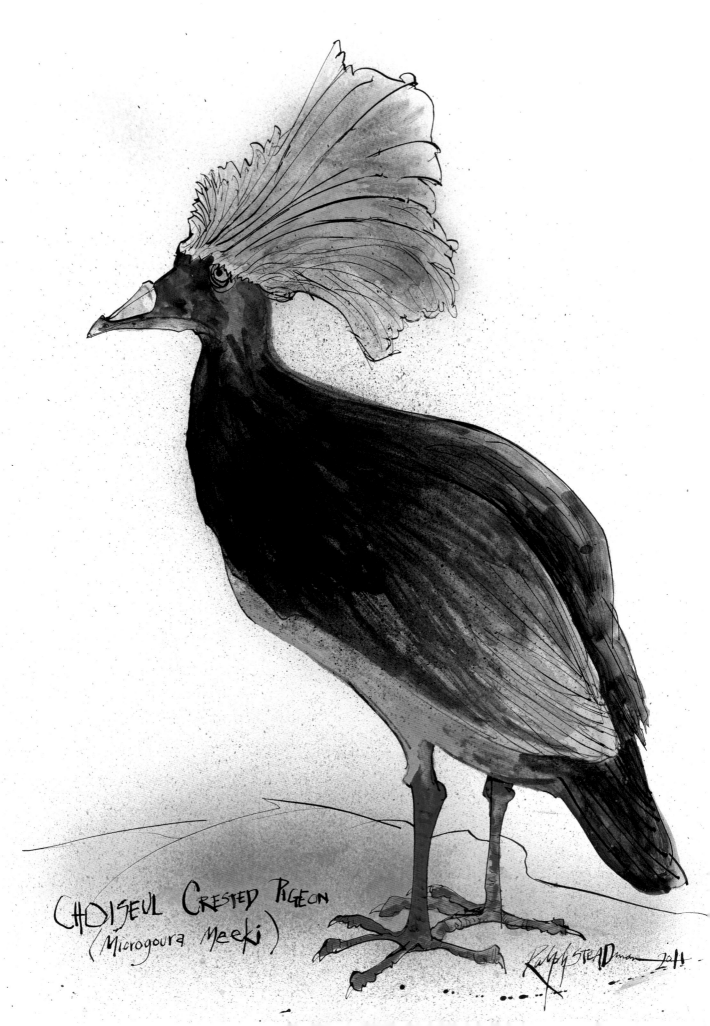

CHOISEUL CRESTED PIGEON
(Microgoura Meeki)

Ralph STEADman 2011

16th March, 20:02. Ralph emails:
Here's a couple more… let know what you think – it may be an opinion, but you know best! I was thinking that what is desirable is to get the spirit and personality of the BOID!! Rather than some odd 'accuracy'!!
OK, over to you.

17th March, 12:09. Ceri emails:
What can I say? You've summed up what I wanted to say about these birds. You have provided Ralphicity to these birds and have brought them back to life in your own inimitable way. There is a life there and also a strength, which leaps or (pardon me) flies off the page. These are all I could ask for and more. There is definitely a power on seeing them lining up together to face the viewer.

Ceri's Diary: I found this quote today about the hunting of one of the very last Black Mamos in the name of science. Alanson Bryan tells of his hunting of one of the last specimens of a Black Mamo, which was taken in 1907:

Actively hopping and flitting from limb to limb, scarcely stopping a second, eyeing me sharply all the while, it persisted in keeping so close to me that I could not with safety fire even my auxiliary barrel. Yet the restlessness of the bird made it apparent that I must fire soon or lose my chance, for if the bird got fifty feet from me in the tangle of trees and vines on the side of the ridge, it would, in all probability be gone from sight, and forever. I pulled the trigger and, to my consternation, my gun missed fire. It was after all little wonder that gun and ammunition failed me, for both had been soaking wet for three days. The next few seconds were moments of painful indecision. To break and reload my gun would surely frighten the bird; to use the heavy charge in the left barrel was almost criminal, but my only recourse. Without further delay I availed myself of the first opportunity when the bird was screened by limbs and fired. The feathers flew: my first Black Mamo had been shot.

Black Mamo
Drepanis funerea

The Black Mamo was a bird of the forest undergrowth on Molokai in Hawaii. It was a trusting, almost tame bird, which was last seen in 1907. Searches for the Black Mamo went on into the 1930s and 40s. but these were fruitless. Loss of habitat through introduced species such as deer and cattle as well as the impact of rats were the primary reasons for the Black Mamo's disappearance from this world.

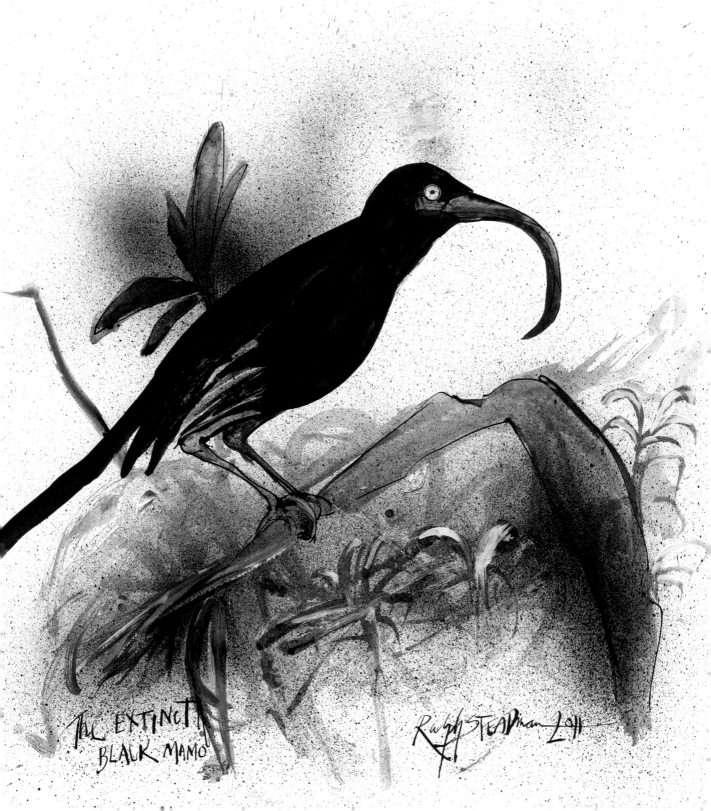

THE EXTINCT
BLACK MAMO

Ralph STEADman 2011

Ceri's Diary: I am still in shock at what keeps appearing from Ralph's pens, and part of me is curious about whether he'll continue painting birds, and if so what role I should play in the process. After all, I don't want to seem greedy and to ask for more and more. But the truth is I have only asked for one picture, and that is all. The rest is a wonderful bonus.

It's a fine line getting the balance right between taking the mickey and doing the right thing, so I am nervous about saying too much to Ralph about where we are heading with these creations. But it does feel as though we have embarked on a relationship created by the birds. I don't want to overstep the mark, as I have no idea where the mark is.

Ralph is putting heart and soul into this work, and seems to be enjoying it very much. As am I. But I feel it isn't right for me to suggest more birds as that decision can only come from Ralph. From the moment the first three birds appeared I knew that something extraordinary was about to happen in my life and I hope that Ralph is destined to play quite a part in it, for the foreseeable future. Let's see where this journey takes us.

The Guadalupe Caracara is my current favourite. It has a different poise to the other birds, and a different centre of gravity, too. The caracara, low down in the frame, skulks across the paper, seeking out its next scavenging assignment, creeping across the rocks on its tiptoe talons. Seemingly on a mission – searching for its survival perhaps.

Guadalupe Caracara

Polyborus lutosus

Birds of prey have been the subject of persecution by man for centuries, so it is quite surprising that rather few have become extinct. The Guadalupe Caracara was one of the unlucky ones. It disappeared due to 19th century settlers' successful harassment of the bird, in particular by goat herders, who shot and poisoned the caracaras at every available opportunity to protect their animals. Their campaign proved successful, as the caracara disappeared from this world in 1900.

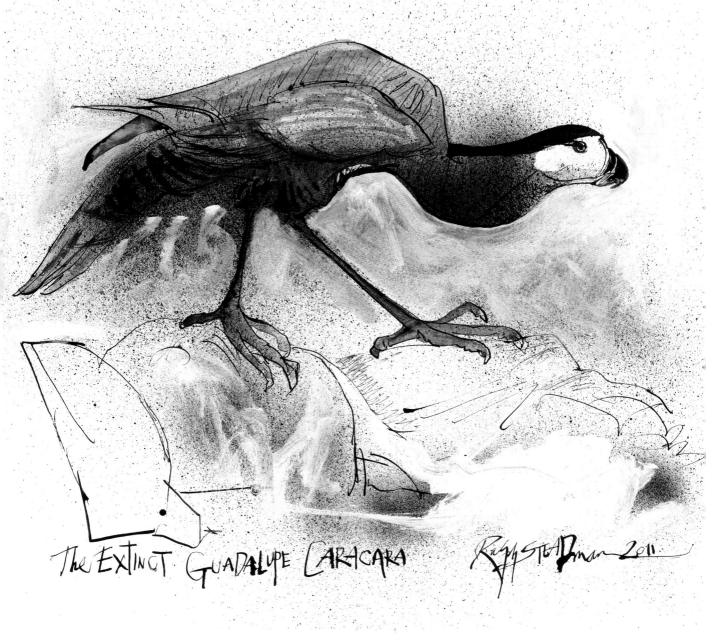

THE EXTINCT GUADALUPE CARACARA

RalphSTEADman 2011

17th March, 13:22. Ralph emails:
Glad you like what is happening! I am going to attempt a few others – if it is going to further your cause. I am going to include them in a story called TOADSTOOL ISLAND. Just a strange piece of serendipity!! OK. Watch this space

Ceri replies:
Serendipity is how this whole enjoyable enterprise has worked so far. Serendipity has got me working with so many wonderful artists, musicians and writers all working as a creative voice for birds. Perhaps serendipity has landed us both on Toadstool Island (which I cannot wait to read) for a reason. Do you think we could somehow incorporate Toadstool Island and this collection into the feathers of the show?

Are you finding these birds have a knock on effect in creating another one? You seem to have flown (Jesus, I'm sorry about these bird words) through these rapidly. Do you still want other birds to think about? Or is the list fine that you have? Or perhaps you feel that you have done enough now. All I know is that they will look wonderful in the show.

Extinction does seem to have struck a chord with you, and perhaps this is why serendipitous forces have brought us together. Just an idea, but I hope we can find an enjoyable place to work on extinction and stories together.

17th March, 19:11. Ralph emails:
Here we go Ceri!! I took a couple of liberties just to see what happens... We will talk things over regarding all the plans – etc...

Ceri's Diary: By liberties I presume he means painting the birds in his inimitable fashion. If that's a liberty then long may he take them. The expression he gives this owl is just so funny. One ear up, one ear down, and that circular owlish stare. Fantastic bird.

Mauritius Owl
Mascarenotus sauzieri

The Mauritius Owl was apparently once a common enough woodland bird, but it was last seen in 1837 and declared dead and gawn in 1859. The probable cause of its extinction was deforestation of its island home.

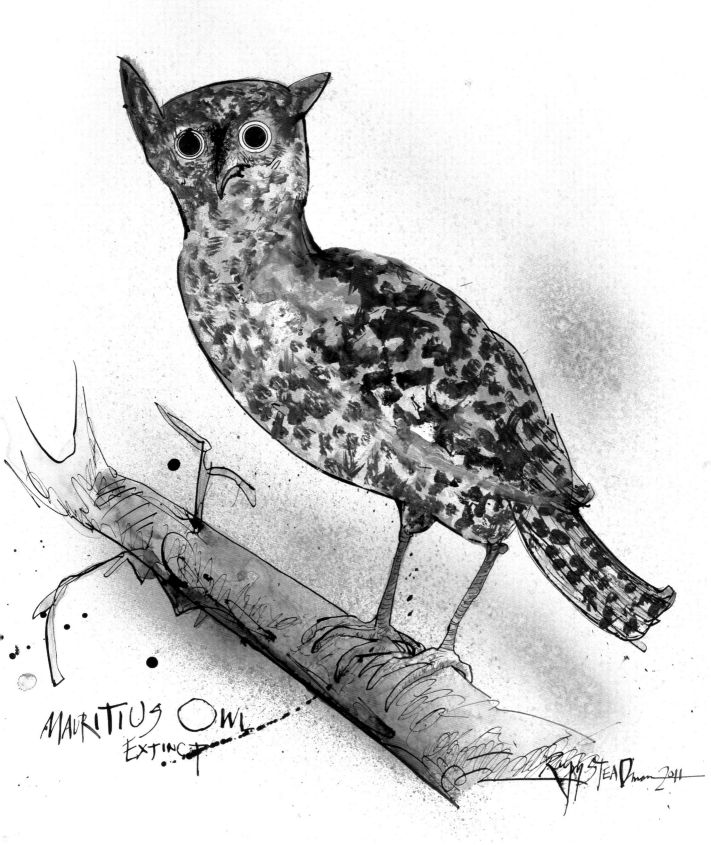

MAURITIUS OWL
EXTINCT

Ralph: He was a busy fella that Rodrigues. He seems to have discovered an awful lot of birds and had them all named after him.

Ceri: I hate to tell you this Ralph, but those birds are named after the place where they lived. Rodrigues was an island, not a man.

Ralph: Well, that explains a lot!
Extinct birds. It's such a pointless idea, really. It's extinct, it's gone. Bit like my old computer. That's had it. I need a new one but I don't like change.

Ceri: I like change. It can be a little scary but that's what makes it exciting. If you get a new computer I'll help you set it up… You mentioned plans. How do you see things panning out? You've gone well beyond the call of duty and if you want to stop that's fine… but if you want to continu…

Ralph: Ceri, don't feel that you have to be careful of what you say to me. You can tell me exactly what you think or reveal your ideas without fear of upsetting me. I am enjoying doing these birds; I am just not sure why we are doing them.

Ceri: Neither am I. But I feel they will lead us somewhere very interesting if we continue. I would love to see you create more as I think they have a real future ahead of them.

Ralph: Perhaps I will draw the whole damn lot of them…

Rodrigues Solitaire

Pezophaps solitaria

This disgruntled-looking Rodrigues Solitaire is another of the superstars of the extinct bird world. Standing just over two feet tall and endemic to Rodrigues Island, which lies to the southeast of Mauritius, it was a close relative of the Dodo. Ralph has depicted it looking stern and apparently able to take care of itself. Unfortunately it couldn't look after itself in the face of human persecution and the solitaire must have indeed felt like the only game in town, where every road it took led to extinction. The bird was hunted by humans and introduced cats alike, both with the same intention – dinner. The Solitaire is thought to have become extinct by the 1760s.

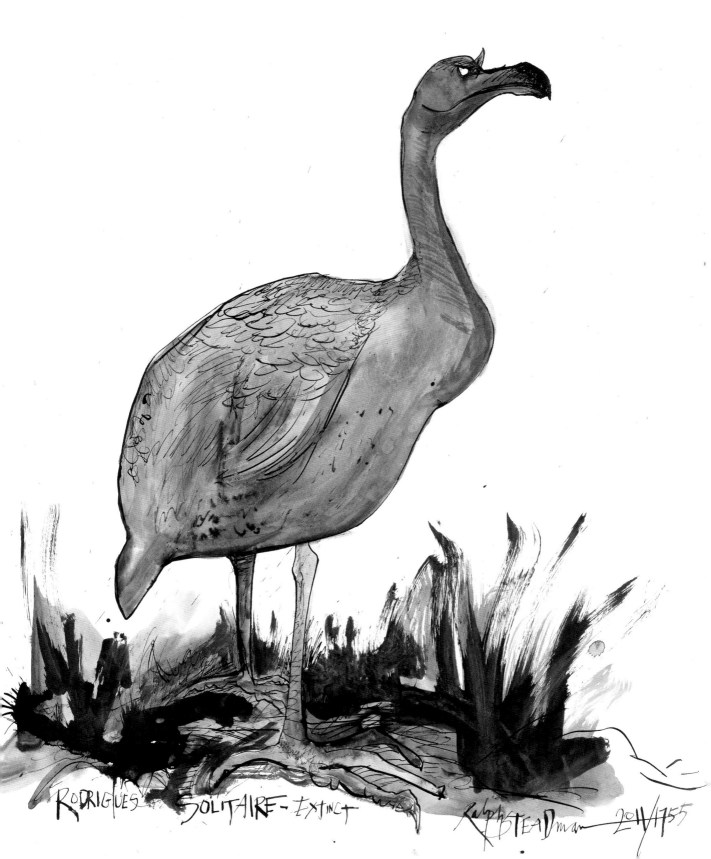

RODRIGUES SOLITAIRE - EXTINCT Ralph STEADman 2014/1755

23rd March, 14:37. Ralph emails:
I have one more bird on board but I don't know
what we are trying to do?????

Ceri: I am not sure what we are trying to do, either.
But I do think that you have embarked on creating
a series of birds and only you can tell me when you
think it's time to stop. If you feel that you have
done enough now then that's fine by me. After all, I
only asked if you might do one bird for *Ghosts*, and
now look at how many there are. Put it like this,
however many you make, we will exhibit them all in
the show, whether it's ten, twenty or a hundred!
So the future is in your hands...

Ralph: As long as you think there's a reason to do
them let's carry on regardless.

Ceri's Diary: I think that neither of us quite knows
what is going on. We are having great fun, Ralph in
creating these creatures and me on the receiving
end of them. But why is Ralph continuing making
birds when he was only asked to draw one? My
hunch is because birds can be addictive, that's why.
They transfix us as they perch within our minds.
I am now certain that this will become a *magnum
opus* if Ralph creates more of these avian wonders.
There is no discrepancy in quality and there seems
to be as many ideas as boids hurtling through my
broadband connection with extreme regularity.

But Ralph is right to ask the question. What are
we trying to do? I don't know what the answer is.
But sometimes you have to follow your instincts.
My gut tells me we are doing something worthwhile.

23rd March, 19:19. Ralph emails:
OK. Summink else – but next I do my OWN Boids!!!
And Come VISIT!!! I got that wretched new computer-
THANKS TO YOU!!! I wouldn't have bothered
otherwise @!!!! OK

Oahu 'O'o

Moho apicalis

The Oahu 'O'o was a mysterious, virtually unknown
bird. Its time on Earth was probably ended by
habitat destruction and introduced species, as well as
over-hunting for its yellow plumage. The last specimen
was collected in 1840.

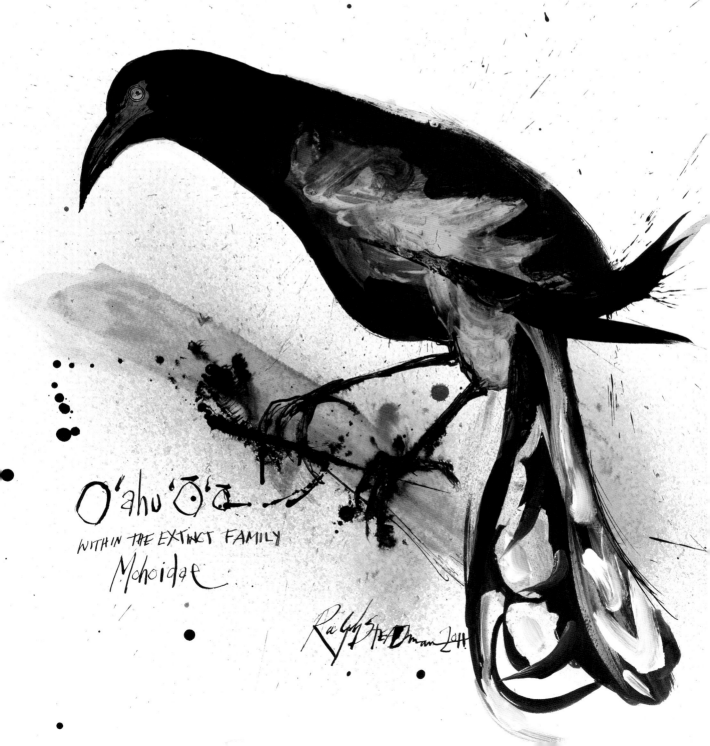

O'ahu 'Ō'ō

WITHIN THE EXTINCT FAMILY
Mohoidae

Ralph Steadman 2011

2nd April, 15:24. Ralph emails:
My Jamaican Red Macaw is coming along. He fell off his perch once or twice – but I think he will make the grade!!

18:21. Ralph again:
Here is the Jamaican Red MACAW – I am leaving certain 'accidents' that may occur – because all will be accident prone – or they wouldn't be extinct, would they??

I am doing the, er, Liverpool Pigeon now – awright?? If there is an empty space in this mail where the Macaw should be its because my sodding computer is throwin' a woosey – 'cos of me new machine, like...

Ceri's Diary: After a week without a boid being sighted, this angry old so-and-so appears. It does indeed look like we are continuing on our sail around the Isles of Extinction. It's hard to describe the sensation that washes over me when I see Ralph's name in my inbox and that the message contains an attachment. It has never been a disappointment either.

I know that it is time to go and meet Ralph as well. We have got to know each other through email and that greatest of inventions, the phone, but it would be good to see each other face-to-face. I would also like to take my camera along and record some footage of Ralph at work. I have a feeling he will be an entertaining subject.

Jamaican Red Macaw

Ara erythrocephala

The Jamaican Red Macaw is yet another mystery bird of which little is known; it may not have existed at all. The great thing about Ralph doing a bird such as this macaw is that now it is committed to paper it definitely exists in our world, and it is a much better place with this angry fellow in it.

The look of the Red Macaw is one of absolute disgust, as if to say to His Nibship "How dare you draw me like that!" Or perhaps "How dare you perch me on a cliff face like this, that's not my kind of habitat!" If the Jamaican Red Macaw did actually exist it was presumably hunted to extinction towards the end of the 18th century. It's hard to dodge the bullets when you're so brightly coloured.

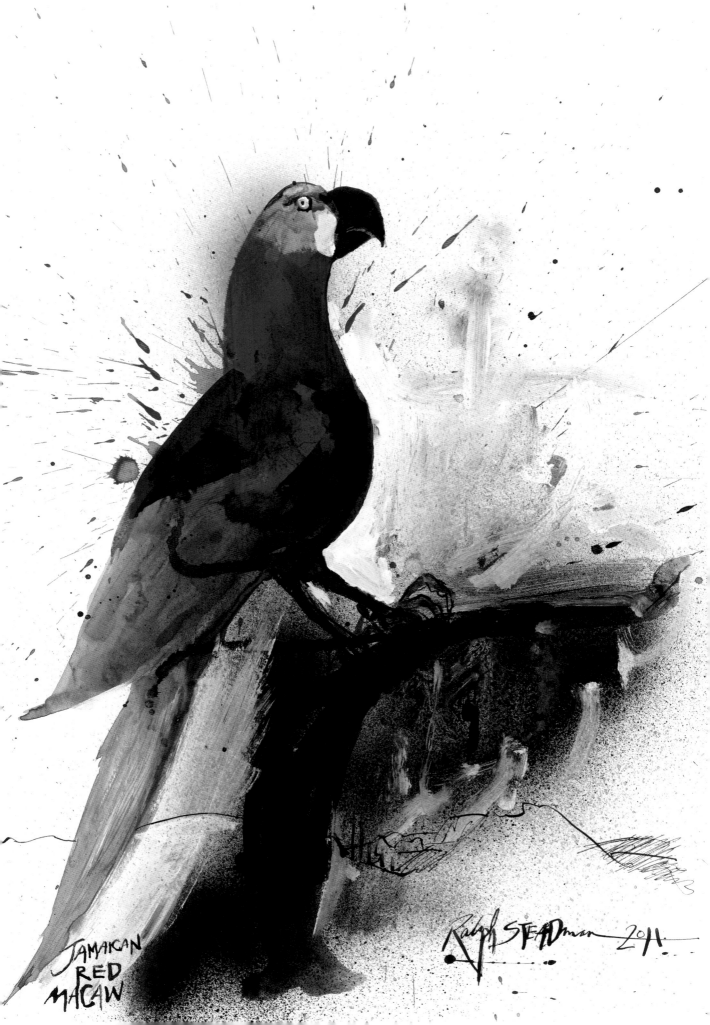

JAMAICAN
RED
MACAW

Ralph STEADman 2011

Ralph: When I was growing up John Lennon and I became birdwatchers together. Well, Liverpool Pigeon watchers actually. That's all there was in Liverpool then.

3rd April, 17:04. Ralph emails:
Here is the Liverpool Pigeon.

Ceri: That is funny!! I love him…
I really think I should come and see you this week and we can finally meet each other.

Ralph: Yeah! Maybe you should!! Nearly finished the Purple Gallinule. We will speak tomorrow. OK

Later, on the phone:
Ralph: I could hear John Lennon talking when I did this. "Eh, wack, what're you doing?" "I'm playing the guitar!"

Ceri: So really it should be known as Lennon's Liverpool Pigeon.

Ralph: Why not?

Liverpool Pigeon
Caloenas maculata

By portraying the Liverpool Pigeon – also known as the Spotted Green Pigeon – like this, Ralph has really done it no favours; it was a much more elegant bird than the feral Scouser he has come up with.

The name, Liverpool Pigeon, is used because Liverpool's World Museum houses the only specimen of the bird in existence. It is thought to have come from somewhere in the Pacific, and this sole example was taken some time between 1783 and 1823.

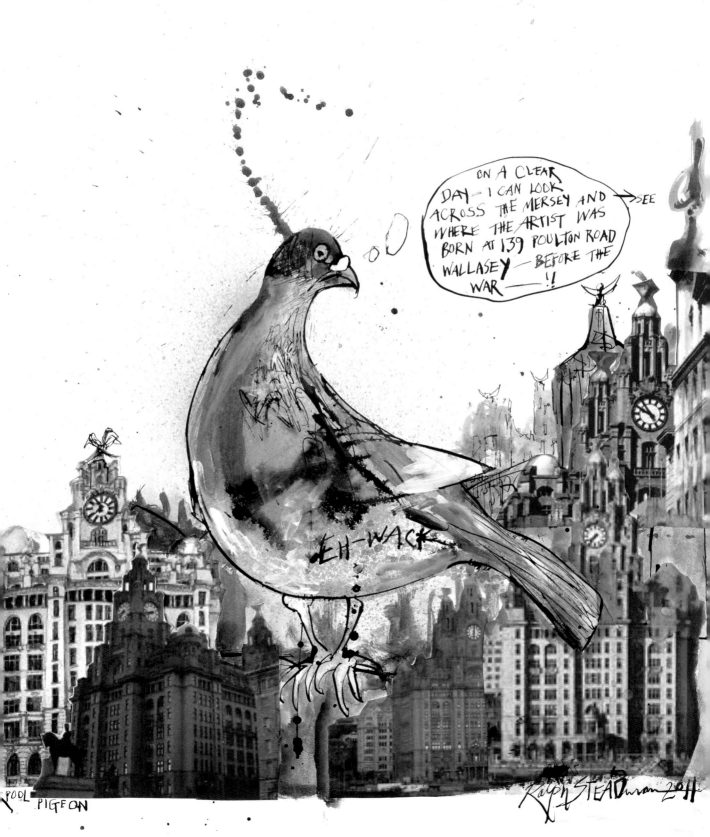

3rd April, 17:58. Ralph emails:
Here be a Purple Gallinule!!!

18:10, phone:
Ralph: I love his body, and that eye… a dead eye. He looks startled, and I love that about some of these boids.

Ceri: How do you know where to start a picture?

Ralph: I look at the paper and I think maybe I'll start there and I just have to give it a try. I won't do it any other way. I think it's called spontaneity, isn't it? It's all about making your mark on a white sheet of paper and it all starts with that very first mark you make. The journey starts there. And I'm not irresponsible just because I don't give a damn where it ends up!

A saxophone player or a guitar player starts playing and at first they're never quite sure of what they're doing if they're playing without music, but it's just happening… something's happening and that is the creative process, isn't it, within the human being… or the monkey… whoever's playing.

Ceri's Diary: Ralph has captured an intimate moment with this gallinule, as it looks like it is gripping onto the earth that lies beneath it for dear life. Either that or we've caught it in the act of doing something it really ought not be doing. But I have some shocking news for Ralph…

Purple Gallinule
Porphyrio porphyrio

The Purple Gallinule – AKA the Purple Swamphen – is NOT an extinct bird. It is still alive and squawking in various locations around the world.

Ralph has got his gallinules in a mix. The White Gallinule (which used to live on Lord Howe Island) is the one that is extinct. Though there is a school of thought that believes that as the Purple Gallinule is prone to albinism, the extinct White Gallinule may have been a Purple Gallinule but in a different colour morph. If this is true then it was a cunning disguise, which didn't work out.

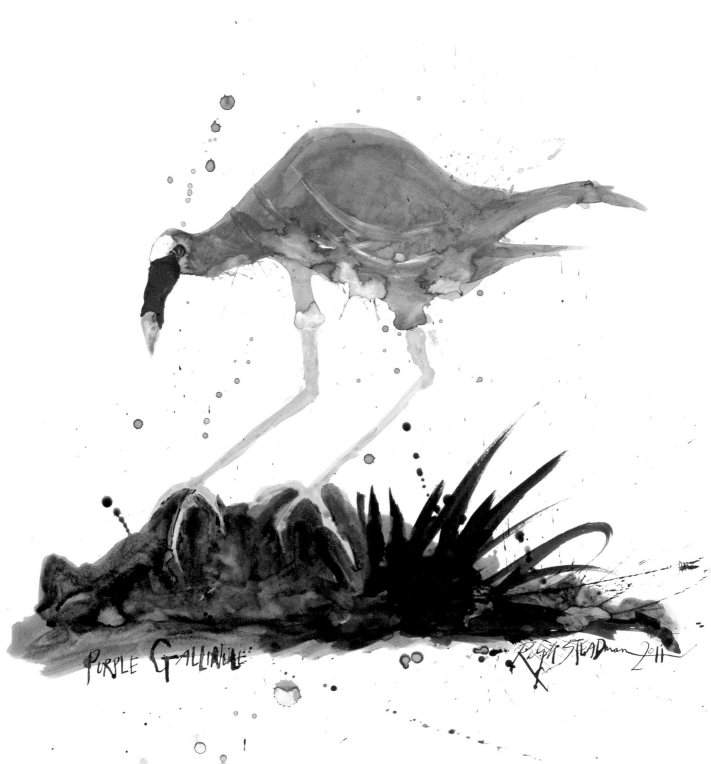

PURPLE GALLINULE

Ralph STEADman 2011

3rd April, 19:47. Ralph emails:
Here are the new TWO!! See you Thursday!!

He's quite a decent specimen of that sort of bird. I did him for television, so I gave them television.

Ceri's Diary: The South Eastern Telly Chat is an extraordinary move in a new direction and I really don't know what to make of it. I laughed as soon as I saw it as it reminds me of Ralph himself, in a cunning bird disguise. But such a mischievous look I have never seen on a bird before. It was created when a BBC South East television news crew came to interview him about some furore he'd caused, about a beer label he had drawn for the Flying Dog Brewery from Michigan. Ralph had drawn mad dogs to represent a beer they made called Raging Bitch, and this had apparently upset the sensibilities of some of the locals.

Whilst talking to Ralph about the dogs, talk turned to the subject of the birds that he had been creating. The film crew wanted to get some shots of Ralph in action, and he started working on a bird that turned out to be a whole new species of creature, inspired by the fact that the television people surrounding him were from the south east. Consequently, he drew for them this impish take on a boid. Needless to say that after a couple of hours spent filming with Ralph, what appeared that night was cut down to 90 seconds and showed none of the Telly Chat being created at all! Typical telly behaviour. But the boid remained in Ralph's studio, and having just landed in my inbox it is now staring at me from my computer screen.

But what to do with him? My first thought is that it is fun but I can't see where it could actually fit into the oeuvre. It is a weirrd creation, brilliantly so, but does it really sit well alongside the other birds Ralph has created so far? Right now I am not certain it does.

South Eastern Telly Chat

Ralphartum televisio

A Stonechat, yes. A Whinchat, yes. But a Telly Chat? Whoever heard of such a bird? Probably only Ralph has.

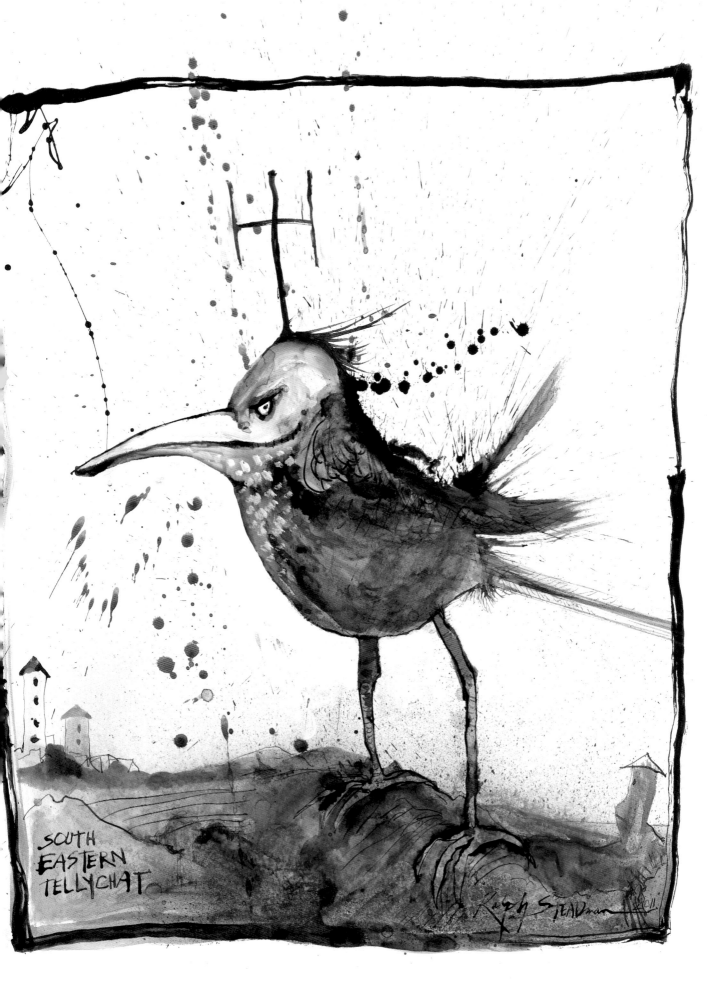

SOUTH
EASTERN
TELLYCHAT

7th April, 13:10. Ralph emails:
Cabalus modestus. He looks like a modest sort. I thought of dear old Chatham down the road here in Kent. But to be honest it's nothing like Kent, although you can see the railway.

Ceri's Diary: Today I visited Ralph at home in Kent. It was a glorious day and I was looking forward to finally meeting Ralph after all we've been through. He and his wife Anna prove to be the perfect hosts. There are few things more magical than entering an artist's studio for the very first time, and Ralph's is no different. His imagery roared at me from all directions – knick-knacks, books, photos of Picasso, plan chests, a guitar, a clock without hands and other sorcerer's paraphernalia fill the working space that is Ralph's nerve centre. One of his notebooks is a gigantic 19th century ledger, from which he read the occasional poem to me. There was a crackle of electricity about the place.

Ralph then pulled me out of my reverie and over to a corner of the room, to where the birds are. All the boids created so far. I reached for my film camera and began to document the moment. What amazed me was that the images were much larger than I had imagined – A1 in size, and so imposing. I gasped at their power.

We went through the paintings one by one, and for the first time I began to really see them as a collection. There are fifteen in total, enough for a show in their own right. The time passed quickly as we chatted and chuckled about his creations, the notion of extinction and the enjoyment Ralph is getting from bringing these birds back to life. Time flew by; I am certain that I have some wonderful footage in the can. And then, before I could believe it, it was time to go and reacquaint myself with that old friend, the M25.

Chatham Rail

Cabalus modestus

The Chatham Rail was endemic to Chatham, Mangere and Pitt Islands in New Zealand and not, as reported by Ralph, Chatham in Kent. Deforestation by the islanders in creating grazing pastures for sheep, and a further decimation of the countryside by goats and rabbits plus predation by cats and rats (all introduced), led to the bird's demise. The last specimen was taken between 1895 and 1900.

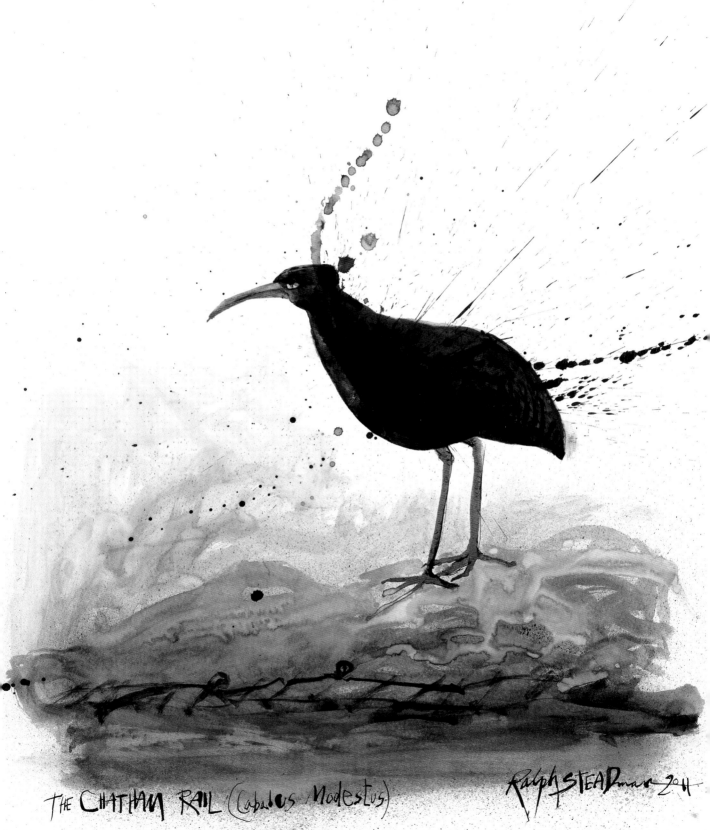

THE CHATHAM RAIL (Cabalus Modestus)

Ralph STEADman 2011

8th April, 9:38. Ceri emails:
Just a quick note to say thank you for making me so welcome yesterday, I had a wonderful time. I really think we're onto a winner with these boids and can't wait to see the next installment. I don't have the latest one you have done, the North Island Takahe…

Ralph replies:
Great to see you yesterday. Glad you enjoyed the day. Me too!! I think we did fine!! But I think this ole Computer is fighting – or sulking!! Having problems with my mail. I might need a new one. HA!! I am going to attempt to send North Island TAKAHE… I am doing the Pallas's Cormorant at the moment…

You have got to check out my friend Keith Newstead – the Automaton Creator – who does the most divine things with mechanical genius! We have worked together often, and since you showed me that wonderful metal Emu by Harriet Mead, I figured you would love Keith's work!! Have a look at his website. OK

Ceri's Diary: I'm glad Ralph enjoyed yesterday as much as I did. I loved being in his company. He makes me laugh, constantly. I followed the link to Keith's site and his work is phenomenal. To my eyes automata are bedfellows of magic, and what he creates are utterly unique pieces. Films of his work abound on the pages and I watch mechanical dragons fly, strange devils ride in automated cars and there is a piece called Mad God Universe, a collaboration with Ralph, which stands over nine feet tall. It depicts God rising above a storm, and below it four elephants support the Earth. Strange flying creatures in turn support these. Everything moves and is fantastical.

North Island Takahe

Porphyrio mantelli

The North Island Takahe was another New Zealander, and another flightless bird that never stood a chance. Not a lot is known about it, other than it was related to the South Island Takahe (which still survives – just), and it may have survived until the late 19th century. Habitat change and predation by introduced mammals probably finished the bird off.

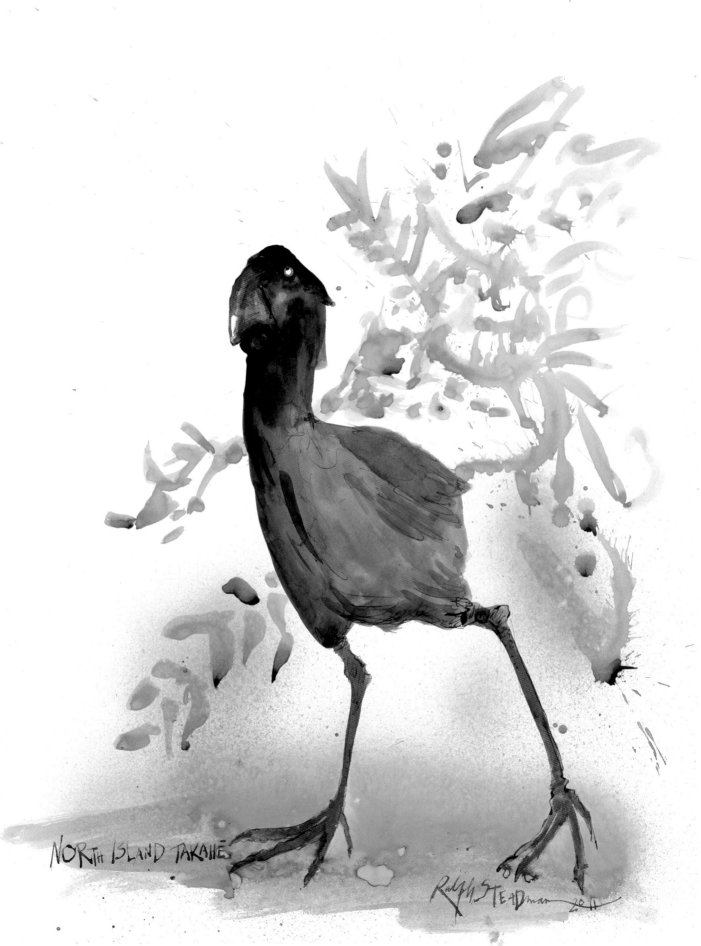

NORTH ISLAND TAKAHĒ

8th April, 18:27. Ralph emails:
Dear Ceri
Here is my Pallas's CORMORANT.
OK. That makes sixteen – so far.

18:32. Ralph again:
Sorry! Sent it to meself!! RALPHZX

Ceri's Diary: I keep thinking about my day with Ralph yesterday. We talked about Ralph continuing to create boids, as he felt that he wasn't finished yet. We have more than enough to exhibit in *Ghosts* but I think Ralph realises that the work is taking us in an interesting and unexplored direction, and I have an overwhelming sensation that we are heading to an unexpected place and that I am witnessing a man in the midst of a creative maelstrom. Ralph will tell me when he's had enough, but for now he will keep on going, as it remains fun for him to create these creatures.

If Ralph stops drawing birds tomorrow, I know that he will have brought something truly phenomenal to *Ghosts*. This expedition that we have embarked upon is already littered with exciting stop-off points, and what we have discovered already has had me gawping with astonishment. But I do hope that our big tour of lost birds is to carry on sailing a little longer. "Full steam ahead, Your Nibship. Take us to more islands of extinction, please!"

My jaw drops when I see this beauty. Such elegance. The richness of the blue is heaven-sent as the bird stares wistfully out to sea, overseen by the new moon rising. This is perhaps the most poignant work done yet. It is a real reminder that this bird has gone. A gone bird. Forever. Why?

Pallas's Cormorant
Phalacrocorax perspicillatus

The once abundant Pallas's Cormorant (also known as the Spectacled Cormorant) was eaten out of this world by Aleut settlers, who in 1826 set up their homes on the bird's long-standing homeland of Bering Island, off the coast of Russia. It didn't take long for the supply of cormorant meat to dwindle, and by the 1850s it had ceased to be a square meal at all.

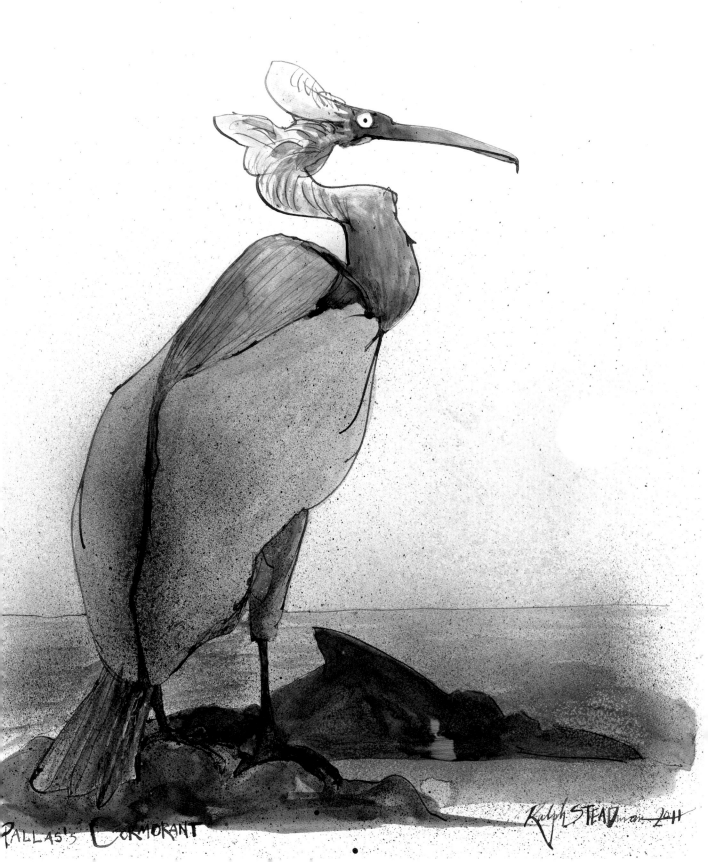

PALLAS'S CORMORANT

Ralph STEADman 2011

Dodo

Raphus cucullatus

There are many bones, and many reports from Mauritius where it was resident, to supposedly give us a lot of information on the Dodo. This, the number one extinction superstar, was large, tame and flightless, attributes that time and again have proven to be a winning formula for entering the bird extinction Hall of Fame. Or at least that is what we have been led to believe over the years. The truth is that little is really known about the life of this tragic bird. It may have been rather slender, and may not have been hunted for food too often due to its apparently vile taste. Heated debates continue to this day about the Dodo. The date of its extinction lies anywhere between 1662 and 1693, and the reasons for its demise probably include introduced species such as rats, pigs and goats, all of which would have threatened eggs, chicks and food resources.

11th April, 18:38. Ralph emails:
Here are four new ones with a couple of added bits. See if you can spot them.

Ceri's Diary: And with these words life takes a turn. I recently received the South Eastern Telly Chat, a fictional boid, which I had no idea what to do with. This is an altogether different experience, as these boids roll through my inbox. And they've changed my thinking on the Telly Chat too. Now it may well have a place within the extinct birds firmament.

Sitting underneath the backside of the Dodo is the Blue Slut, for God's sake, and it looks brilliant! What had seemed like a comic aside with the Telly Chat has now evolved into Ralph inventing boids that *could* have existed. Well, the Blue Slut could have, couldn't it?

Later, on the phone:
Ralph: The Blue Slut was an afterthought that lived, said God. I want a slut and I want it blue and I want it now and... apprehensively it came out of the woodwork, well actually out from behind a couple of rocks, saw the Dodo, and thought – well, if that bird can live then I'm sure that I can, too.

Blue Slut

Sluta caerulea

Questions remain about the Blue Slut. Was she one of the reasons the Dodo became extinct? Was theirs a relationship? Was it untenable? Or was she just in the wrong place at the wrong time when Ralph drew this picture? If only we could have seen what came out of the Blue Slut's nest.

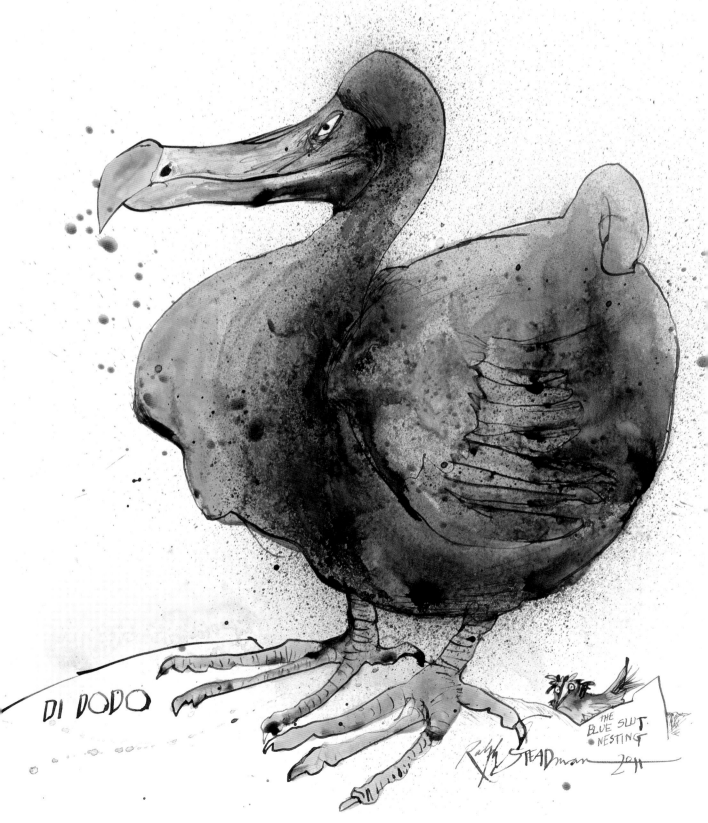

DI DODO

THE
BLUE SLUT.
NESTING

Ralph STEADman 2011

Ceri's Diary: And then just when I thought it could not get any crazier, this raving, maniacal creation leaps from the landscape, bursting forth in its ink-blotted way, announcing its arrival into Ralph's extinct world. This Throstle looks ready to throttle anyone who gets in his way. That could just be paranoia on my part, and he may well prove to be a softer lunatic than I first imagined; being part of the thrush family, and a song thrush at that, perhaps all this bird is readying to do is break into a bawdy birdsong to shock an unsuspecting passer-by.

12th April, 11:00. Phone:
Ralph: I love the names that people come up with for a lot of these birds. A Swamphen. What a name. Lord Howe's Swamphen. Wonderful!

Ceri: I love the made-up ones you've done today. It has added something extra to the collection. Added a new dimension to it.

Ralph: I think I'm going to do some more. No, I AM going to do more. I like making them up.

You've reawakened an interest in something I think I knew I liked all along, which is a bloody nuisance because I was just about to give up everything, retire, sleep a bit…

Ceri: And now there's boids to be created!

Ceri's Diary: And so, yet another major turning point in the project. There are now going to be two types of birds appearing in this assembly that Ralph is collating – Birds and Boids. One being the extinct birds that Ralph started out creating, and the other these oddities that he's now conjuring up, which have never been seen or heard before.

Rodrigues Blue-Black Throstle
Turdus lividifuscus

Throstle (*noun*)
1. Song Thrush
2. Old Spinning Machine

I think this may make a better Spinning Machine than a Thrush.

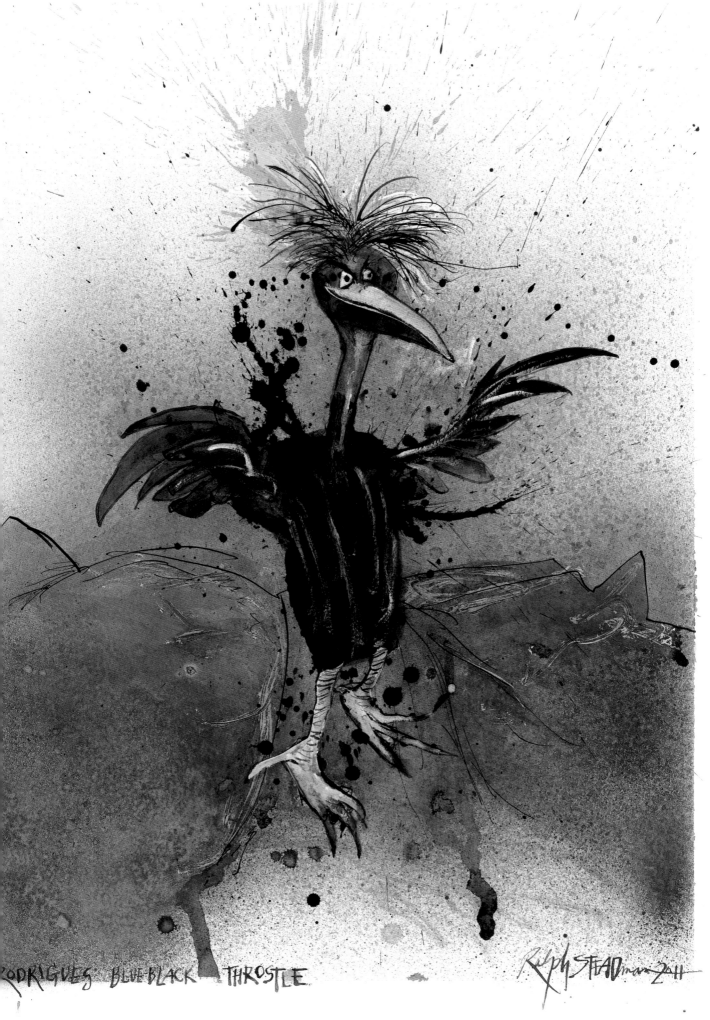

RODRIGUES BLUEBLACK THROSTLE

Ralph STEADman 2011

Ceri's Diary: We discussed what word could encapsulate a mixed flock of birds and boids and we decided that an apt name would be a confusion of boids. Much like we have a parliament of Rooks or a charm of Goldfinches, we are now bringing confusion to the world. All points of Ralph's compass lead to the conclusion of a perfect confusion.

Birds + Boids = A Confusion of Boids.

Ceri's Diary: Ralph has pointed out to me that he's glad that the birds came along as he had become sick and tired of doing politicians and that they had become too boring to do any more, and these birds have given him renewed vigour. We have also started to discuss a place called Toadstool Island that he has invented and which he had mentioned previously.

12th April, 11:32. Phone:
Ceri: So what is Toadstool Island?

Ralph: It's a place where my made-up boids live.

Ceri: Have they always lived there? Have they always existed on Toadstool Island?

Ralph: As far as I know they have always been there, doing whatever it is that they do. This is the safest place in the Universe for extinct boids to exist. So keep it under your hat.

Ceri: I had a quick peek under *your* hat, and found the Lesser-blotted Bitwing.

Lesser-blotted Bitwing
Pterofragmenta submacula

By the look of the Bitwing it is a slovenly creature that can't be bothered to look after itself properly. But it probably enjoys every minute of whatever it does or doesn't do, whenever it does or doesn't do it. You wouldn't trust this bird with your house keys, pets or important members of your family. But the Bitwing has one saving grace – it has an artistic bent.

Ralph drew this picture of the Bitwing inside its abode. A little-known fact about the Bitwing is that it likes to paint. Its latest creation is hanging on the wall by its bed, though it seems a little twisted for a bird artist to paint a picture of a bird eating a bird. But that sums up the Bitwing.

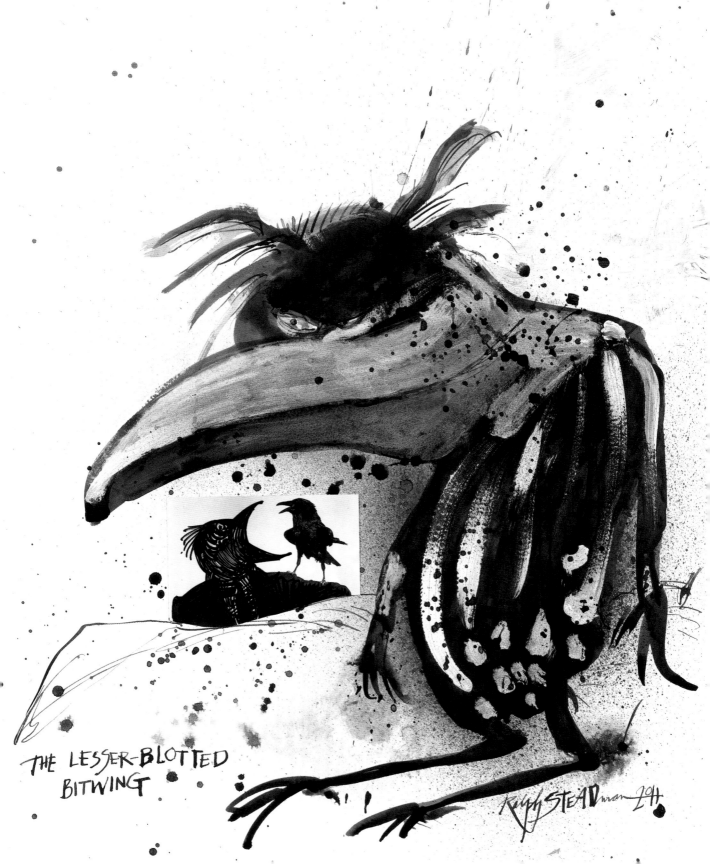

THE LESSER-BLOTTED
BITWING

Ceri's Diary, 18.30: Revelations about Toadstool Island continue to flood in. I have just got off the phone to Ralph and this is what we discussed and learnt.

Ralph (excitedly): On Toadstool Island, there is what I believe to be the only living flock of EXTINCT birds that the world has never seen!! The actual extinct birds, not just my made-up ones. They are there too. A proper confusion.

Ceri: I heard that they moved there because of your boids, and that the extinct birds feel safe there, knowing that no one in the world has the co-ordinates of the island, not even that famous hunter of yours, Rodrigues!

Ralph: He hasn't got a clue that man, not a clue of where to go. Let's keep it that way.

Ceri: Good, then that confusion of boids is safe! Why do you think you are painting so many birds now?

Ralph: Curiosity. To see how many I can do. I wouldn't ever have chosen birds as a subject and I'm sick to death of doing politicians. I have no interest in them any more. None whatsoever. I've done dogs and I've done cats, which somehow spook me out – I don't particularly like them. But for whatever reason, these birds aren't spooking me out. And I'm finding them quite intriguing to look at once I've done them. They're very engaging creatures to try and come to terms with.

Ceri: They're very engaging for the viewer as well. There is such variation in each bird that you have drawn. There's a feel of spontaneity about each one.

Ralph: I just let things become what they become.

Ceri's Diary: In among the madness of the strange and wonderful creations that are streaming through is this Mauritius Night Heron. It is tentatively putting its right foot forward, as if to check that Ralph has painted the floor properly for him to move on, whilst checking that no odd boid is going to leap up at him from the side of the page.

Mauritius Night Heron
Nycticorax mauritianus

The Mauritius Night Heron has been extinct since the turn of the 18th century. The reasons for its extinction are unknown, although the usual introduced foes such as cats and rats are suspected to be among the guilty parties.

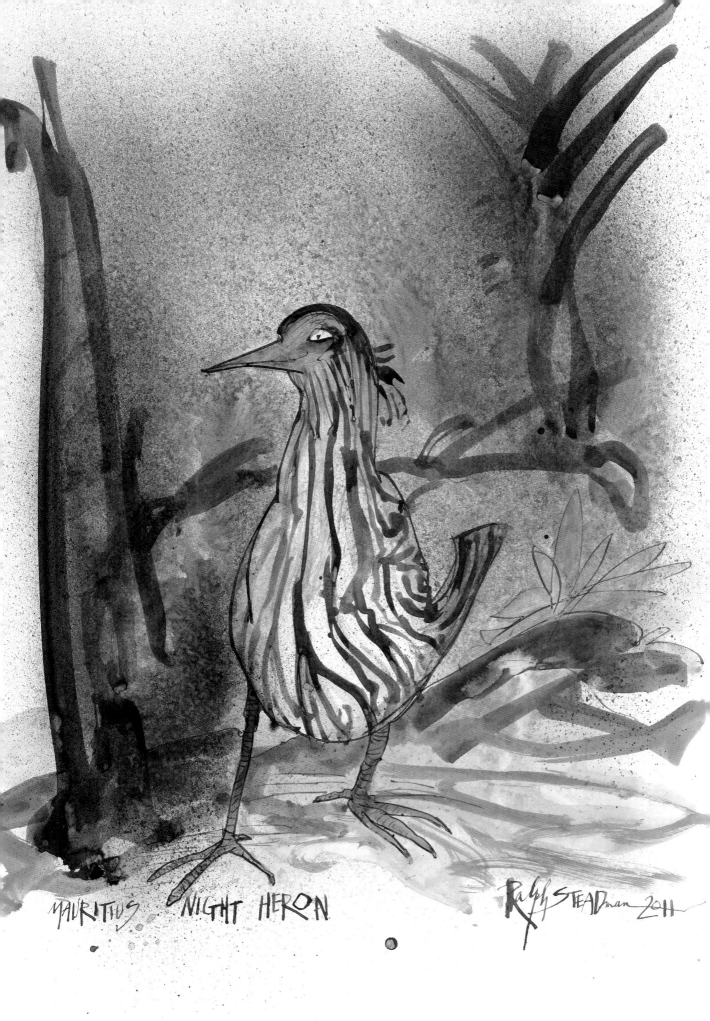

MAURITIUS NIGHT HERON

Ralph STEADman 2011

Ceri's Diary: Ralph tells me he is going to get in touch today with Keith Newstead, the automaton-maker. Having worked together in the past Ralph is interested in exploring the possibility of Keith turning some of the boids into working models for the show.

12th April, 13:12. Ralph emails Keith Newstead:

Dear Keith,
I have been doing these extinct boids, but not sure yet if I want to do a whole lot of 'em!! I am quite liking the made-up ones! They make me laugh... You have seen the DODO – BUT what you haven't seen is the Mechanical Botanical SPUNT!!! I haven't yet drawn it – so- I will draw it- Just for YOU. A Dedication species - just for you!!!

Wait for it!!!

12th April, 18:08. Ralph emails Keith and Ceri:

Here is the Mechanical Botanical SPUNT... but I never said it could – or ever did fly – it was last seen in Rhyl, North Wales, prancing about the Queen's Ballroom with Mavis Green. Now, the Mavis Green was an exotic bird – but she flew away!!

Ceri's Diary: The Mechanical Botanical Spunt has to be the most out-there of all the boids so far. I can see that it is a creature inspired by an automaton-maker, and thanks to Ralph I now know Keith Newstead. He has also agreed to become involved with Ghosts. He is going to create 3D sculptures of three of Ralph's birds and bring them back to life; the Dodo, the Guadalupe Caracara and the Mauritius Owl, plus three ghost birds of his own magical invention. The Spunt was inspired by his genius.

Keith in his studio.

Mechanical Botanical Spunt
Keithus spontanaicus modestus

The Mechanical Botanical Spunt is dying to whirr into action. Connect it to a power source and who knows what may happen, although I have a sneaking suspicion it has been designed to dance and dance and dance... a Saturday night out with this chap would lead to a Sunday morning with tired dancing feet.

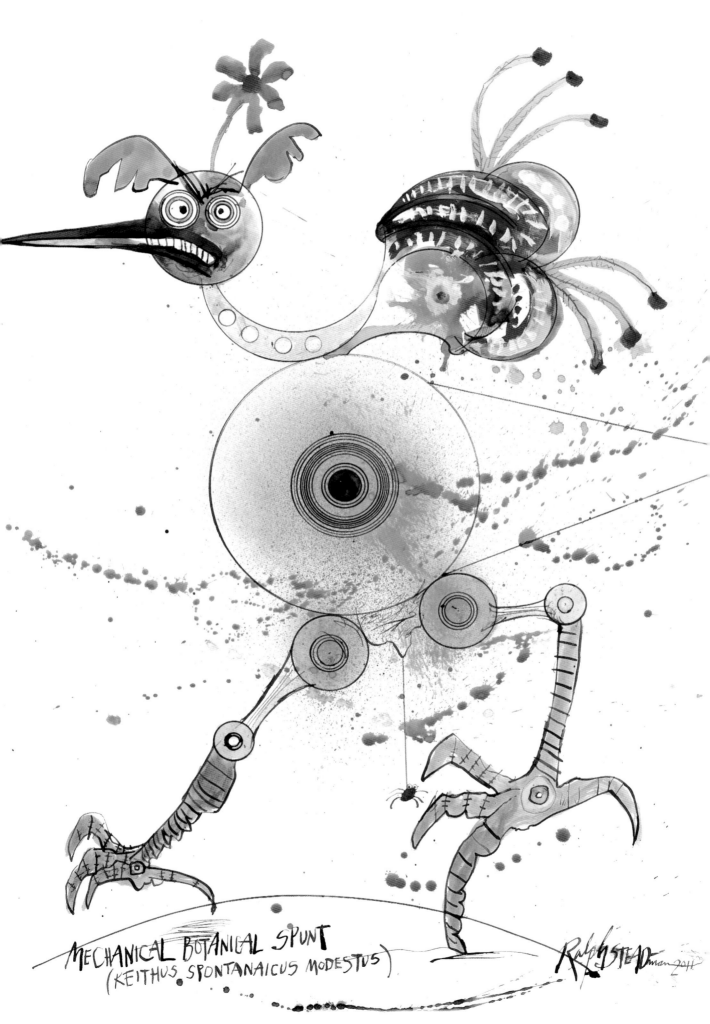

MECHANICAL BOTANICAL SPUNT
(KEITHUS SPONTANAICUS MODESTUS)

Ralph STEADman 2011

Ceri's Diary: Why do I call birds like the Imperial Woodpecker twilit birds? Because they inhabit that space between night and day, life and death, extinct and living. When does a bird become an extinct bird? When is it deemed that it has passed to the other side forever? The more I ask this question, the more difficult it becomes. The Imperial Woodpecker has not been seen since 1958; if it is an extant bird then it is very good at hiding from the many that have searched for it.

E. W. Nelson wrote on hunting a pair in 1898:

The male was only winged, and as we approached threw himself over on his tail, with outspread wings, presenting a warlike front of threatening beak and talons. It was impossible not to admire the courage and defiance shown by the fierce glow of his golden-yellow eyes and upraised flaming crest... The birds were surprisingly easy to stalk, even after being hunted and shot at for several days, but were difficult to secure because they are powerful, hard-muscled creatures possessed of remarkable vitality. They showed considerable attachment to one another and when one was shot the other members of the flock remained scattered about on the trees for a short time calling each other at intervals. Wounded birds fought with savage courage.

Boid or non-boid, who is going to have the cojones to finally say 'It's gone! Let it go', because someone surely needs to. Should we still be holding a candle for this woodpecker after all these years, never giving up hope of its return? Or should we finally lay down the torch, and find some closure?

Imperial Woodpecker
Campephilus imperialis

This Mexican bird was the largest woodpecker in the world. The probable cause of its extinction was the decimation of the pine forest it depended upon, which left it nowhere to call home.

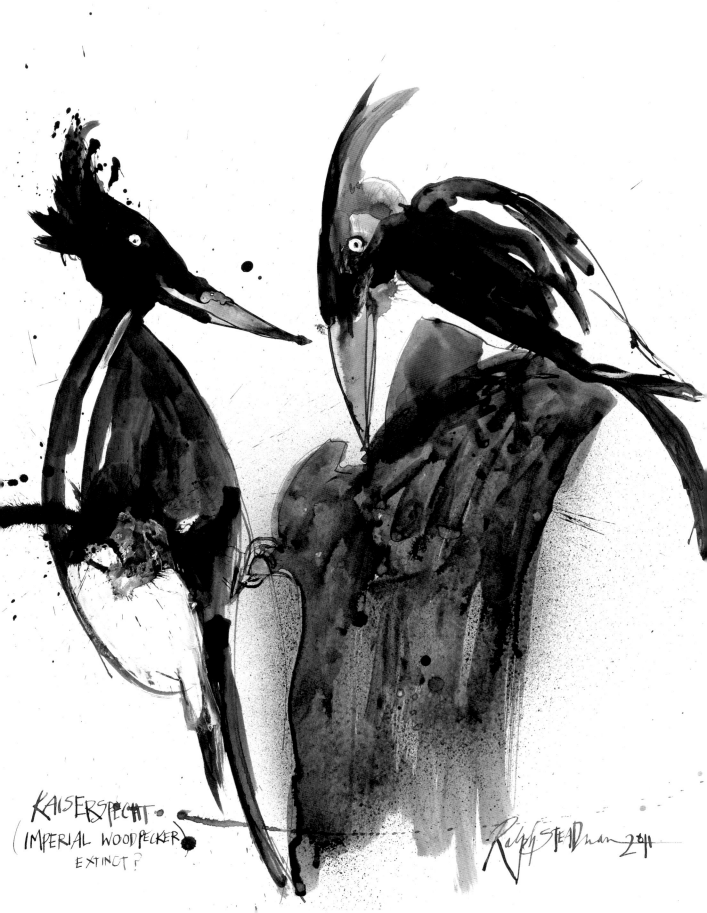

KAISERSPECHT.
(IMPERIAL WOODPECKER)
EXTINCT ?

Ralph STEADMAN 2011

13th April, 15:27. Ralph emails:
There will be another BOID before the day's out – maybe TWO…

17:33. Ralph again:
Suddenly during the making of the Martinique Amazon Parrot – I find these!! The Shtum and the Mwit!

Ceri replies:
That's because boids have been bouncing around your ether for some time! You bring existing birds back to life and then discover ones that no one knew were there.

Ceri's Diary: The birds are literally flocking onto my computer. It is arrival upon arrival. Well, it is the migratory season after all, so it's quite apt that all these unusual birds should be appearing. It's the perfect time of year for rarities to turn up. The gloves are definitely off with Ralph, after our talk about the mix of birds and boids on Toadstool Island. Here we have the perfect mix of the two.

18:05. Phone:
Ralph: The King Island Shtum wanted to burst into song but couldn't find its singing voice. It sat on its branch and kept silent. The only thing it could occasionally say was "Shut up!"

Ceri: So he couldn't quite keep shtum. What about the Mwit? What's his story? He's very orange.

Ralph: The Orange-beaked Mwit gained its colour from its love of oranges. It would eat nothing else, and would often leave pools of orange juice wherever he went.

Martinique Amazon Parrot
Amazona martinicana

The Martinique Amazon was noted once in the mid-18th century, and there was never another sighting. Little to nothing is known of this species – even whether it actually existed. If it did it probably disappeared some time shortly after its solo sighting. It is quite fitting that a possibly imaginary bird should end up hanging out with a couple of boids ….

King Island Shtum
Aureus silentium

A deeply frustrated songster, whose inability to communicate the music it writes in its head is deeply frustrating. One day it may all pour out.

Orange-beaked Mwit
Mwitus luteorostris

A noted lover of the orange's citrusy goodness.

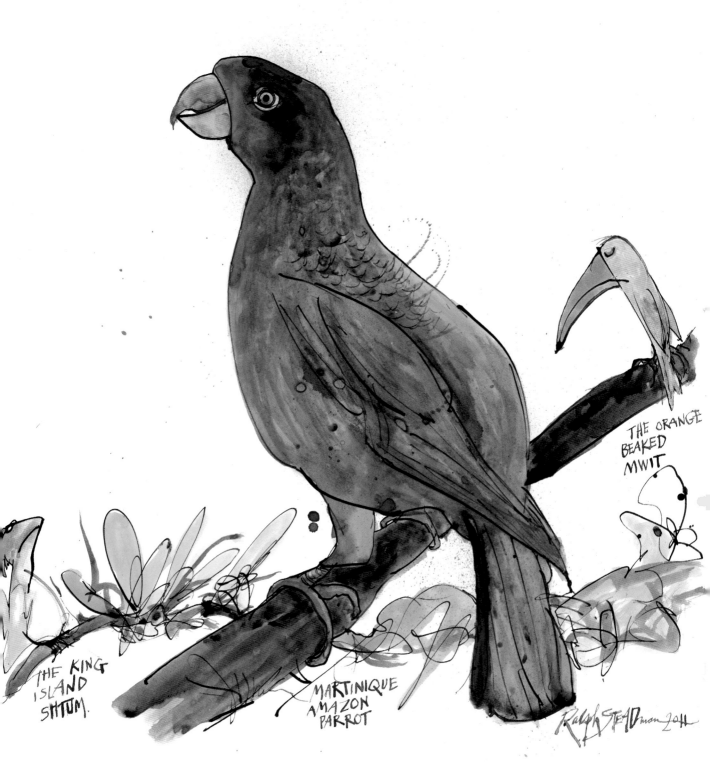

THE ORANGE
BEAKED
MWIT

THE KING
ISLAND
SHTUM.

MARTINIQUE
AMAZON
PARROT

Ralph STEADman 2011

Ceri's Diary: We have been talking about Toadstool Island constantly, and of how Ralph's boids behave. Just looking at them, it is obvious that they may well have unique behavioural patterns that will be worth examining. We are heading into uncharted waters, and it is perfectly exciting.

Later, on the phone:
Ralph: We should have a careful look at the boids on the island. Study them, and report on their behaviour to the world. You're the commentator, and I think there is a lot to commentate *on* with these creatures.

Ceri: You're not kidding. Look at all the birds you have created so far and what they do. Bitwings who paint, Throstles who rave, Shtums that can only say "Shut up," and Blue Sluts that hang out with Dodos. I think of myself as our ship's scientist. I have already started recording what these boids of yours get up to, and I will report back to you – and therefore to humanity – with my findings.

Ralph: Perfect. I'll look forward to receiving detailed reports on the boids, at regular intervals.

Ceri: Aye aye, Cap'n. I'm off to the poop deck. A popular place to spy a bird from, I should imagine. You carry on with your nibshippery in the midshippery.

Huia
Heteralocha acutirostris

The Huia was from New Zealand; it went into decline from the middle of the 19th century, and was last recorded in 1907. Habitat destruction, in particular the removal of dead trees, which the birds loved for its housing of tasty beetle larvae, was responsible for the bird's end, as well as over-hunting and possibly disease. In 2010 a single Huia tail feather was sold at auction for a world-record price of NZ\$8,400 (£4,300 or US\$6,500) in Auckland, New Zealand. Imagine the price a whole bird would fetch. Such is the price of extinction.

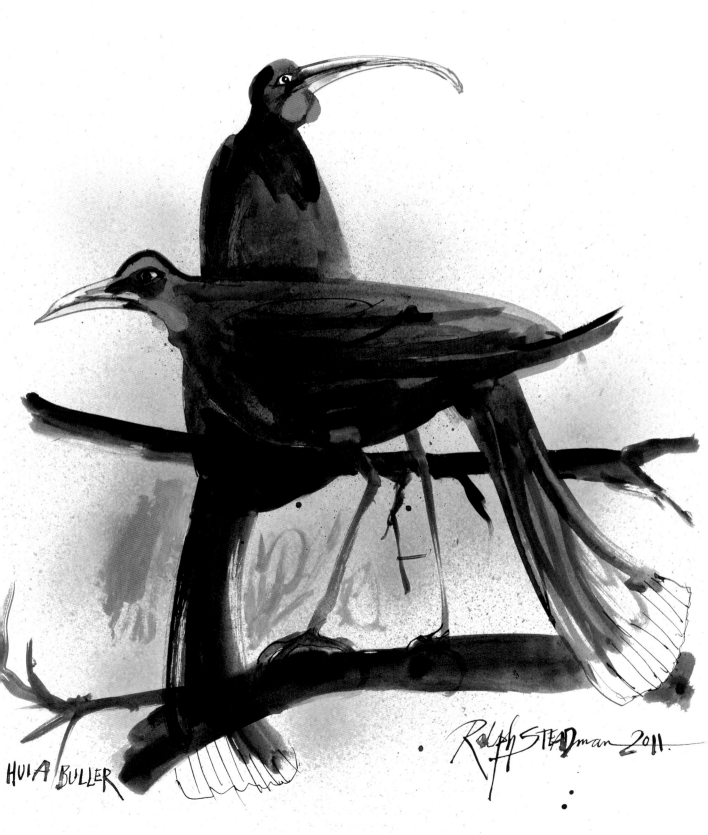

HUIA BULLER

Ralph STEADman 2011.

15th April, 18:39. Ralph emails:
I managed to do one boid today – the Red-Footed
BOOBY!!

Ceri: They are wonderful but it's a bit of a boob, as
they're not extinct.

Ralph: Show off!

19:05, Skype:
Ralph: I loved this poem as a boy. My mother used
to read it to me. It's by an anonymous poet.

Spring is sprung, the grass is riz
I wonder where the boidies is
They say the boid is on the wing
But that's absoid
The wing is on the boid

Ceri: This poem shows that boids have always
been with you, and for those who disbelieve in the
existence of boids it shows that they have always
been *here*, too. Maybe they have been sat in the
back of your mind since then, waiting for the
chance to finally break out, and now they have
seized their opportunity. You are the Boid Keeper.

Red-footed Booby

Sula sula websteri

The Red-footed Booby is NOT an extinct bird, and
I hope that this isn't a prophecy and the booby is soon
to join the ranks of the extinct, just because Ralph has
committed it to paper. Nah, I'm being daft. It's just
a mistake and shouldn't be in here at all. I love the
painting and the way Ralph has drawn them as
inquisitive creatures. But it does serve as a reminder
that any bird could join the list of the disappeared.

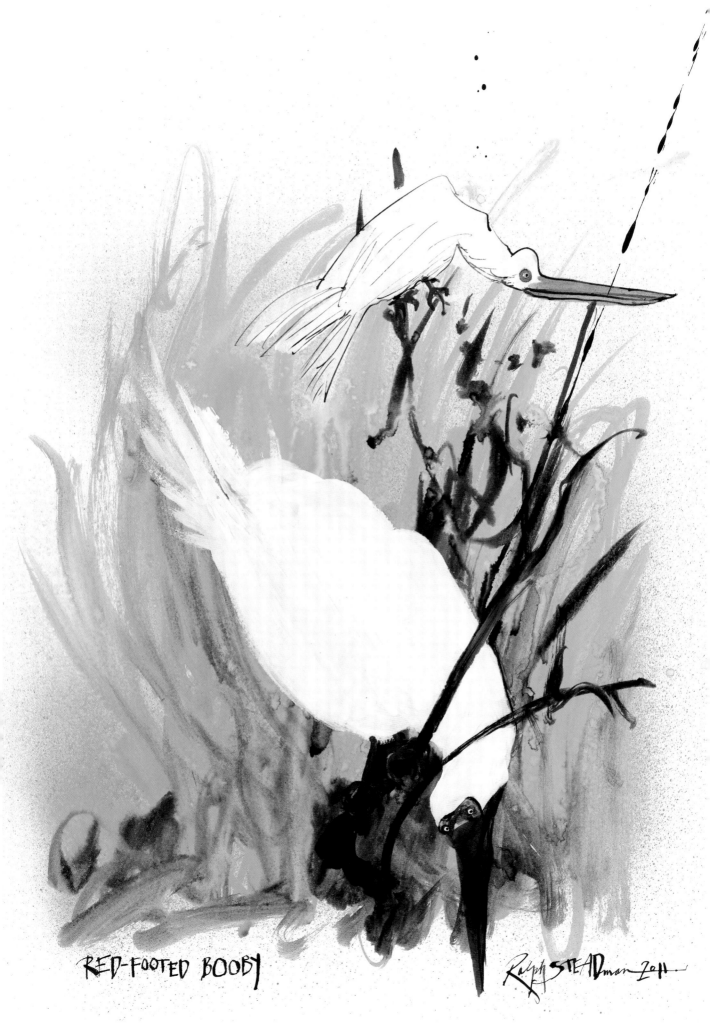

RED-FOOTED BOOBY

Ralph STEADman 2011

17th April, 13:28. Ralph emails:
Here is the Bonin Wood Pigeon – as far as I can tell.

Ceri: I love his mysteriousness, Ralph... really works well, and a little plaintive too.

Ralph: I don't know what part of the world he's from. We need to find out exactly where Bonin Wood is.

Ceri: It's not on the Central Line...

Ceri's Diary: There is a vacant stare in this pigeon, which I have often seen in pigeons and doves. They often look a bit bored with their lot in life, as if things have passed them by, and they could have amounted to something but never really did. Ralph has captured this pigeon's stare out to infinity and beyond, which was unfortunately a place this bird would soon visit.

It is also worth thinking about the Turtle Dove, which comes from the same family, the Columbidae, and is in serious decline at the moment. This is a beautiful bird, which appears in songs, often as the symbol of a deep and resolute love. It used to be common during the summer months in Britain, but is now disappearing. The population is under threat from habitat loss, and the fact that it is continually hunted as food, especially in the Mediterranean. I have never seen a Turtle Dove in this country, and that makes me sad. This bird is disappearing before my eyes right now, in the present. We have lost several species from this bird's family – must we lose more? Will we never learn that we need to protect the wildlife on this planet, especially as we are the instigators of the majority of problems for many of the creatures of the world?

Bonin Wood Pigeon
Columba versicolor

Bonin Wood is on Bonin Island, which is part of Japan. The first records of the Bonin Islands Wood Pigeon were in 1827 and the last specimen was taken in 1889. Reasons for extinction are unclear but probably deforestation was a major issue.

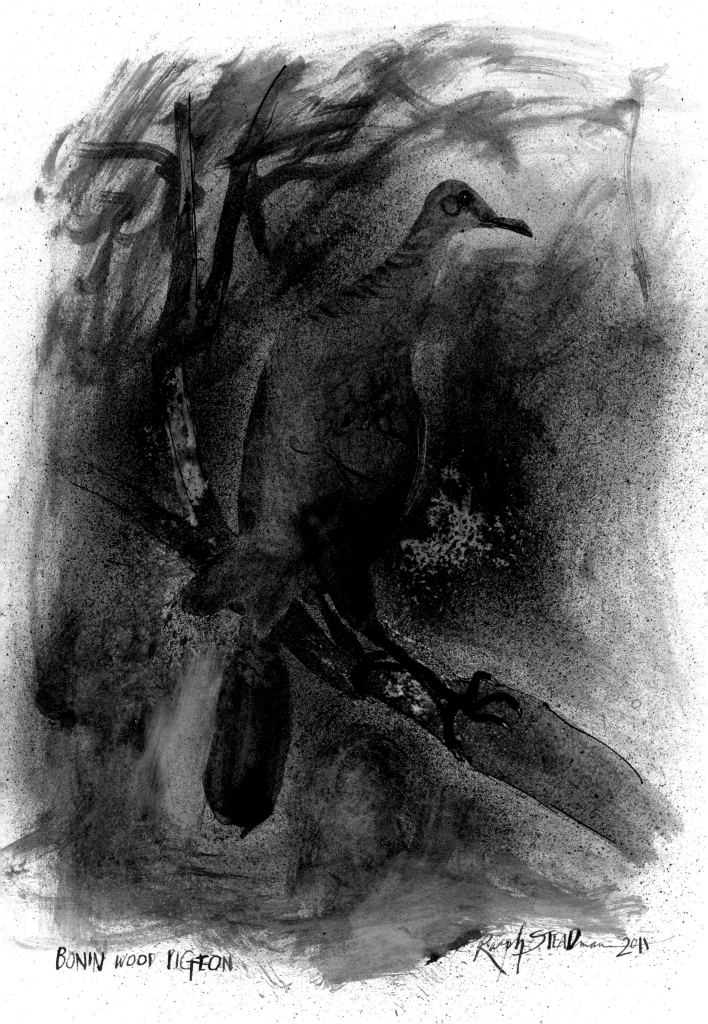

BONIN WOOD PIGEON

Ralph STEADman 2011

18th April, 19:18. Ralph emails:
Here's one more.

Ceri replies:
I adore Hoopoes. It is most definitely one of the best birds in the world. I love watching them whenever I get the chance. So I am unbelievably happy that you have decided to do this...

Ceri's Diary: There is nothing quite like the first time that you see a bird that you have always wanted to see. And the first sighting of Ralph's Giant Hoopoe is no different. It also brings memories flooding back to me of my first sighting of a Hoopoe in Spain. I first saw the crest peeping out from behind a tree, and then the Hoopoe magically appeared in full view. It was a glorious sunny day, and the peachiness of its plumage and the vibrancy of the black and white made it one of the most beautiful birding moments of my life. To think that we have lost a giant version of it is utterly depressing.

Most references to the size of the Giant Hoopoe regard it solely as 'very large', which I suppose a giant would be. Seeing as Ralph's bird has what looks a lot like a whippet with prawn-legs in its mouth, it must have been pretty big indeed.

This creature has such a funny look on its face. It is an 'I'm such a fool'-look. A thought crosses its mind that it had just done something that it should have avoided doing, and if it had done otherwise then it would not now be sitting in the hoopoe's beak. If only it had a better memory it could have remembered what it was it shouldn't have done, and could then have avoided being caught. It's a face resigned to its failure to survive. And then it remembers. "I know I was meant to keep to the long grass but I just got over-excited and ran to the short stuff... There's a reason why we haven't amounted to much... our short-term memory is just... Ouch! That's a little unpleasant."

St Helena Giant Hoopoe

Upupa antaois

The St Helena Giant Hoopoe was endemic to St Helena Island. Very little is known of this flightless bird, and it is presumed to have become extinct due to hunting and introduced predators soon after the island's discovery in 1502.

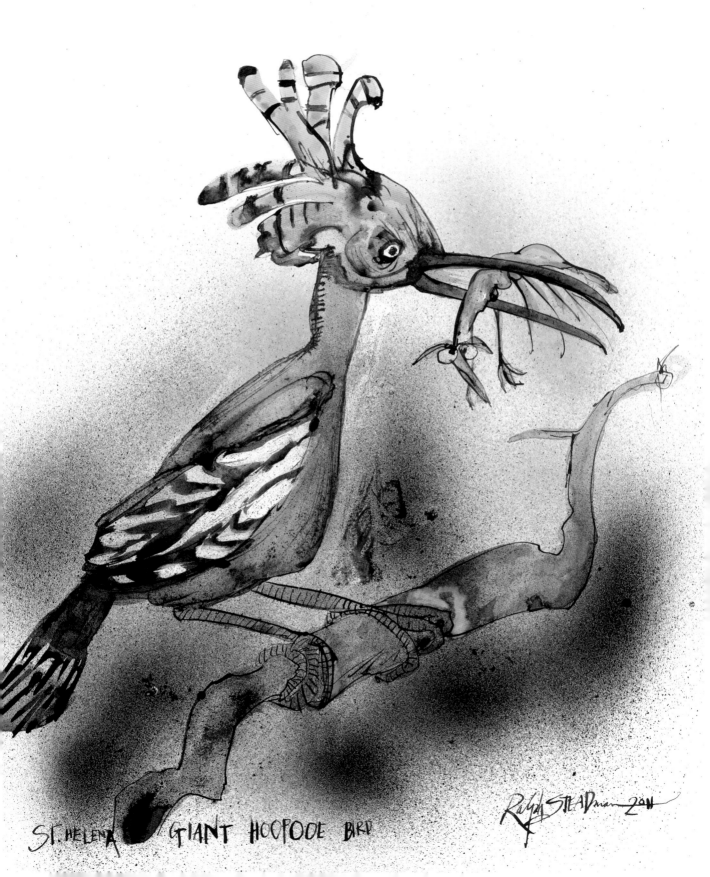

ST. HELENA GIANT HOOPOE BIRD

Ralph STEADman 2011

Here is a fanciful one…

Ceri replies:
Now that's a bird I would love to have seen. What a perfect toff!

Ceri's Diary: I am becoming spoiled with Ralph's art. He continues to turn up the volume and the quality never deteriorates. He has always been assured from the start with the birds that he has created, but this fellow takes the biscuit. Quite simply, a dapper dandy of a bird, who manages to get away with that colour combo! If I wore that kind of outfit I'd be drummed out of town. But what sets me thinking with this fruit dove – and the question I ask myself – is this: Didn't people enjoy seeing this bird? Have we lived through centuries without noticing and admiring the beauty of the creatures that surround us? Wouldn't the simplest soul stop and catch their breath if a bird like this flew past them? Or have the majority of people over time been so self-centred that they have not cared about the rest of the world and what lives in it? Has our instinct really been to survive at all cost? I fear this may be so. How utterly futile to live such lives. I vow to look for something wonderful in the world around me every day from now on.

This bird has the hallmarks of the upper class Victorian gentleman in his finest madness, although it looks as though his moustache could do with a little more waxing to match the generous brilliantine slick of vermillion upon his head. Decked out in all his finery he surely must be on his way to his Club, and Ralph and I should be meeting him to discuss his patronage of our adventures. He makes me feel as if we are in the movie *Around the Bird World in 80 Days*.

Red-moustached Fruit Dove

Ptilinopus mercierii

The Red-moustached Fruit Dove was a forest dweller, endemic to the Marquesas Islands in French Polynesia. It was last collected in 1922, and its extinction was caused not only by the usual introduced rats and cats, but also through predation by an introduced bird, the Great Horned Owl. This owl sounds scary, and it proved too scary for the Fruit Dove.

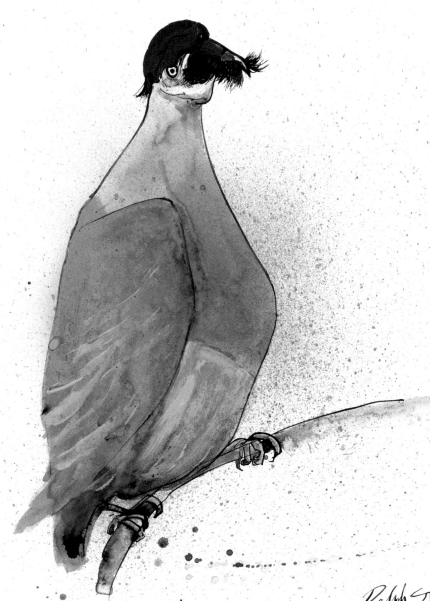

RED-MOUSTACHED FRUIT DOVE
(Ptilinopus Mercierii)

Ralph STEADman 2011.

21st April, 19:48. Ralph emails:
Here we go Ceri, one more exists.

Ceri replies:
Now I never imagined the Coua to have appeared like that! He looks more interested in riding the snail than eating it. Or is this his way of toying with it? Or does he ride it into submission? Whatever, it doesn't look like a fair battle, but then that's nature. Survival of the fittest. If only this snail had held on a little longer this predator would no longer have been around, and the snail could have breathed a little easier.

Ceri's Diary: It is starting to feel very strange if a day goes by without me chatting to Ralph. We discuss birds and boids and laugh a lot, and from that laughter something always appears that is right on the money. And today's bird is no exception.

Before the days of skateboarding, snailboarding was extremely popular with couas. Not so popular with the snails, which knew that no matter how fast they went they would end up as grub for their riders. But the couas would be cooed at as they slowly glided past. You can see the pride in this coua's eye as it engages with the viewer. And there is the glimmer of a grin creeping across its beak. Once it reached the finishing line it was dinner time.

I am starting to feel sorry for some of these creatures that are being taken advantage of by Ralph's birds. This snail looks so put upon, and has a bemused 'here we go again' look on its boss-eyed face. I suppose that when you're a snail you know you're never going to be able to go fast enough to shake the bird off your shell. That bird is there for the duration.

Snail-eating Coua

Coua delalandei

The Snail-eating Coua hailed from Madagascar, with the last specimen taken in 1834. Probable causes of extinction include hunting for the bird's feathers as well as deforestation, while introduced rats may have depleted the snails that provided one of the coua's main food sources.

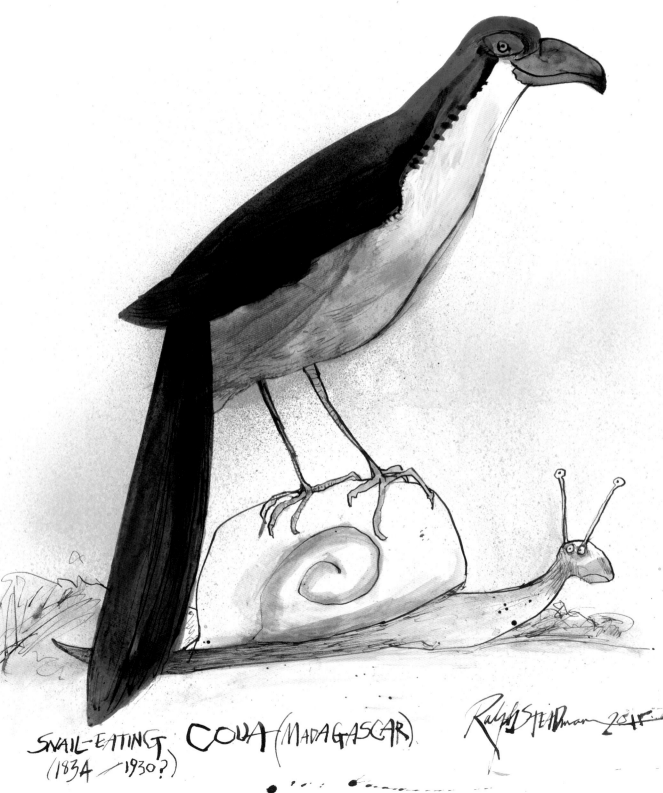

SNAIL-EATING COUA (MADAGASCAR)
(1834 / 1930?)

Ralph STEADman 2014

26th April, 18:33. Ralph emails:
What am I doing??

I phoned Ralph immediately:

Ceri: You're capturing the feel of an extinct bird, the idea and essence of that bird. That's what you're doing. They are your interpretations, your boids. They are such strong works, I think, because there's no set style to them and they're all so completely different. That's what makes them survive so well and makes them utterly and completely yours.

Ralph: Style is what I don't like. If there is any style it's purely accidental, which is OK. Accidents are OK. Often my work comes from an accident! And it's all your fault. You've buggered my life up. I'm doing all these birds, I can't stop and they don't even exist! It's a project about non-existing birds and it's mad. Quite, quite mad.

Ceri: Then maybe you are the perfect man for it.

Ralph: Or maybe it's the opposite. Maybe I'm the worst man for it. An imperfect man for it, and perhaps that's the best way to be for this... I've been enjoying them and that's enough reason to go on.

Ceri: Every time I see them they fill me with joy. They're so free and full of freedom.

Ralph: That's good. I was thinking you were going to tell me they were untidy. We'll carry on then!

Ula-'ai-Hawane
Ciridops anna

The Ula-'ai-Hawane was found on Hawaii, and is only known from five specimens. The last was caught in 1892, with a possible sighting by the Hawaiian bird specialist George Munro in 1937. Very little is known of this bird or the reasons for its extinction.

Greater Amakihi
Hemignathus sagittirostris

The Greater Amakihi was another Hawaiian resident, last seen in 1901. Its forest was cleared to make way for sugar cane, with this being the probable cause of the bird's extinction

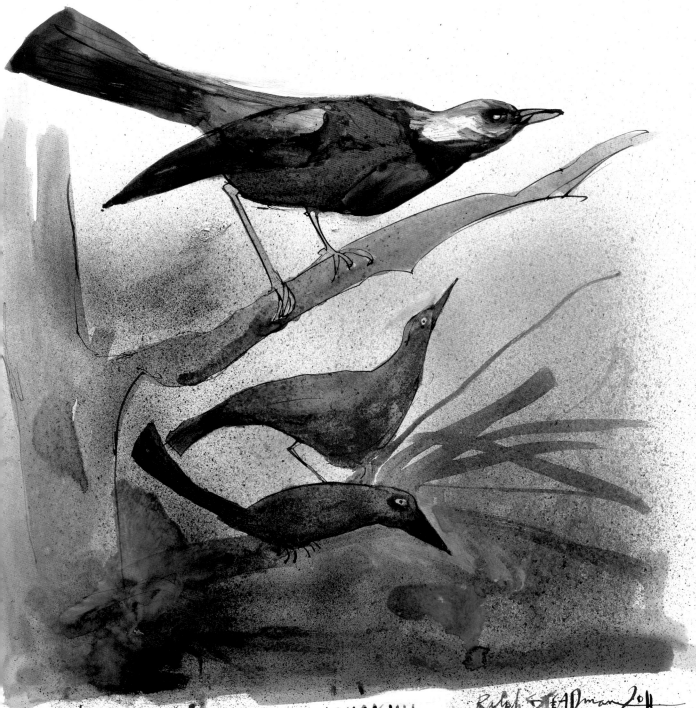

↑ ULA-'AI-HAWANE
(CIRIDOPS ANNN)

TWO GREATER 'AMAKIHI

Ralph STEADman 2011

28th April, 18:25. Phone:
Ceri: Extinction is a weird subject to tackle isn't it?

Ralph: It is weird because it's about the end of things. You're finished, you're washed up, you've had it, mate.

Ceri: But every bird you've created is so full of life.

Ralph: I'm playing God. I'm bringing them back to life. That's what I'm trying to do. And I don't care if it is slightly different to the ones that people know, and a bird is not quite as it should be... so what! I'm just doing them as they come. If a caracara isn't quite 'caracara' enough then so be it. I'm doing them as best I can and if it isn't as spontaneous as that then I'm not really interested in doing them.

Ceri: It's how you feel them isn't it?

Ralph: No, you mustn't feel them. People will talk.

Ceri's Diary: When this bird arrives it strikes me that this bird's name is like a secret agent. OO birds? OO7? Similar? And this Hawaii 'O'o certainly has a look of the conspiratorial, 'would kill you as soon as he saw you' spy-bird about him. With that pronounced, sharpened like a Stanley blade, steely-blue scimitar bill upon him, he looks ready for action. "Oh-oh, here comes the 'o'o". That must have been the cry whenever these birds were about. Perhaps they would go undercover when out stalking their prey. You wouldn't want to mess with this Bishop! 'O'o no!

Bishop's 'O'o
Moho bishopi

Bishop's 'O'o was quite a timid bird, which lived on the Hawaiian island of Molokai. It was last recorded by George Munro in 1904, and was considered extinct by 1949. Habitat destruction, introduction of the black rat and disease spread by introduced mosquitoes ultimately banged the Bishop off his perch.

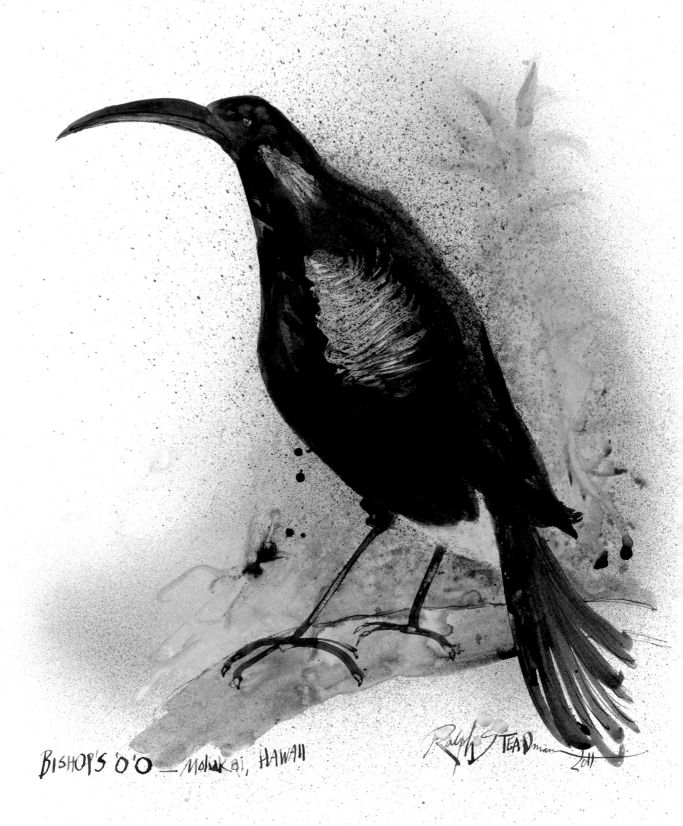

BISHOP'S 'Ō'Ō — Molokai, HAWAII

Ralph STEADman 2011

29th April, 12.45. Phone:

Ceri: Toadstool Island is a very secretive place. And it has to remain so. If people discover birds that taste of bananas all hell would break loose, wouldn't it? People would be clamouring to discover this 'O'o, and then would find the rest of your birds. Our supposedly progressive real world has defeated the extinct birds once, and we cannot allow it to happen again to the boids. The island and its inhabitants must be protected at all costs. Have you thought as to where Toadstool Island is? Do you even know where it is?

Ralph: Of course, I know where it is. And you should know where it is too. Our ship has been sailing in its waters for some time here in the furthest corner of the Urinic Sea.

Ceri: Ah, so it must be part of the Urinic Archipelago if I'm not mistaken. Are we the first explorers to discover it?

Ralph: Of course, because we're the only people who've set out to look for it.

Ceri: It must be the last great secret of this planet – let us hope that it remains so forever.

I have to say that the Honduras Banana 'O'o is quite possibly the silliest of all your creations but I wouldn't dare tell him to his peel. I hate to say it but he looks as though he would be more successful as a hammock than a boid.

Ralph: Just remember that anything is possible on Toadstool Island.

Ceri: I am starting to realise that, Captain Ralph. I look at the 'O'o's serious demeanour and that stern expression on his face and think that he may be silly, but he's certainly not one to mess with.

Ralph: You better NOT mess with him, as he is trained in various martial arts.

Ceri: Then maybe he could keep an eye on the security of the Island. Somebody needs to keep an eye out for intruders such as rats, cats, sailors, mosquitoes, goats, pigs and any other creature that may bring harm to the ecosystem. Am I going too far with this?

Ralph: Maybe, but then again maybe not far enough!

Honduras Banana 'O'o

Ariera sternifica

Is it a bird or is it a banana? Somehow, it's both. And it's got a soft centre. Trained in the martial arts, and an expert in Cornish Wrestling.

HONDURAS BANANA ÖÖ Ralph STEADman 2011

29th April, 16:40. Ralph emails:
Thought we should do the life history – they all started somewhere, so time for a biology lesson! Birds don't just grow on trees. So here is a moment I managed to capture this morning of a hatchling bursting forth from its shell before my very eyes. He looked up at me, then scarpered pretty sharpish. Luckily I was quick enough on the draw to capture the moment.

One thing is puzzling me. Last night I finished a picture of a pair of pale blue piddles who were struggling with each other at the time. But this morning they seem to have disappeared from the studio, which is most strange. But then piddles are strange beings and seem to have piddled off somewhere. I do have a small snapshot I took of them but I hope they return soon so I can photograph them properly.

Other astonishing things are also happening all acoz of the BOIDS!!

YOU started this. I hope that you have a worthy explanation!!

Speak soon…
RALPH

Ceri's Diary: And what's your explanation for lost Pale Blue Piddles, I think to myself. But first things first. Ralph's 'astonishing things' refers to a message he's received from a fan, who saw the Black Mamo on Ralph's website and decided to have it tattooed onto her body. Strange things are happening as HMS *Steadmanitania* ploughs on through the newly named Urinic Sea, and Ralph is blaming me. Things usually are my fault, as I am often the instigator and the hatcher of plans, and I suppose none more so than with Ralph and his aviary. After all, I approached him in the first place. But it takes two to perpetrate boids, that's all I can say. One thing this does show, though, is that the birds are starting to exist happily out there in the world, and people are falling under their spell. J'accuse, Monsieur Steadman!

MISSING
(presumed extinct): Two Pale Blue Piddles

Last seen in Ralph's Studio on 28th April, at 18:25. If found, please return to the artist.

How a Bird is Born

One minute there is an egg, the next there is a boid! One big push and an inky shake of its plumage, and a boid is boin!

Pale Blue Piddle
Nonsensicus blotanicus

Piddles are filthy creatures that spend their time messing up wherever they find themselves. They are habitual dirt-gatherers, and adept at sullying any clean quarters within moments, piddling away with delight. There's no riddles with piddles, what you see is what you get. Filth, pure and simple.

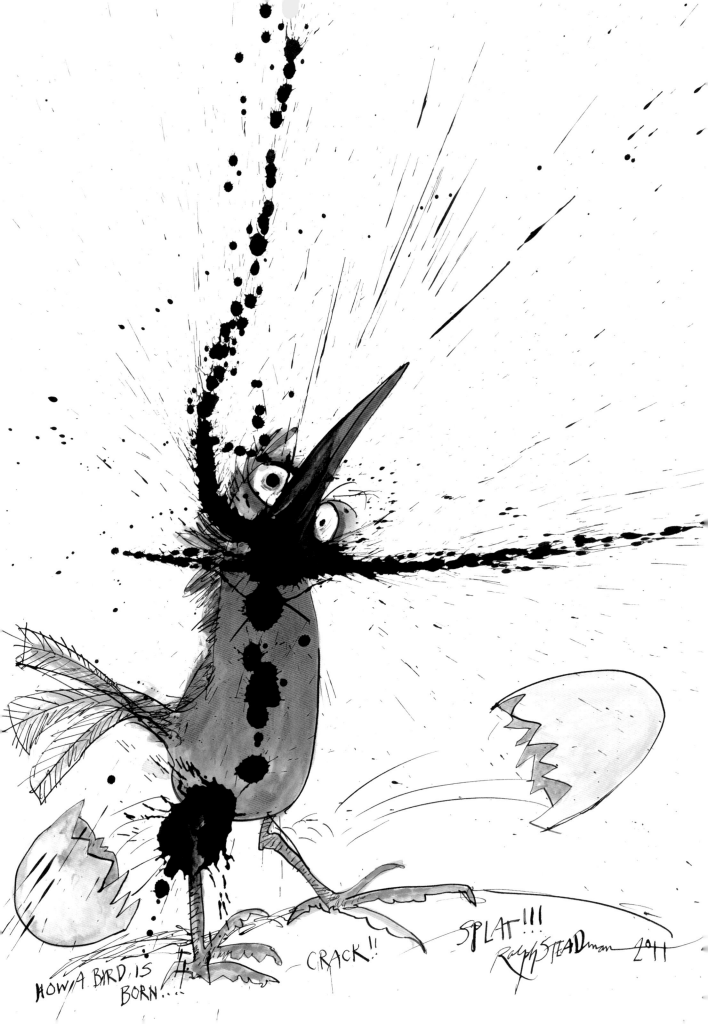

Carolina Parakeet
Conuropsis carolinensis

The Carolina Parakeet lived in the eastern United States, and was common during the early part of the 19th century. The last bird was collected in 1904, and the species disappeared some time after, although rumours of sightings continued into the 1930s. The main reason for extinction was indiscriminate hunting of the parakeet, for everything from food to feathers; whole flocks were killed because of the damage they did to fruiting crops. They were also captured for the cagebird trade; demand and the prices achieved rose as the birds grew rarer and rarer. Competition for nest sites with introduced bees may also have been a factor in their decline. The last known Carolina Parakeet was called Inca; he died in captivity in Cincinnati Zoo on 21st February, 1918.

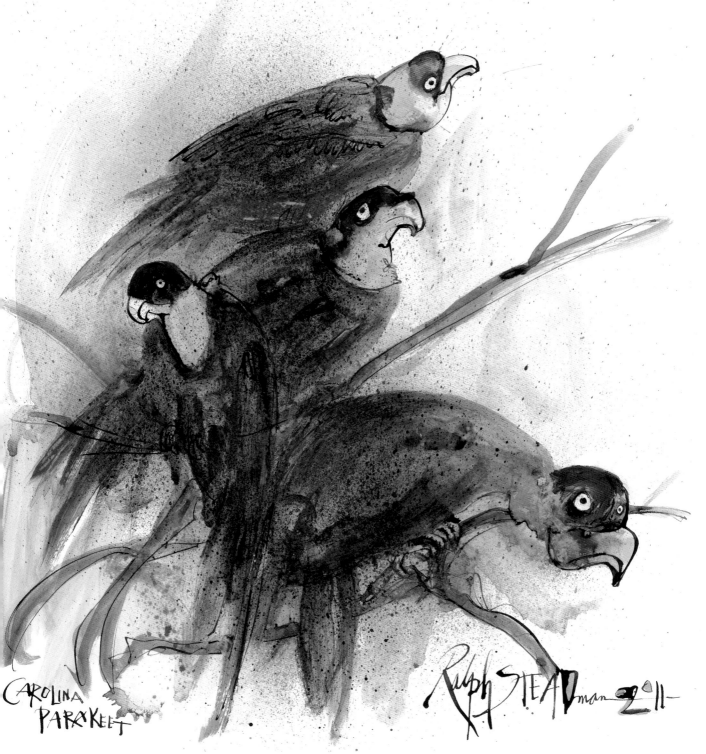

CAROLINA
PARAKEET

Ralph STEADman 2011

1st May, 11.10.
My phone rings. There is the sound of a birdcall down the line: Pio-pio! Pio-pio! Pio-pio! Pio-pio!

Ceri: I'm sorry but you've got the right number.

The whistle of other approximated bird song continues as I sit back and listen. It's really rather good. After a while I say "Good morning Ralph…"

Ralph: Pio-pio! Pio-pio! Pio-pio! Pio-pio!

Perhaps in another life Ralph could have been a bird impersonator.

Often birds take their names from the sounds they make and I presume the Piopio was named after its song or call, although it never ceases to amaze me how some people listen to bird sound and then translate it into English. Take the Yellowhammer's song for example. A beautiful little ditty, which someone took time to sit down and translate as "a little bit of bread and no cheese." I have sat down and listened to it, and I can make it sound like that, but I can also turn it into "two pints of bitter if you would, please!"

North Island Piopio
Turnagra tanagra

South Island Piopio
Turnagra capensis

Both of the piopios were supposedly common enough New Zealanders during the 19th century, but they fell by the wayside due to the usual mix of predation by rats, cats and people and habitat destruction. They were possibly too common for anyone to take too much notice of until one day they had gone. Abundance is not always a sure sign of survival.

NORTH ISLAND
PIOPIO

SOUTH ISLAND
PIOPIO

Ralph STEADman 2011

1st May, 18:36. Ralph emails:
Hi! Ceri
You are familiar with the ole RED RAIL!!!

Ceri replies:
Hey Ralph!
That is a majestic looking creature indeed. I reckon he believes he is definitely in charge. A Sergeant Major of boids, I reckon.

1st May, 18:57. Phone:
Ceri: He really is a super bird. Actually he looks like a superhero of a bird! He's confident and full of self-belief and surveys the landscape as if he owns it. He exudes an air of 'if there's a problem I'll sort it'. I would be happy if he was keeping an eye out for me.

Ralph (sung to the tune of Red Sails in the Sunset by Nat King Cole):

Red Rails in the sunset,
I happen to see
Red Rails in the sunset
They're coming to me

Ceri: Unfortunately the sun did forever set upon this rail.

But this Red Rail came to Ralph, who proceeded to paint it with certain defiance, a belief in its personality and its strength to survive. If only this bird knew what we know now he may not have had quite the same demeanour.

Red Rail
Aphanapteryx bonasia

The Red Rail was endemic to Mauritius. This flightless creature was hunted heavily for the pot, and became extinct around the turn of the 18th century.

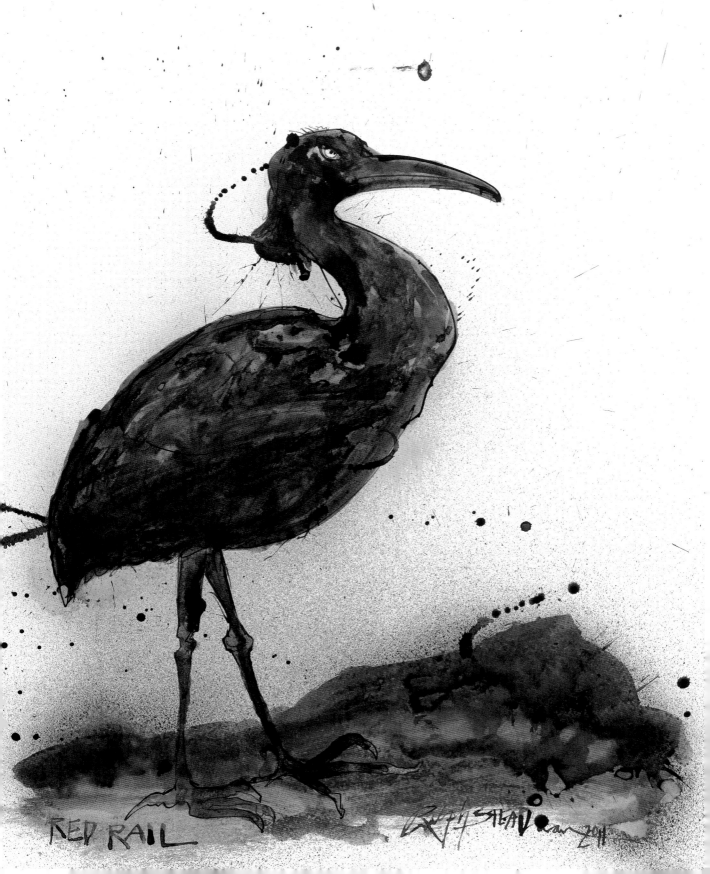

RED RAIL

2nd May, 12.30. Phone:
Ralph: I enjoyed that new drama on the telly last night.

Ceri: It was good but there was just too much needless smut in it.

(pause)

Ralph: The Needless Smut. It needs to exist!

17:28. Ralph emails:
A bit silly!!
RALPH

Ceri replies:
Not at all! That is the finest representation of a Needless Smut I have ever seen… it's amazing that we only discovered him this morning. Yesterday he didn't exist in our lives and yet here he is today.

Ceri's Diary: These birds often provoke differing reactions from viewers. Some think that the Needless Smut has said something shocking to provoke the Moor Pen into a state beyond hysteria, while others look at the Needless Smut as the innocent bystander, watching on in bafflement at the Moor Pen's unnecessary show of emotional instability. I think it's the former, and he may have scarred the Moor Pen for life. The Needless Smut has never been proven guilty of having said anything smutty. But try telling that to the Moor Pen.

19.00. Phone:
Ceri: I love the Needless Smut. He looks so innocent. But I know he's not. I reckon he has the attributes required to be the ringleader of all the boids.

Ralph: A ringmaster no less! Cracking his whip at the miscreants. Whipping them into shape. Keeping them in line.

Ceri: Then perhaps he should be elevated to the status of Mayor of Toadstool Island, and placed in charge of all boidal activity.

Ralph: He may prove to be not so needless after all…

Moor Pen
Maurus stylus

Normally a solitary creature, the Moor Pen has a deep distrust of other boids, in particular short, stumpy little Smuts. It is an uncontrollable and panic-riddled creature, which cannot contain its outbursts. The last job it applied for was librarian, a position that was not proffered.

Needless Smut
Supervacuum spurcitia

The Smut is a powerful and controversial voice on the island. Little can be done without its approval or say so. It is said that it was the Smut that put the kybosh on the Moor Pen's application to be a librarian.

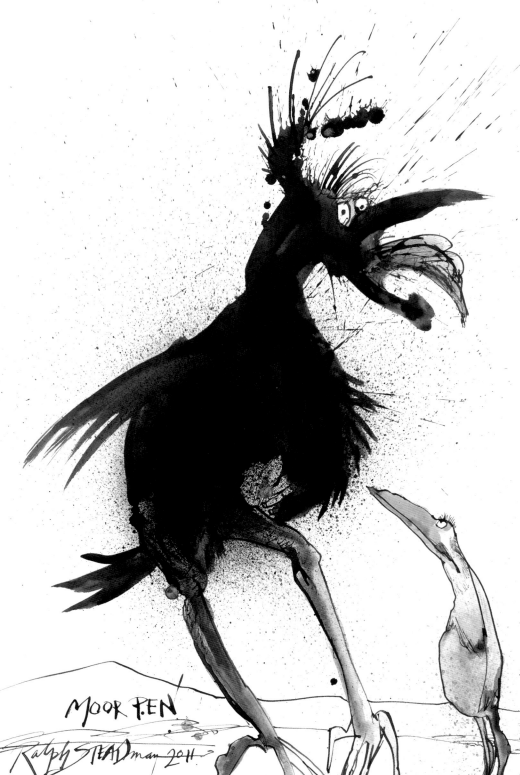

MOOR PEN

NEEDLESS
SMUT

Ralph STEADman 2011

3rd May, Ceri's Diary: The Quink kept a journal entitled *The Ibis and the Quink*, which sounds like a famous Japanese fable but was actually a collection of the teachings of the Sacred Ibis… unfortunately, the ink the Quink used to write down the Ibis's ramblings was invisible, and some say not even an ink at all. So the Ibis's words of wisdom have been lost, as all the Quink can say is… 'Quink'.

There is something mystical and powerful about the Sacred Ibis as drawn by Ralph. It has become the one true Zen bird. At its feet supplicating itself in its adoration of his Sacred Ibisness is the bird's true acolyte, the Quink. It is thought they named an ink after it. Looking to learn at the claws of the ibis, the Quink soaked up information as readily as he could, in anticipation of following the Wise One through eternity and beyond. Unfortunately eternity was ready to take the ibis much sooner than expected, and without the ibis's sagacity to guide it, the Quink soon followed through the same door. But both now reside happily on the Island.

I look at our ever-growing aviary and I start to wonder if extinction is something we should worry or care about. Extinction is part of the natural order of things, after all. Every species will face its end at some point. That is how the world works. The natural 'background' rate of extinction for birds is about ONE species per century. 21 species have become extinct in the last thirty years alone.

Right now, an accelerated decline in bird populations is taking place. Today there are 189 critically endangered bird species, which will potentially disappear from the face of the earth. Birds are an early indicator of problems for other species. Remember canaries down a coalmine? The situation has drifted into a catastrophe. We are heading for a period of mass extinction, and birds have been trying to communicate this fact to us for some time. I wonder if the Réunion Sacred Ibis can give us some spiritual advice…

Réunion Sacred Ibis
Threskiornis veneratus

The Réunion Sacred Ibis is believed to be the Réunion Flightless Ibis, also known as the Réunion Solitaire. Its extinction probably occurred in the early part of the 18th century. The Ibis or Solitaire probably didn't look too much like Ralph's portrait of it. But I know which one I prefer.

Quink
Quincautum quincautum

The Quink is a bird that follows. A small, inky creature, the Quink needs a bird to look up to, such as the Ibis. It follows in its wake, taking copious notes on the deep sayings of its Zen master.

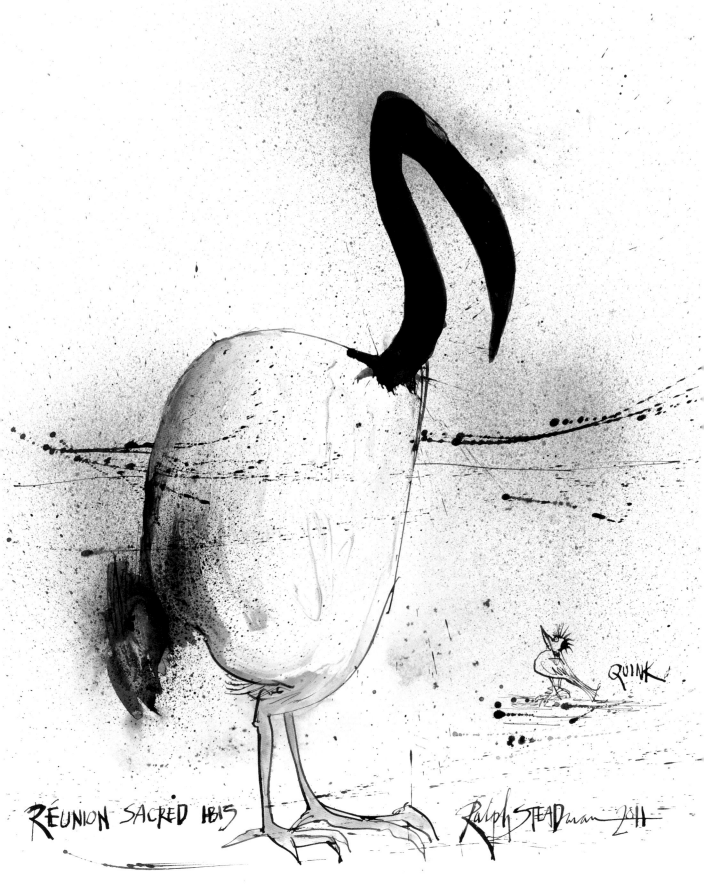

RÉUNION SACRED IBIS

QUINK

Ralph STEADman 2011

4th May, 17.51 Phone:

Ceri: This creature, Spundwick's Fret, is probably on a par for manic madness with the Rodrigues Blue-black Throstle and the Moor Pen. They really are the lunatics of the boid world. The Fret reminds me of a cross between a chicken and a scorpion with its strange tail rearing up and over its body. Noise also screams through Ralph's inks as the Fret's tongue rings alarmingly inside its mouth. To be near such a creature would be deafening. All in all this is a very fretful bird, which verges towards a nonsensical panic. God only knows what it would do if faced with its reflection in a mirror.

Ralph: But there is a reason for his highly agitated state. He is afraid of the boids coming under attack from hunters when they find the island. Everything sets him off.

Ceri: I suppose the noise the Fret makes when surprised or frightened would scare any hunter away, pretty rapidly. He looks as though he would be louder than the shrillest of alarms and would cause panic through the undergrowth, making it impossible for a hunter to get a decent shot at any boid.

Ralph: You can't be too complacent about hunters. They are very committed to killing. There are people about who hate the thought of extinct boids being alive as that is such an existential notion. But we know nature will exist whenever and wherever it can if given a helping hand. This means that these birds do exist again, now that we are bringing them back to the world's attention. That's why hunters are dangerous, as they would dust off their guns and gun belts and seek to destroy our extinct birds. It is imperative to keep Toadstool Island a secret from all those who mean harm to its inhabitants.

Spundwick's Fret

Frotapicus spundwicki

The Fret was a bird to give a wide berth to; one of the main reasons it became extinct was that no one wanted to give birth to it anymore.

A SPUNDWICK'S FRET
(SPUNDORUS FROTAPICUS)

Ralph STEADman 2011

6th May, 19:46. Ralph emails:
One Cuban Macaw!

Ceri replies:
Hey Ralph,
He's another wonder of your world of boids. He is just so lifelike. I can almost hear his harsh call as he searches for some grub. I am in Spain at the moment but will come and see you next week.

7th May, 13:33. Ralph emails:
Hola!!
I can understand this beautiful bird being extinct. I would want the feathers from that... to make a hat!! Come down any day next week. Look forward to seeing you... hope you are enjoying Spain and getting a chance to see some birds. You must get plenty there.

Ceri replies:
I have been lucky enough to see lots of birds while I have been here. Wonderful sights such as Short-toed Eagles, Booted Eagles, Ospreys, buzzards, harriers and my new favourite – as I have just seen them for the first time – Bee-eaters. It just makes me realise how worthwhile it is to point out the diversity of birds we have lost. It makes me appreciate more what we have surrounding us.

Ceri's Diary: This is a very beautiful and sensitive work. It is hard to believe that such a bird does not exist anymore. He is full of life, vim and vigour – doing what macaws do. Appearing at odd angles on the branch, almost smiling to itself at its ability to perform with such agility. To be able to look at your own tail while bending over a branch at the same time is a remarkable feat.

Cuban Macaw

Ara tricolor

The Cuban Macaw hailed from Cuba and the Isle of Pines, and probably died out in the late 1800s. Hunting by local folk and habitat destruction were the two main causes of its demise. Red, green, yellow, blue, purple ... this vibrantly coloured bird must have left a hole in the skies after its disappearance. A rainbow had vanished forever.

CUBAN MACAW

Ralph STEADman 2011

8th May, 18:21. Ralph emails:
I have just done three Labrador Ducks with slightly different markings. They were just too miserable to live. The one on the right is the most miserable and deserves to be extinct!!

Ceri replies:
They are the grumpiest ducks I have ever seen. But if I knew that today might be my last day I'd be grumpy too.

18:50, phone:
Ceri: These ducks make me laugh out loud. They all look so foul-tempered, as if they have just had some huge disagreement between themselves. Or maybe that's because it looks as though you have thrown tea over them whilst depicting their day out at the seaside.

Ralph: Those stains should *look* like tea because they are tea stains! The picture was missing a little something. And that did the trick. I did shout 'Duck' when I did it.

Labrador Duck

Camptorhynchus labradorius

Labrador Ducks were residents of the Atlantic coast of North America. They generally did not suffer from that eternal problem that so many ducks have faced on this planet – being shot for the pot. Apparently a foul-tasting bird, it was never considered a great meal. The Labrador Duck was always a rarity, but hunting, trapping and the taking of eggs may have exacerbated the problem. The last specimen was collected in the 1870s, by which time this duck was off the menu forever.

LABRADOR DUCK

Ralph STEADman 2011

Mauritius Blue Pigeon

Alectroenas nitidissima

The Mauritius Blue Pigeon was last collected in 1826 and was extinct by the late 1830s. The pigeon had managed to survive alongside people and introduced predators for a couple of hundred years, so it is reasonable to assume that deforestation put paid to the bird.

Dusky Seaside Sparrow

Ammodramus maritimus nigrescens

The Dusky Seaside Sparrow came from Florida, and represents one of the modern-day tragedies of extinction. We can even pin its extinction down to 16th June, 1987. The spraying of its saltmarsh home with DDT was the main cause of its demise. As well as killing mosquitoes, DDT can cause infertility in birds. 17th June 1987 was a very sad day indeed. A 'one less bird in the world' day.

Lord Howe Swamphen

Porphyrio albus

The Lord Howe Swamphen also goes by the name of White Gallinule. It was endemic to Lord Howe Island, and was a common enough bird in the late 18th century, but had been seen off rather hurriedly by 1844. It was large, tame and easily killed, as it was far too trusting and gentle a bird. Whalers, sailors and sealers effortlessly clubbed to death these approachable creatures, and this hunting is believed to have beaten the swamphen into extinction.

9th May, 18:13. Ralph emails:
OK, Ceri
I am now an authority on Boids – but I ain't boastin'!!
RALPH

11th May, 17:59, Ceri emails:
You are definitely the finest and most knowledgeable boid authority in Christendom!

Later, on the phone:
Ralph: Pigeons are just thought of as cheap old things but I like this one. Much better looking than people realised. The Sparrow was just a little old brown bird that we got rid of because it ate too many dropped crisps at the seaside, and the Swamphen lost its swamps, I presume!

Ceri: Why did you put these birds together? They are so unrelated.

Ralph: Because I can, and they all fit together nicely!

DUSKY
SEASIDE
SPARROW

MAURITIUS
BLUE
PIGEON

LORD HOWE
SWAMPHEN

Ralph STEADman 2011

11th May, 17:48. Ralph emails:
Here is an odd one… loosely drawn in Loose.
OK RALPH

Later, on the phone:
Ceri: There is a diffidence about the Bar-winged Rail, a snooty ambivalence to all that surrounds it that makes the viewer feel slightly inferior in its presence. He is a holier-than-thou, smug-looking fella. God knows what he's got to be sanctimonious about.

Ralph: A Sanctimonious Godnose! I like the sound of him. I may draw him in the future. I'll write him down so I don't forget him. If it's not written down then it becomes forgotten.

Ceri's Diary: The more I look at extinction, the more I see that many species that disappear are from islands. I presume this is because an island's environment is much more fragile than anywhere else's. And when new arrivals arrived damage was easily done, since the land had never before been touched or sullied by human hands, feet or minds. In the early days of exploration, the more we discovered, the more we changed things to suit us, and therefore the more we ended up destroying the native ecosystem. We have an innate inability to leave things alone.

Tomorrow I am going down to Ralph's for a visit, to do some filming and to catch up with the boids, as I know he has done some that I haven't seen. It would be great to get a checklist together of what he has completed so far. If I'm lucky I may get to watch him work on a picture this time. I haven't seen Ralph in action yet. I have seen the aftermath of his creativity and perhaps I'll see the creative spark in action. I would love to film a bird being drawn into existence.

Bar-winged Rail

Nesoclopeus poeciloptera

The Bar-winged Rail was endemic to the Fijian Islands of Viti Levu and Ovalau. It was a large, probably flightless rail that was last seen in 1890. The main reason for its extinction was probably introduced mongooses.

BAR-WINGED
RAIL

Ralph STEADman 2011

12th May, Ceri's Diary: I am at Ralph's and we are going through all the pictures. It has built into quite an assortment of birds, especially when you see them all sitting together. At the moment I am standing in Ralph's studio filming Ralph finishing off the kakas, with a final flourish of ink and a big bold signature.

Conversation in the studio:

Ralph: A catalogue of dead birds that must look exactly as they were would be boring for me to do. Who knows exactly how they looked or how they behaved? We don't know, anyway. These are my impressions of the birds. That's why I'm doing them this way. I'm letting them be what they are. And I love throwing ink on them. What I liked about this one particularly was pouring the inks I had on it. Making it darker and it still has a richness to it. And it looks like a bird, not a polar bear. And that's the point of these things.

Ceri: It's your interpretation of it though, isn't it?

Ralph: It is. Or it's a mistake. It's lovely when a mistake turns into something you didn't intend it to be and it works. It's a different picture than you set out to make, and that's the beauty of it for me. And that's why I never pencil a picture or plan it out first. NEVER. I never plan anything. I just want it to happen if it's going to happen, and I don't care if it's one glorious mistake. That's the way it is. And that's how I work, and that's what I do.

Ceri: It seems to me that the longest time you take over anything is your signature.

Ralph: I worked on getting that right for years. And it takes time to do.

Norfolk Island Kaka

Nestor productus

Convicts and settlers hunted the Norfolk Island Kaka to extinction, on Norfolk Island in Australia. It was apparently a very tame bird, easy to catch and eat. This parrot was last cooked some time before 1850.

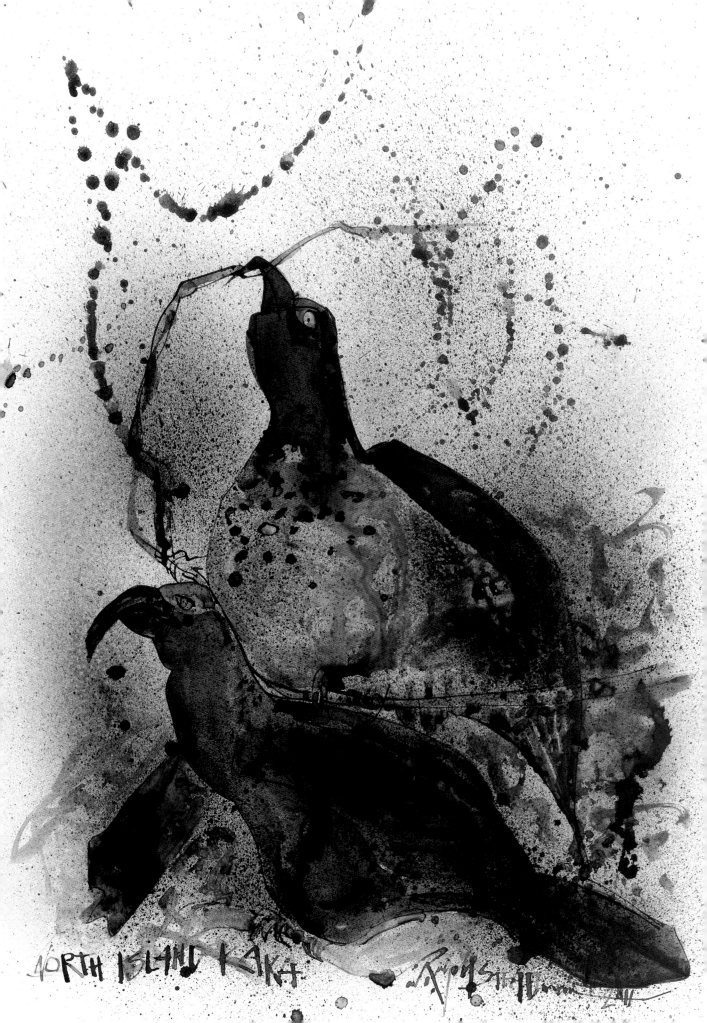

NORTH ISLAND KAKA

Ceri: Often boids just appear out of conversations.

Ceri's Diary: This weirdo is being created before my very own eyes in Ralph's studio. Ralph has been telling me that yesterday he had been trying to explain the notion of an extinct boid to his young grandson, Ollie, who couldn't quite grasp the idea of extinction. Ralph had started telling him about the extinct Kaka he has been working on and on hearing the word Kaka, Ollie asked 'does it stink then?' This cracked Ralph up, and as we are chatting about it a boid is born.

There is a magic watching an artist at work and having discussed with Ralph how he creates a work I am enthralled to watch the conjuror in action. This is my first opportunity to film Ralph at work from start to finish (hopefully) on a bird, and I am itching to see what happens. I raise my camera and...

It all starts with the first mark on the paper, the first dispersal of ink, which is the black splatter in the middle of the page. The body quickly appears and is followed by the spindly legs, making the creature look as if it might tap-dance across the paper – and then the hideous wind appears. I watch the mischief in Ralph's eyes as he creates this. The look on its face is the last element to appear. Almost apologetic, the Ex-Stink Boid looks embarrassed to have been caught in mid-gaseous flow. Ralph blows red ink through a tube onto the boid's posterior, creating an even spray of colour. Lastly, the beak is coloured in; a final flourish of inkblots and the boid is finished. And here it is in all its finery, and I can witness this boid's completely shocking mastery of flatulence. I reckon he could run a wind farm with that amount of gas, and do the world a favour.

Ceri: What I find fascinating is that you work so rapidly. Before I can even blink the picture changes and evolves. All moves so quickly as you dip into your inks and apply them to the bird. What was a line becomes a bird, which sits before us. I can't believe how quickly you draw.

Ralph: We are do-ers. We do things... that's what we do.

Ex-Stink Boid
Windus magnificus

The Ex-Stink Boid is one of those windy little critters who has a condition. It's not something to laugh at, and he really needs to look at his diet, which is rich in unabsorbable carbohydrates, his favourite food being prunes and sprouts, neither of which he can leave alone.

EX STINK BOID

Ralph STEADman 2011

16th May, 21:46. Ceri emails:
Happy Birthday for yesterday Ralph. x

17th May, 18:20. Ralph emails:
Thanks!! Now forget all that...

Here are two more Nonstinct Boids. I think we done it – there can't be any more – otherwise we would be cheating!!! OK! Speak in the week!!!
RALPH

Ceri's Diary: "I think we done it." Does Ralph mean that's it? Have we finished? Are we done? Is it *sayonara*, baby? I really don't know. Not for the first time I begin to wonder if we have reached our final port of call.

If Ralph has now put down his pen and ink, then we have had a whirlwind Grand Tour of Extinction – what an amazing journey. It has felt like one of those endless holidays I remember from childhood, where every day has been full of play and wonder. Something marvellous has always been attached to Ralph's boidy emails. It would be impossible to choose just one image to put in *Ghosts*. Any picture Ralph has created would work perfectly.

Blue Lidwink
Diabolocervus homoboides lividus

No one is going to hoodwink the Lidwink. A cunning and devious creature; part-boid, part-devil, part-deer, part-man. He looks as if he has covered himself in blue guano. Perhaps this is to attract the equally foul female Lidwink. I can almost smell the blueness of his scent as he sprays the surrounding air with his pheromones. Up until now the Lidwink population has not increased.

gua·no (noun)

1. animal droppings
2. guano – fertiliser

THE BLUE LIDWINK

Ralph: It started with a splat!

Ceri: A lot of your drawings seem to begin that way.

Ralph: It's the best way to begin. I love to get to the beak of the bird. It fascinates me drawing beaks, such strong features with so much character. They define the bird's face and give it gravitas and expression. Just look at the beak on this Thront!

19th May, Ceri's Diary, 9:30. Today we open a lo-fi version of Ghosts at the Liverpool School of Art for a couple of days. We have brought along three of Ralph's pictures to exhibit, to whet people's appetites for his work – the Guadalupe Caracara, Pallas's Cormorant, and of course the Liverpool Pigeon.

20th May, 18:00. Plenty of people have come along through the day, which has gone by in a blur. Two-day exhibitions are hard work, but strangely rewarding in their intensity. We know that there is already an audience for birds, but we have been heartened by the non-birdwatchers that have come to see the show due to the array of artists and diversity of work that has been created for the project.

21st May, 19:00. Just taking everything down after a successful smash-and-grab show. It has been a great experience and we know that we are capturing people's imagination. Boids exist. We are all looking forward to the full show in the autumn.

Blackened Thront

Throntius negrus

The Blackened Thront looks how we have all felt on certain mornings in our lives. Pretty damn shabby. Does he have a hangover from hell? Is he just miserable, or are there reasons why he is gingerly placing his right foot (I don't know whether it's his best foot) forward? There is a terrible scraping sound as his claws drag on the ground, compounding the way he is feeling. If I made that sound as I walked I'm sure I would look as miserable as the Thront. Or is he just having one of those days. We all get those, don't we?

A BLACKENED THRONT

Gould's Emerald

Chlorostilbon elegans

Gould's Emerald, which is also known as the Elegant Hummingbird, is a mystery bird. Nothing is known of it, other than the only specimen, which was taken in 1860, may have come from Jamaica or possibly the northern Bahamas.

Aldabra Brush Warbler

Nesillas aldabrana

The Aldabra Brush Warbler was endemic to dense coastal vegetation on Middle Island, Aldabra, in the Seychelles. Having only been unearthed in 1967 and never common, it was deemed extinct by the mid 1980s, probably due to rats.

Stephens Island Wren

Traversia lyalli

The Stephens Island Wren was a happy-go-lucky, flightless, trusting little fellow, who lived a lovely sheltered life until a lighthouse keeper came to the island, bringing his cat with him. Other factors such as rats may have contributed to his extinction, but I'm afraid the cat got the boid for its dinner far too regularly. I wonder if the cat missed the bird once it had gone. Do cats feel remorse?

Grand Cayman Thrush

Turdus ravidus

The Grand Cayman Thrush was last seen in 1938. Extinction was probably due to destruction of its habitat.

Robust White-eye

Zosterops strenuus

The Robust White-eye was endemic to Lord Howe Island. A Black Rat invasion from a stricken ship in 1918 assured the bird of a quick trip to extinctionville.

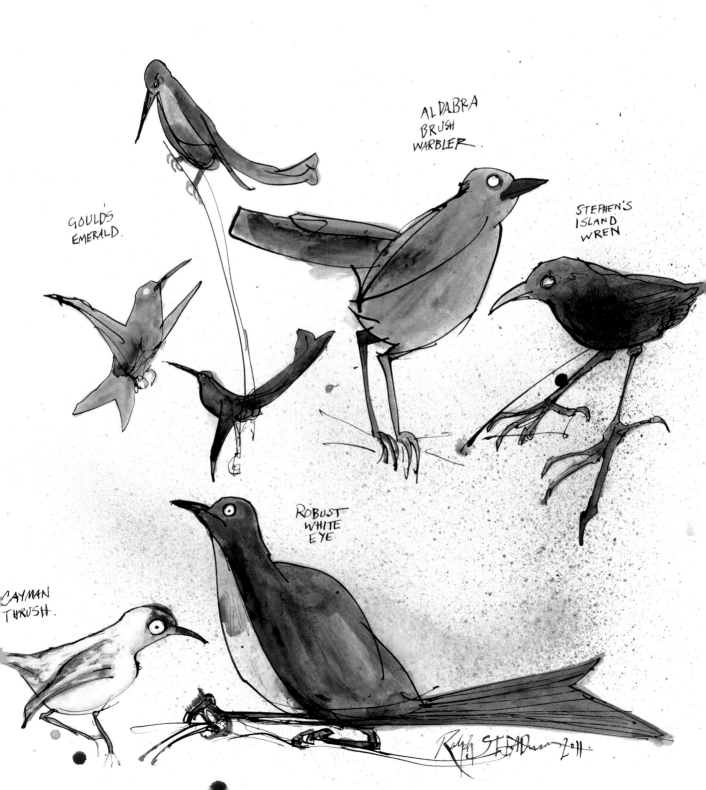

ALDABRA
BRUSH
WARBLER.

GOULD'S
EMERALD.

STEPHEN'S
ISLAND
WREN

ROBUST
WHITE
EYE

CAYMAN
THRUSH.

Ralph STEADman 2011

25th May, 19:32. Ceri emails:
You mentioned there was a strange bird to come?
Is he likely to appear before you go?

Ralph replies:
Sorry Ceri! Here he is…
The bloody thing flew in through the open door to
my studio and he wouldn't leave until I had drawn
the wretched creature!! It doesn't look ex-stink to
me!! What do you think?

Ceri: He is an odd one for sure. I will do some
research, study him as well, and see what I can find
out while you're gone. Happy holidays…

Ceri's Diary: After fearing that Ralph may have
finished with birds altogether ten days or so ago, it
looks as though the trip hasn't finished, after all.
We are in the midst of strange seas, populated by
creatures such as the Splindwilf, the Blackened
Thront and the Blue Lidwink, but we are still sailing!
I wonder if we have now moved solely into the
creatures borne from the chasms of Ralph's mind?
Does it matter? As soon as they leave his pen they
exist, don't they? I am still afloat with Captain Ralph
and the beasts he continues to find.

But for now the boid noise will still a little, until
Ralph's Turkish holidays are over. He deserves a
break as he has worked tirelessly since this all
started. I hope he comes back having missed the
birds, and he allows more to enter his studio to be
studied and painted.

Splindwilf
Inexcitabilis crura

This iron-legged boid was born a little time after
the coldest iciness this world has seen. It was still
a little slippery underfoot after the Ice Age, but the
Splindwilf's heavy-hewn steely limbs could grip like
crampons upon the surface. This bird was made to
survive, but misses the cold on temperate Toadstool
Island.

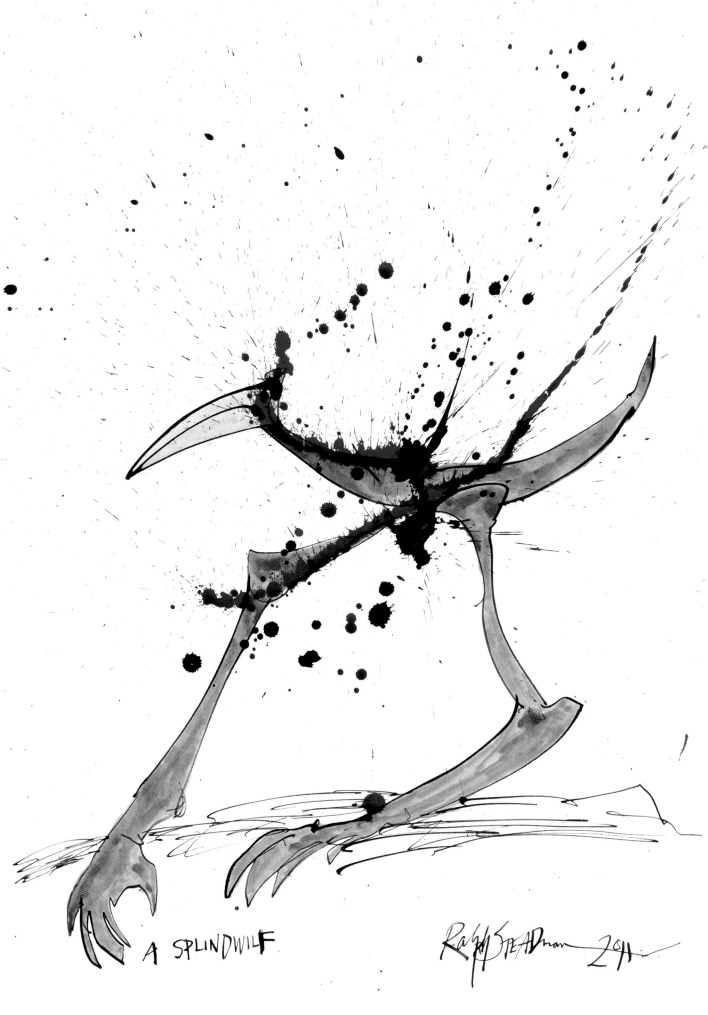

A SPLINDWILF

Dear Ceri

HI! We are back from Turkey where there are many birds flyin' about... but glad to be back amongst the Extinct ones. Here is one who never really flew but tried to. Hope you are OK. I am now bound to the board trying to do as many Extinct BOIDS as possible to be a book – and I think – since you started it you can do the bloody writing!!!
OK
RALPH

Ceri's Diary: That is an emphatic arrival back home from Ralph. And what a positive message it contains. Our quest continues to discover the lost and undiscovered fliers of the world. So we may compile a book of all the birds he has created. This had made sense to me after about twenty or so, and makes even more sense now as more and more have poured from His Nibship's pen. An elegy of birds in honour of extinction have come forth and flown into our midst, brightening up the day, and it makes sense for the rest of the world to have a chance of seeing them, too. Better get thinking of some woids to go with dem damn boids.

The next painting to appear is another of the ancient ones, carrying on Ralph's recent predilection for boids as opposed to birds. I really don't know what's going on with his single wing... it looks like a broom or a brush or some type of strange rushwork you'd find in the seat of an old country chair. A wing? Never... and Ralph reckons this bird nearly learned to fly! That is a flight of fantasy. There are a lot of those in this here book.

Orange-beaked One-wing Jurassic

Monalus (jurassicus) luteorostris

The Orange-beaked One-wing Jurassic looks like the toucan, which may be descended from it. Its sawn-off beak is very toucanesque. But maybe that's what evolution is all about, and why the toucan has such a beak now; what didn't work for his ancestor works perfectly for the updated model. The scientific name reflects that fact that ornithologists are considering splitting this bird from the yellow-beaked version.

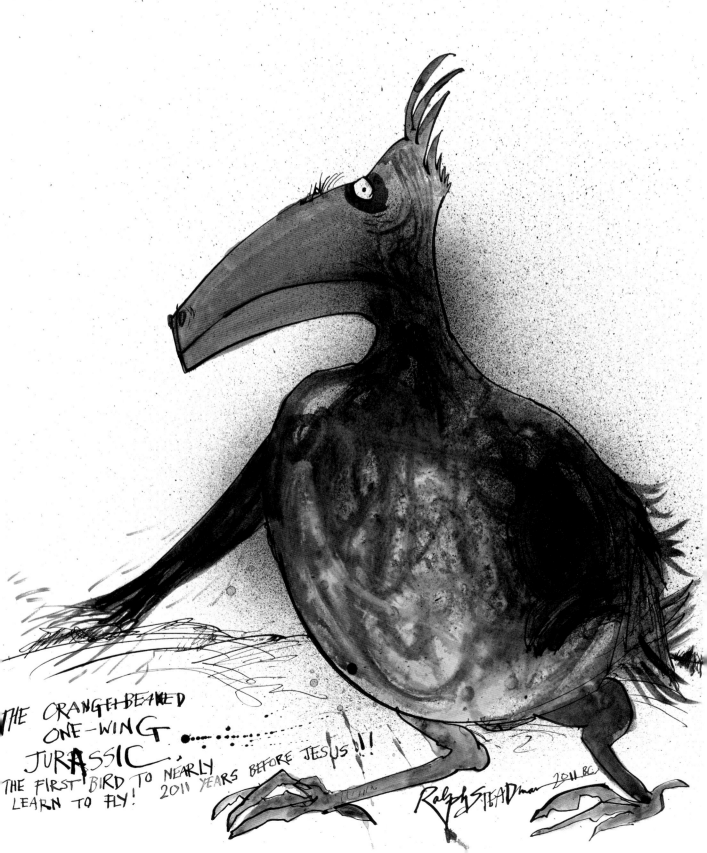

THE ORANGE-BEAKED
ONE-WING
JURASSIC
THE FIRST BIRD TO NEARLY
LEARN TO FLY! 2011 YEARS BEFORE JESUS !!!

Ralph STEADman 2011 BC

Ceri's Diary: And then with this Grebe we are back to actual extinct birds again. The water has become clearer again as this graceful bird paddles into view. Ralph gets across a compassion and understanding for this bird – a documentarian artist again. There is something so poignant and sad about seeing this bird in mid-shake of its wings, making this a touching snapshot of the final flourish from a sadly lost bird.

10th June, 18:00. Ralph emails:
It's a Goddamn Atitlán Grebe – I think!!!

Ceri: Lovely! And it is...
I have compiled a list of all the birds you have done so far, including the Atitlán Grebe and other suspects. I have made a list of the birds left to do as well so we don't leave any must-do birds out of the book, although everyone will have an opinion as to what should be in it. DESTROY all the other lists you have worked on until now! Eat them, burn them or lose them! This is the definitive list to work with from now on!

Ralph: Thanks Ceri. They are extincting at such an alarming rate- we must get a move on!!!
The Laughing Owl should be next!
Warm salutations RALPHZX

Atitlán Grebe

Podilymbus gigas

The Atitlán Grebe was endemic to Lake Atitlán in Guatemala. Its population dropped in 1960 due to competition for crabs with introduced bass. This continued until 1975, when the number of bass fell drastically. However, habitat change, the use of gill-nets and falling lake levels led to the bird's extinction by 1986.

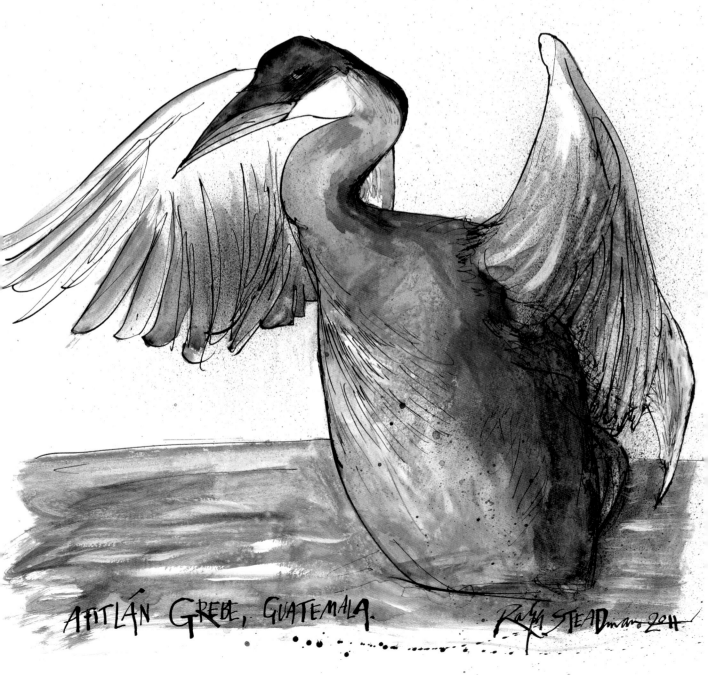

ATITLÁN GREBE, GUATEMALA. Ralph STEADman 2011

14th June, 12:15. Ceri emails:
Any sign of The Laughing Owl?? x

16th June, 13:05. Ralph emails:
Dear Ceri
I had to take a break from extinction for a bit. I will stalk my drawing board and wait for inspiration... hope you are well

Ceri's Diary: This immediately feels different to the other times there has been a pause in creation, and I don't know whether I have seen the last new boid. If Ralph has gone as far as he can then so be it. – after all, the journey has been astounding, and I will be eternally grateful for such an adventure. But somewhere inside of me I hope that we will continue on our quest and trawl through the waters of extinction just a little bit longer. After all, it's fun hanging out with Ralph. I also hope that he is OK and finds his muse again. They can be terrible things to lose...

18th June, Ceri's Diary: And just like it was the first time, I waited for an email from Ralph, and after nearly a week without a dose of Ralphicity a mail suddenly arrived in my inbox. It is simply entitled Boid. The world seems complete again when I see there is an attachment on the email. I know it's going to be another goddamn bird!

18th June, 11:51. Ralph emails:
Dear Ceri
Here is the odd Laughing Owl!!

Laughing Owl
Sceloglaux albifacies

The Laughing Owl was endemic to New Zealand, with the subspecies *albifacies* on South and Stewart Islands and *rufifacies* on North Island. It was not a particularly rare bird until the nineteenth century, when it started to enter in to decline. The subspecies on North Island was considered gone by the 1930s, and the one on South Island by the 1960s, though neither had been seen definitively for many decades before then. The extinction of this owl was caused by habitat change and predation by introduced predators.

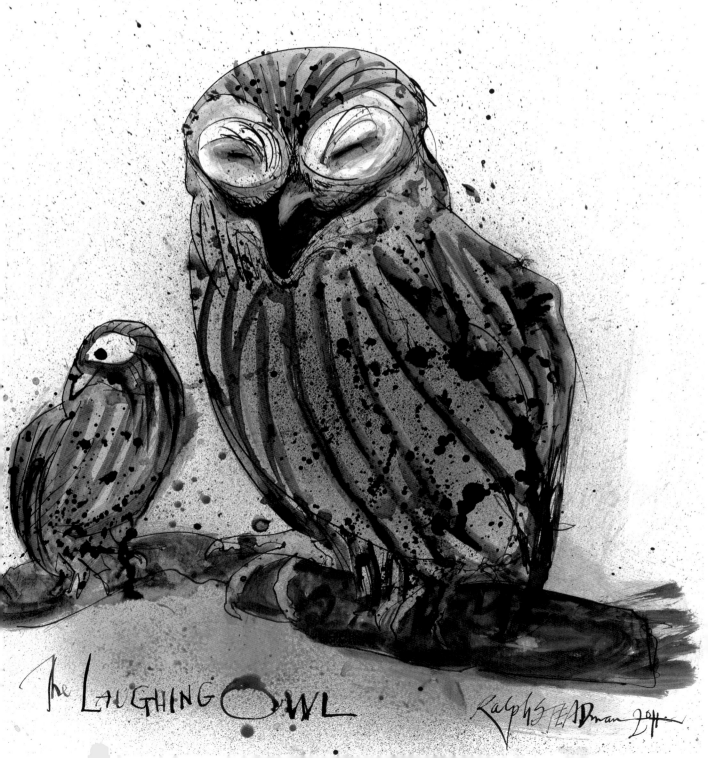

The Laughing Owl

Ralph STEADman 2011

19th June, 13:39. Ralph emails:
OK! I'm going to have lunch!!! Here's a bird that may or may not have existed, or so you have told me!!! RALPHWheeeee!

Ceri replies:
Excellent! He looks as though he's not sure whether he'll actually exist if he opens his eyes.

You certainly seem to have got going down the path of extinction again!

Ceri's Diary: With the arrival of yesterday's bird and today's Double-banded Argus I breathe a sigh of relief. We can continue our journey to unearth more hitherto unseen, unknown and forgotten birds. I don't know why I feel the need to find more creatures, as we have enough for the show, and possibly a small book too. But Ralph is great company and I thoroughly enjoy our time with the boids, creating their back-stories together.

Ralph has taken an image of the single feather in existence of the Double-banded Argus, and created the whole bird from this solitary clue. This is artistic DNA profiling at work, ladies and gentlemen. By creating this image, has Ralph finally proved this bird's existence? I don't know, but as each day passes he becomes more of an expert on these matters.

Double-banded Argus

Argusianus bipunctatus

The Double-banded Argus has caused arguments to rage among the finest minds about whether this bird even existed. There is only one feather in existence, and many people think that it is a rogue feather that came from a normal argus pheasant. But it has the wrong pattern on it; it is an aberrant feather, a mistake made by nature that has led many folk up the garden path and beyond for quite some time. But the bird is listed as an extinct species and it certainly doesn't exist anymore, if it actually ever did.

THE GREAT-DISPUTED DOUBLE-BANDED ARGUS
WITH ONLY ORIGINAL FEATHER...!! IN EXISTENCE!! Ralph STEADman 2011

Ceri's Diary: The more I think about it, the more I have come to the conclusion that Ralph is a boid-sorcerer. I have always been fascinated by magicians and conjurors and never grow tired of watching magic being performed. I adore the world of illusion and trickery. They always say that a magician should never perform the same trick twice to an audience, unless, of course, that audience happens to be me. A friend's father was a magician; he would often get sick of me, as whenever I saw him I would insist on him performing card tricks. Every trick he delivered would fool me, and I would immediately ask him to perform it again – not so that I could work out how the trick was done, but because I loved the feeling of not knowing. He was never in any danger of me discovering his secrets, and was consequently very obliging especially as I wasn't a gullible child but about 28 at the time.

I've fallen foul of Ralph's sleight of hand whenever he has painted a bird that still exists. It doesn't matter to me as they are all sending out the right message – take care of our birds today. I continually wonder what boids Ralph will conjure out of his hat next, and am staggered by just how deep his hat seems to be.

Lanai Hookbill
Dysmorodrepanis munroi

The Lanai Hookbill, one of the Hawaiian finches, is known only from one specimen taken in 1913 and two sightings made in 1916 and 1918.

Humpbacked Blue Mult
Multianus caeruleum lumpus

The Humpbacked Blue Mult is a scruffy looking bird. It appears as though it is struggling to understand exactly why and how it is perched on a branch – almost looking too scared to let go in case it falls. Perhaps it is a flightless bird that is capable of climbing trees – but only up, and not down.

York Island Fright
Terrifidius yorkum

The York Island Fright is another static bird frozen to the spot by fear itself. Innocent, small and seemingly helpless, one wonders how a creature like this could continue to exist. Or perhaps the Blue Mult looks over him protectively.

LANA'I HOOKBILL

HUMPBACKED
BLUE MULT

YOIK ISLAND
FRIGHT

Ralph STEADman 2011

23rd June, 18:03. Phone:
Ceri: The Bellbird is a beautiful creature Ralph. You've given it such a melancholic disposition. It's such a pity we have lost so many birds like this one.

Ralph: Just because it's not been seen doesn't mean anything though, does it? People could just be searching in the wrong place.

Ceri: A lot of people have spent their lives looking for lost birds.

Ralph: Maybe we'll find one! We might be lucky if WE have a look. We may locate what everyone else has missed... I'll definitely find one, and you'll be amazed when I do. And if I can't find one then I'll bloody well invent it!

Ceri's Diary: The bellbird is one of Ralph's more delicate pieces. The bird seems to almost smell its impending doom in the air. A sense of resignation appears across its face, and its eye seems ready to shed a tear. Maybe I am reading too much into the bird and this particular picture, but sensitivity permeates the page. I love the landscape that Ralph has added in. This is a vibrant land that will soon be light of yet another species. The bell will soon toll...

Later, on the phone again:
Ralph: I couldn't get you on the computer and my email wasn't working. So I used the phone to get hold of you. The phone is the greatest invention in the world. You can always rely on it. You can understand what people are saying and how they are saying it, and you can have an uncomplicated conversation.

Ceri: So this should be the Alexander Graham Bellbird.

Chatham Island Bellbird
Anthornis melanocephala

The bellbird was endemic to the Chatham Islands in New Zealand. It was last recorded in 1906. Reasons for its disappearance are not certain, but habitat loss and predation by introduced cats and rats were the probable causes.

CHATHAM ISLAND BELLBIRD

Ralph STEADman 2011

23rd June, 18:06. Phone:
Ceri: Was he a Welsh bird, this Dieffen Bach?
Sounds like it. Another of the Rhyl extinct-bird Mafia?

Ralph: If he is, he must know the Welsh National
Anthem, Hen Wlad Fy Nhadau, known in English as
Land of My Fathers. Dd is pronounced th, ch is
hard like loch and ll is difficult, a mix between an
l and a cough. Got it? Or maybe it would be easier
to teach you phonetically. After three...

My hair-n wool-ad ver n'had-eye
Un ann-will ee mee
Goo-lard buy-rth a chann-tor-eon
En-wog eon o vree
Eye goo-rol ruvv-el-weir
Goo-lard gar-weir tra mard
Tross rooth-id cor-llar-sant ay goo-eyed

Goo-lard, goo-lard
Played-eeyol oiv eem goo-lard
Tra more un veer, ear beer horff bye
O buth-ed eer hen-vithe bar-hi.

Ceri: It brings a tear to my goo-eye...

Ceri's Diary: The dam has well and truly broken and
a real confusion of boids is flooding through my
inbox. A plethora of creations and colour explodes
into life. Incredibly named creatures such as
Humpbacked Blue Mults and York Island Frights
have appeared in the world, just as if they have
always been there. I am amazed that the machine
that was formerly known as the artist is no longer
tiring but has been increasing his output. He has
obviously found inspiration again. Where will we get
to if this continues?

Dieffenbach's Rail

Gallirallus dieffenbachii

Dieffenbach's Rail was endemic to Chatham, Mangere and Pitt Islands in New Zealand. It was last collected in 1840, and was extinct by the late 19th century. This was probably due to habitat loss and predation by introduced cats and rats.

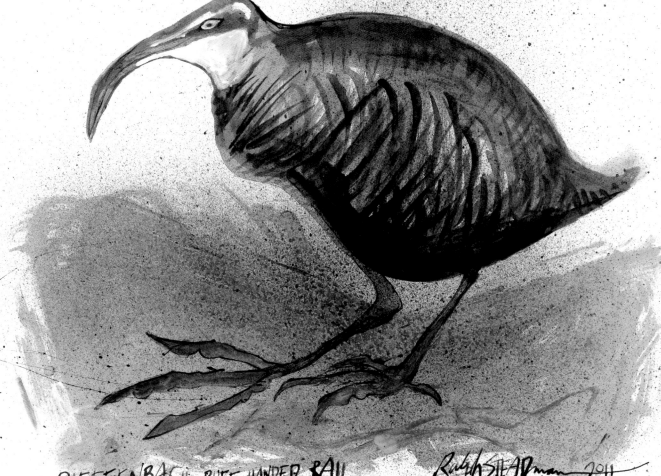

DIEFFENBACH BUFF-HANDED RAIL

I came across other BOIDS in my work from way back – so I must have had a latent interest a long time ago… you re-awakened it!! There's something about THE birds… here's a couple of strange ones!!

Ceri replies:
Birds get everywhere and have probably been waiting for you to give them some time with your pen and paper. I love the thousand-yard stare the white-eye and the gerygone have. Extinction looms. Gery Gone forever! Ha!

Ceri's Diary: Ralph has started looking back at previous work, and found more birds in there than he had realised. He seems somewhat surprised that birds have been with him a lot over the years. This doesn't surprise me, as the more I explore the world of birds the more I realise that they sneak into our psyche, and we become more affected by them than we realise. Birds inhabit our space as much, if not more so, than any other creature on this planet, and have managed to find a way to co-exist beside us in just about any climate and terrain on Earth, yet so many of us seemingly ignore their presence. But once they enter our thoughts it is hard to remove them. They can be a driving force. Look at what they have persuaded Ralph to create in the name of the boids!

Lord Howe Gerygone
Gerygone insularis

The Lord Howe Gerygone was an abundant forest-dwelling bird, endemic to Lord Howe Island in Australia. The appearance of the Black Rat in 1918, washed ashore with the cargo of the SS *Makambo*, which ran aground, was a disaster for the island's birds. The gerygone was indeed good and gone by the mid-1930s.

Robust White-eye
Zosterops strenuus

This is the second appearance of the Robust White-eye that Ralph has presented us with, but he does fit in nicely with his fellow islander, the gerygone. The white-eye was endemic to Lord Howe Island, and is definitely still extinct.

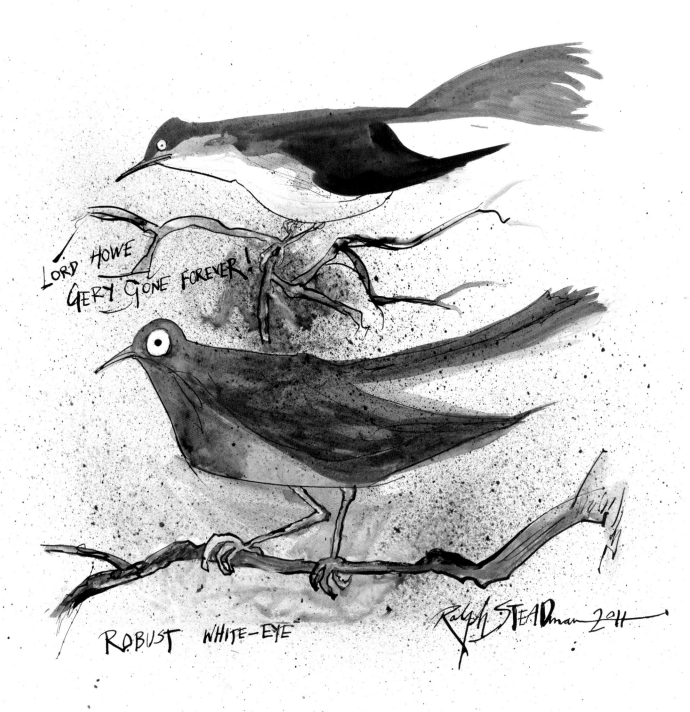

LORD HOWE
GERY GONE FOREVER!

R.O.BUST WHITE-EYE

Ralph STEADman 2011

Guam Flycatcher

Myiagra freycineti

The Guam Flycatcher was once a common enough forest bird on the island of Guam, but it crashed into extinction in 1983, due to the introduction of the Brown Tree Snake. It is thought that the snake appeared on Guam just after World War II, and probably came via military transports from Manus in Papua New Guinea. This snake has done for ten forest bird species, and half of the lizard species on Guam. The forests themselves are now in danger, as birds are important for seed dispersal, insect control and pollination. The two forest species left on Guam have fewer than 200 individuals in their ranks. The snake normally grows to between 3 and 6 feet in length, but due to the abundance of food on Guam, they grow up to 10 feet long there. A destructive and unwelcome guest.

Aldabra Brush Warbler

Nesillas aldabrana

The Aldabra Brush Warbler is another bird that we have seen previously. Endemic to Aldabra in the Seychelles, it was extinct by the mid-1980s, probably, as suggested before, due to rats. Abracadabra – no more Aldabra…

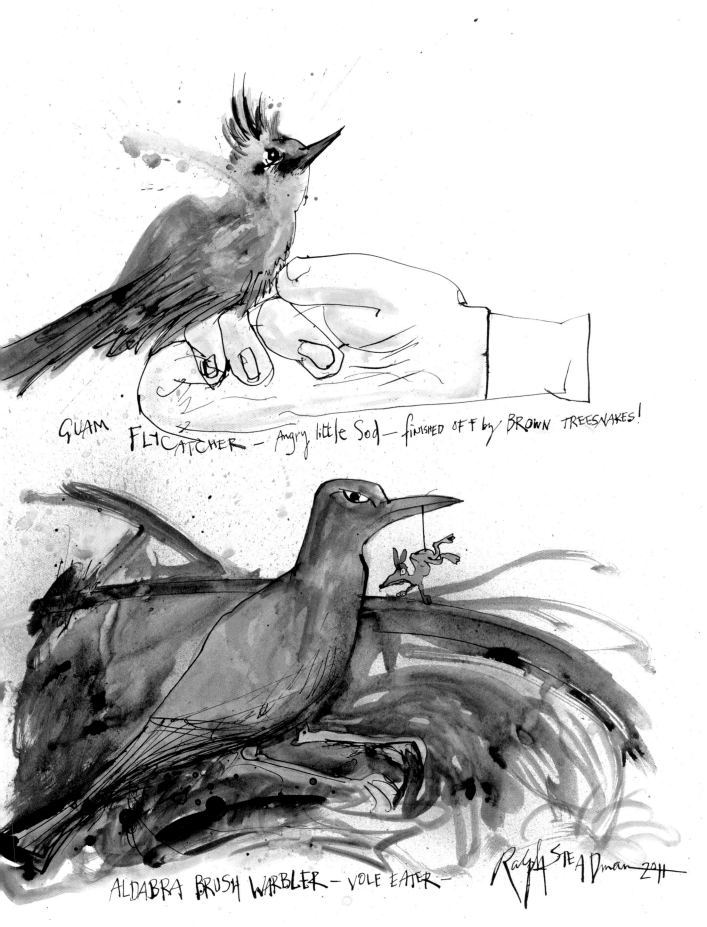

GUAM FLYCATCHER — Angry little Sod — finished off by BROWN TREESNAKES!

ALDABRA BRUSH WARBLER — VOLE EATER —

Ralph STEADman 2011

24th June, 18:07. Ralph emails:
They are still coming and one Boid on the Board!!
The New Zealand Quail and I have located another
ten – something for the weekend!!!
Meanwhile… The Blue-winded Gasp >>>>

Ceri: I like him a lot.
Just one thing to watch out for is doing birds you
have already done, as you have now done the
Robust White-eye twice and the Aldabra Brush
Warbler twice… other than that, ever onwards…

Ralph: On the contrary, Ceri! These were seen on
entirely separate Birdwatches!!!! You can surely
distinguish between them by feather formation!!!!
You ain't observin' as well as I fort!! The most
exclusive extinct boid collection will be those that
require God Himself to determine the difference –
so keep observin'!!! – or get Religion!!! But
I wouldn't if I were you!!!!!!! OK. Into the next
millennium to discover the birds that have not yet
happened!!!!! And incidentally, look at the variation
in my double observations of what I have
duplicated!!? Does that not tell you that I have
discovered a flaw (probably a new Genus!!!). I told
you not to muck about wiv me!!!

Ceri: Well argued, sir! I concede with grace. A new
genus of Steadmanoid boid, I'm sure.

Blue-winded Gasp
Exhalus verditens

The Blue-winded Gasp is a furtive bird, whose breath
turns the air blue with an added hint of birdly
halitosis. The Gasp is always ready to leave the scene
of a gasp, at very short notice. This is one of the few
portraits ever drawn of this particular boid. I believe
Ralph bribed it with fresh figs to keep the Gasp still
for a moment.

The BLUE-WINDED GASP Ralph STEADman 2011

Two quails and a Twit. So there!! One to come soon – the White-winged Sandpiper – It is far too HOT to work again today – I pray for cool, man!! Cooler Regards
RALPHZ X

Ceri replies:
Warm and somewhat sweaty salutations from London town! At least you have an outdoors to visit... I can only try to sit in my window box, which never really works. The pigeons keep kicking me out. Speak soon when there is air... x

Ceri's Diary: At first glance this picture is a well-executed study of the New Zealand Quail, a male and female sitting in the landscape showing off their different plumages. But just creeping into frame is the quipping Wizened Twit, which may look dazed and confused but obviously has its wing on the pulse. Never a truer word said than in his jest. "The quail is gonna fail!", he cries... the New Zealand Quail did indeed fail. It's such a fine line between wizened and wise. Who put the wise in the wiz?

New Zealand Quail
Coturnix novaezelandiae

The last specimens of New Zealand Quail were taken in 1867 or 1868 and the bird was thought to be extinct by 1870. It had previously been numerous, but the usual selection of hunting, habitat change and introduced species brought about its failure to exist. Pheasants were released in New Zealand, and diseases that came with them may have been the final contributing factor in the quail's extinction. Other imported quails were not affected and managed to survive, but the endemic version left them all to it, on what was once its own turf.

Wizened Twit
Daftus inextremis

The Wizened Twit loves to birdwatch other birds – that's why he is hiding. Unfortunately for him his whereabouts are easily discernible due to his incessant parping, which makes a terrible sound and leaves an odious trail in its wake. At least he keeps his thoughts to himself, and the Quail never realise what his opinions are.

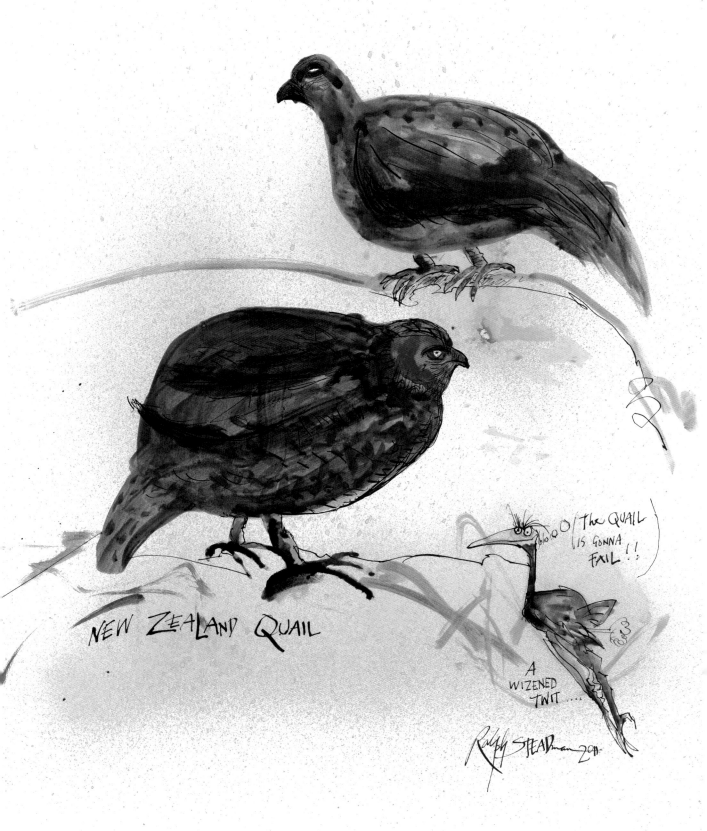

NEW ZEALAND QUAIL

O|o o Q O| The QUAIL
IS GONNA
FAIL !!

A
WIZENED
TWIT

Ralph STEADman 2011

I came across this little Weirrdo and thought to send him along to show you. I have been doing strange things for some years but these Boids are the Weirrdest!
Warm salutations

Ceri replies:
Weirrd seems to be the theme for the weekend!! And I don't think this fellow is overly weird either. A little plaintive, perhaps, but that's only natural if he has an inkling of what's waiting for him, just around the corner.

Ceri's Diary: The Dodo is the usual symbol of extinction but what we are trying to show is that there are so many other extinct birds that could stand up as a symbol for extinction. The collection points out the diversity of what we have lost. It shows that it is possible to use another bird for the saying 'as dead as a Dodo'; 'as dead as a White-winged Sandpiper', for example, or 'as dead as a New Zealand Quail'. OK, they don't quite roll off the tongue in the same way, but you get the picture.

I am starting to worry as to what we are going to do about showing Ralph's pictures in London. There seems to be relentless boidal activity down in Kent. I remember saying to Ralph that no matter how many he does, we will show them all in the exhibition. Last month we counted more than 50 pieces that he has created. That's a lot of pictures, and a lot of space will be needed. Plus, we need to decide if we are going to frame them. If so that's going to be expensive. Too many decisions to make right now, and with the way things are going we could have half as many birds again by the time the show comes round. But this is a good problem to have. Should we only show a selection? That seems self-defeating considering the range of birds Ralph has built up. I will keep on pondering…

White-winged Sandpiper
Prosobonia ellisi

Little is known about the White-Winged Sandpiper, also known as Ellis's Sandpiper, other than it lived on Moorea in French Polynesia; there are no surviving specimens, and the bird is known only from a couple of paintings, made soon after the sandpiper was discovered on Captain Cook's third voyage, in 1777. Its probable cause of extinction was predation by introduced rats.

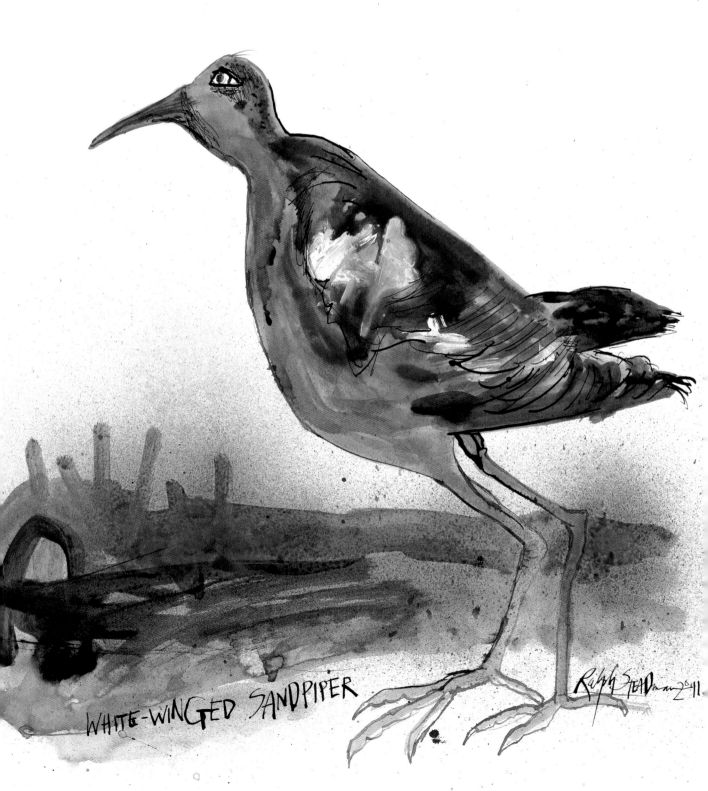

WHITE-WINGED SANDPIPER

Ralph STEADman 2011

28th June, 18:32. Ralph emails:
I hear one comin' now....LOOK OUT!!
RALPHZXX

Ceri: That's funny!
So here's a question... why does Daddy Merganser
not have a Merganser bill but his offspring does?

Ralph: Simple! The mature Merganser (Morgan?) has
exerted its pecking-order prowess and consequently
developed a sharper, finer bill for deeper searches
for food in narrower crevices. Must I always have to
spell it out??!!
I shall continue in spite of the slings and arrows!!
Hot regards RALPHZX

Ceri: And obviously it was this redevelopment of its
bill that must have contributed to its demise!
Perhaps it didn't find much to eat in the deeper
crevices. I like it when you spell it out. Makes it
easier for me to understand the ways of Ralphicity.

Ceri's Diary: Summer has really set in and it is way
too hot at the moment. Ralph's work makes me
forget the heat for a while. 'Keep still son! I think
we're being watched'. I imagine a long line of
birdwatchers being quiet, thinking that they have
gone unnoticed by the birds. But of course the
Merganser dad knows the score and can't help but
see all these people, pointing telescopes and
binoculars at him and his son.

Auckland Island Merganser
Mergus australis

The Auckland Island Merganser was a New Zealander,
who was discovered in 1840. The extinction of this
duck was probably caused by hunting, habitat
destruction and predation by introduced cats, rats,
dogs, mice and pigs. This flightless, tame bird was last
seen in 1901.

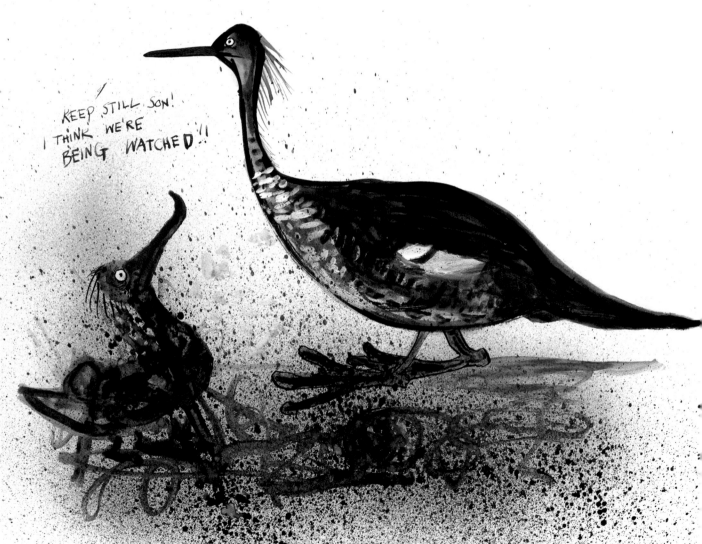

Who are we to judge what should be gone and wot shud stay. If a bird is a gud speller – then it shud steh!! Agrid?? OK
RALF

Ceri replies:
Totallee Agriid!

Ceri's Diary: I can't imagine the Nasty Tern being a speller of anything at all. His only goal is the destruction of rodents. He has no desire to be a spelling-bee champ. Sometimes Ralph creates a boid that is larger than life, and this roaring and intense tern is one of those. It bursts from the page – I imagine the sound of it to be ear-shattering. I wouldn't be surprised if it gave itself a hernia, acting like that.

Later, on the phone:
Ceri: Oh my! This is one of the angriest birds I have ever seen you do. He's terrifying, truly terrifying. I almost feel sorry for those rats.

Ralph: Don't feel sorry for them. Think of all the damage that they have done to birds over the centuries. This time the Boids fight back.

Ceri: Is this what he does on Toadstool Island? Goes around terrifying the incoming rats and scares them off the Island. Or does he capture them and imprison them? Is there a Rat Jail?

Ralph: There could be... he could be the Rat Catcher of Toadstool Island, a dealer in short shrift, which is given out to all types of rat that dare to appear on the island. Someone needs to take care of this incessant problem. And he's the one doing it.

Ceri: So he has a definite purpose on the island. I've heard that the other islanders revere the Nasty Tern, as his success rate when getting rid of rodents is exemplary, dealing with any reported sighting of rats swiftly and ferociously. Every island needs a Nasty Tern on pest control duty.

Ralph: The best control is pest control.

Nasty Tern
Sterna rantus horribilis

Nasty by name and nasty by nature, this creature spends its time putting the fear of God into any invasive species on Toadstool Island. A true boid-protector.

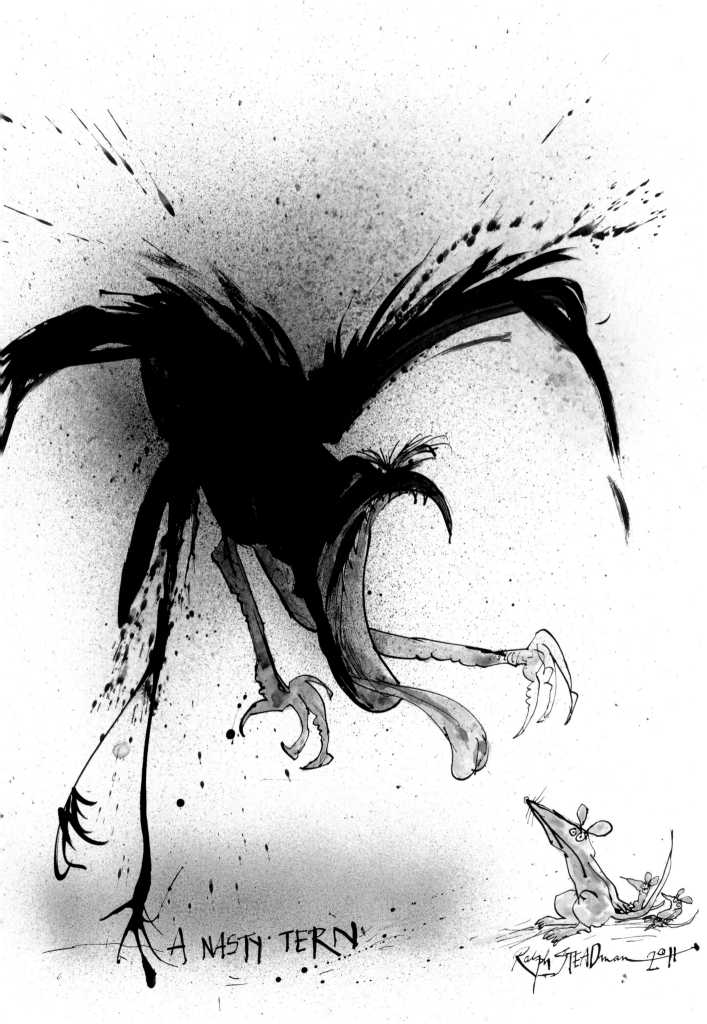

A NASTY TERN

Ralph STEADman 2011

Ceri: It feels as though these birds exist now. Doesn't it?

Ralph: The funny thing is if you put an image down on paper people start to ask about the image. They have questions about it. It exists. You can say things in words and someone can say, 'Oh, that's a lie", but a drawing suddenly means something. It says something we didn't know before. And then you come up with a drawing of complete nothingness, an extinct boid, something that doesn't exist, and people have an opinion about it.

Ceri: A lot of your work seems to be portrait as opposed to landscape. Is this your 'vertical' period?

Ralph: A lot of my drawings for some time have been upright. So yes it is my vertical period and at least I'm not horizontal am I! I might have gone vertical just to prove that I'm still about.

Ceri: The Gob Swallows look like they could be mean, lean flying machines. A little haphazard in their approach to flight, but I believe they're related to our swallows, so I am sure they're excellent at seeking out and destroying any invasive flying insects on Toadstool Island, patrolling the air diligently like stealth fighter jets – and they love mosquitoes. If you ever watch a swallow at close quarters they are constantly hoovering up insects as they fly. They are the ultimate fliers, as far as I'm concerned. Mosquitoes can be a serious threat to birds as they often transmit serious diseases that can kill off a species. So as long as the Gob Swallows continue doing what they do then Toadstool Island should be ok.

Ralph: They are greedy little so and sos. They never stop eating and sometimes eat so much that a Gob Swallow can end up grounded like the lower Boid in this picture. It takes some time before they have digested their food and can get airborne again.

Ceri: The problem with having such big mouths is they can inadvertently eat the wrong thing. They have no filter system, like whales do. They just have very big gobs!

Ralph: Hence the name. That gob can swallow anything.

Gob Swallow

Os gulpus (in flagrante)

That gob can swallow anything. Just make sure he doesn't swallow your soul.

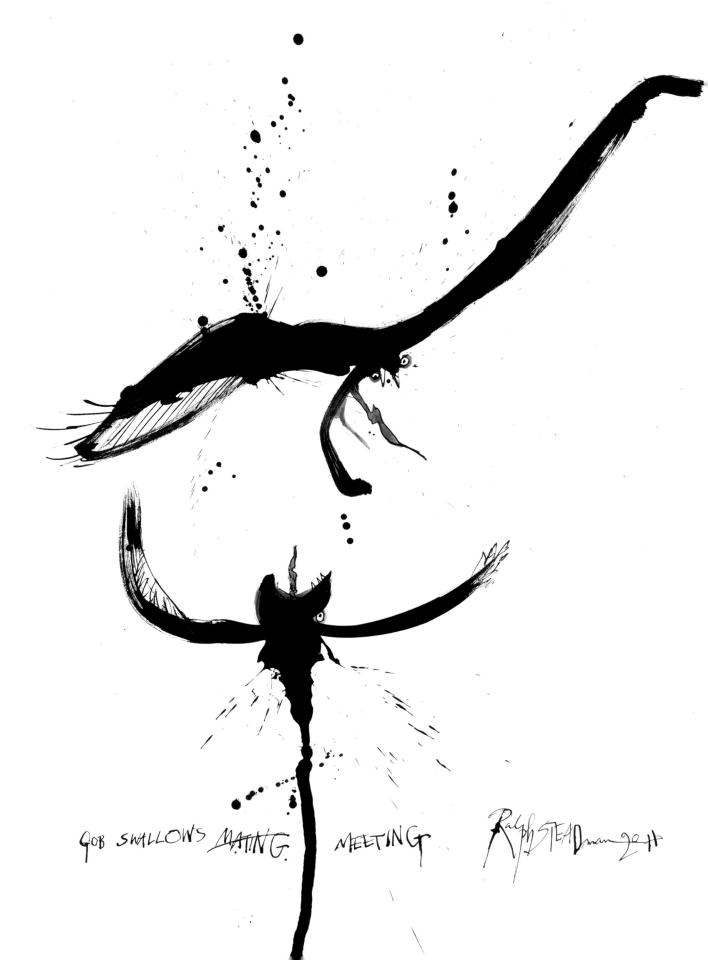

GOB SWALLOWS MATING MEETING Ralph STEADman 2011

Ralph: There are people who now realise that extinct birds exist and will go out of their way to make certain that they don't repopulate the world. Some people don't like these birds existing again. They've been got rid of once before and some don't like the fact that they are in the world again.

Nature is insistent in its ability to exist. It will exist if it can, in whatever form it can. But we have to be aware that if we are going to work with extinct birds, there are people lurking in the shadows who see you and I doing what we do… well you, not me… I'm just doing my job. And they don't like it.

Ceri: It may all have been my fault at the start, but then it became all your fault, and then it became all our fault! There's a sharing of blame here. That's teamwork.

Ralph: I don't like this… I'm god damn blameless! This is frighteningly surreal, the idea of all of this.

Ceri: But Toadstool Island has become an extant island thanks to us.

Ralph: It has mushroomed into the imagination. And that's what's so troubling. It all makes so much sense. But there are people who will look at what we're saying and… we're telling the truth. But there will be people who will deny what we have done. For example, what if someone denies the existence of the Gob Swallow?

Ceri: Thankfully, no one can deny the Gob Swallow's existence now because we can just show the book to the boid-deniers. It exists for all to see!

Ralph: It'll be in there because of us. So we do share some responsibility for what we have done. We have alerted people to these birds.

Ceri: We have alerted people in the same way that the Spundwick's Fret alerts everyone on the island to the imminent dangers of predators and invaders who try to extinguish the extinct boids.

Ralph: It's awful that there are people like that. People who think 'this is terrible, these birds are actually existing. We can't have that'.

Ceri: And that is why the boids have a role to play in the island's protection. It is a self-policing society. They all know that they have to take care of themselves.

Gob Swallow

Os gulpus

Watch out… here comes another one…

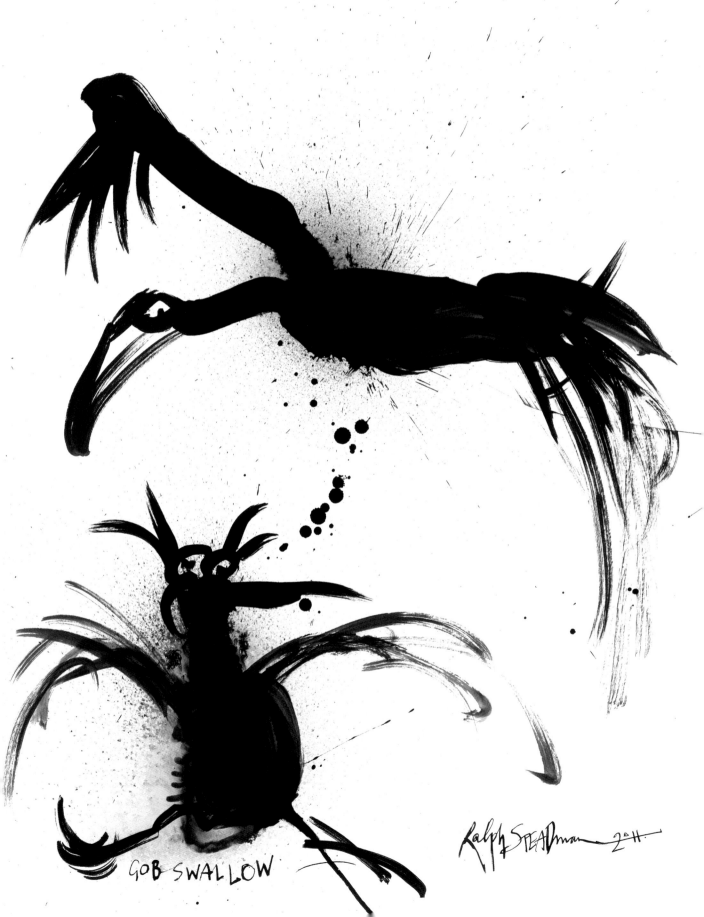

GOB SWALLOW

Ralph STEADman 2011

2nd July, 16:40. Phone:

Ceri: What's going on with these boids at the moment? They seem like The Angry Bunch! The Once Bittern, a Nasty Tern and those Gob Swallows are without doubt your angriest inventions. What's got into you, and what's got into them?

Ralph: Sometimes it's not easy being extinct. How would you like it?

Ceri: I guess I wouldn't. That could explain why they seem to be so aggressive. If they are all part of the island's security force, then I suppose they need to be forceful in order to protect it from danger. I do wonder what the Bittern's just done that has upset the tree creature so much? What is he being told not to do again? Did he see something so untoward happen that he felt he had to take some action? Or was it a moment of blind hysteria? After all he has really funny eyes, which make him look like he is wearing odd goggles of some unusual design. I'm really curious about this scene. Do you know what the issue is?

Ralph: I have no idea. I just caught the end of the argument.

Ceri: And if I'm not mistaken he has terrible knock-knees too. Maybe they exacerbate his anger. He looks like a bad flier, so maybe he has had to climb up the tree, which has been painful as it can't be easy shinning up trees with those knobbly joints.

Ralph: Well observed, Ceri. Quite a few of the boids have knock-knees. It's a rheumatic problem that affects a lot of boids and this is why so many of them are not so good at flying. It's hard to run and take off with knees like that.

Once Bittern

Ixobrychus aliquando

The Once Bittern is a very strange beast. He looks like a boid who could be easily annoyed, and his tail looks like a bell pull. I wonder if someone has just pulled his tail and that's what has upset him so terribly. The tree creature that Ralph has drawn may be a new species, as I don't recognise it from any of my nature books. I have no idea what this beast might be, but it most certainly doesn't seem to be a bird-lover.

2nd July, 17:21. Ralph emails:
Some Boids deserve to be stinked!! OK

Ceri: Especially those damned Grudgians!

Ralph: Got a couple of Boids on the go…

Ceri: Looking forward to the next installment of… BOIDS FROM PLANET OITH. One question Ralph, is there any reason why the Mauritian Shelduck looks exactly like a Mandarin Duck?

Ralph: Shhh… Covert operation. The Shelduck is a master of disguise and is carrying out some undercover surveillance for the Honduras Banana 'O'o. Mum's the word, ears have walls and all that.

Ceri: You mean walls have ears.

Ralph: Not these walls, trust me. Let's speak no more of it.

Ceri's Diary: Imagine a Spot The Ball competition; now decide where you would expect the Grudgian to hit its target. It would be somewhere on the Shelduck – right behind the neck is the perfect purchase point, and it would be impossible to miss, surely? Is that what you think? You would be wrong. Unbelievable as it may seem, even from such a small distance the Grudgian would miss the Shelduck by at least three feet, rendering it totally and utterly humiliated and proving it to be a lousy hunter. The lousiest!

Speaking of hunters there are still a lot of bird-hunters in the world, for example the gun-happy Maltese, up to 10,000 of whom go and shoot magnificent birds from the skies in the name of pleasure each migration season. It's a travesty that this continues, as is the awful pastime of lime-sticking, which occurs in places such as Cyprus; a stick is covered with lime and small birds stick to it when they land on the perch. Once their legs and wings are attached they cannot escape and are stuck solidly in place. Many birds will try and bite through their attached wing or leg to get away. It's a cruel and barbaric way to find a filling for a pie.

Lousy Grudgian
Turdus vilus completicus

The Lousy Grudgian is related to the Gob Swallow, although of course a decent birdwatcher would immediately identify the difference in the primary feathers – plus it has much piggier eyes. It got its name because it was lousy at attacking anything at all. Hence the calmness of the Mauritian Shelduck below, which had far more pressing matters to think about at this moment in time.

Mauritian Shelduck
Alopochen mauritiana

As for the Mauritian Shelduck its serenity was short lived. Hunters and predation by introduced species led to its disappearance by the turn of the 18th century – as if being hassled by the Grudgian wasn't enough.

A MAURITIAN ~~DUCK~~ SHELDUCK CONTEMPLATING ITS FUTURE WHILST BEING ATTACKED BY A LOUSY GRUDGIAN — ALSO EXTINCT!!

Ralph STEADman 2011

3rd July, 17:59. Ralph emails:
Sit'n'look at this Little Bittern, which looks BIG to me!!!

Ceri: Now that is the biggest Little Bittern I've ever seen... In fact the angriest, biggest, Little Bittern I've ever seen...

Ralph: There seems to be an awful lot of birds that have disappeared from New Zealand. Why is that?

Ceri's Diary: One of the main reasons is because many of its birds evolved to be flightless or poor fliers. This is because there were no mammals to eat birds or their eggs. It was the land of birds, with plentiful supplies of food at ground level. Why fly? There was no danger. But then this veritable garden of bird Eden changed forever. Abel Tasman discovered New Zealand in 1642 but he was unable to land due to the hostility of the native inhabitants. It was left for Captain Cook to circumnavigate and explore the islands between 1769 and 1770, and he would go there twice more after his first visit.

Along with extensive habitat changes, the discovery of New Zealand by European people led to the arrival of an array of introduced mammal species. These wrought havoc upon the ground-dwelling birds, as they had no defence against their new, hostile cohabitants. Flight could have been useful for many of the endemics, but there was unfortunately no escape for a lot of them, and they paid the ultimate price – a one-way ticket to extinction. New Zealand has suffered an extremely high extinction rate – 34% of its endemic land birds have gone.

New Zealand Little Bittern

Ixobrychus minutus novaezelandiae

The New Zealand Little Bittern has not been seen since the 19th century, although it has still not been officially declared extinct. Debate continues as to whether it was actually an endemic bird, or just the Australian species having a wander. Subsequent examination has shown that the leg bones are thicker than in your average Aussie variety, and it seems likely that New Zealand did indeed have its very own Little Bittern. That's probably why this Kiwi bird looks so upset. Calling him Australian – what a faux-pas! It's just as well he didn't realise that he would soon have bigger things to worry about.

LITTLE BITTERN

Ralph STEADman 2011

6th July, 18:11. Ralph emails:
Folks are saying that this is what it looked like –
according to those in the know…
Fine by me – I said – I am easily led!!

Ceri replies:
And I will happily follow too! So that is what the
Colombian Grebe looked like.

Ceri's Diary: The purples, blues and greens Ralph
uses in his palette create a beauty and warmth in
this portrait of the Colombian Grebe that is moving.
Perhaps I am reading too much into these pictures
but Ralph captures the essence of extinction in so
much of his work. Even though there is so much
resurrection going on with his birds I still can see a
line that draws upon moments in these birds' lives.
The grebe looks down on its unhatched eggs in
disbelief. Trying to will the insides of the eggs into
existence, the grebe stands in a moment of time
that was a pivotal turning point in its future.
No more kids equals no more species.

There is a special place in my heart for grebes,
especially Little Grebes and Great Crested Grebes,
as they were among the first birds that I became
familiar with as a birder. I loved the minty-green
patch on the side of the Little Grebe's head, and
they way they dived into water, searching for food
with an upward motion and then a forceful
downward dive through the skin of the surface.
I have been lucky to watch Great Crested Grebes
in all their ritualistic mating glory, water-dancing
with each other, their crests quivering and shaking,
necks bowing, creating shapes to the sensuous
rhythms that only they can hear. The grebes'
graceful serenading across the waters is a sight to
behold – this moving courtship of love is a wonder
of the world. I defy anyone to see this and deny that
birds have feelings, too.

Colombian Grebe

Podiceps andinus

This grebe was once considered to be an abundant
bird of the freshwater lakes of Colombia, but by 1968
its numbers had dwindled to fewer than 300. Since
then there have been just two sightings of the bird,
with the last in 1977, when three were spied on Lake
Tota. The probable cause of extinction of this waterbird
was habitat change.

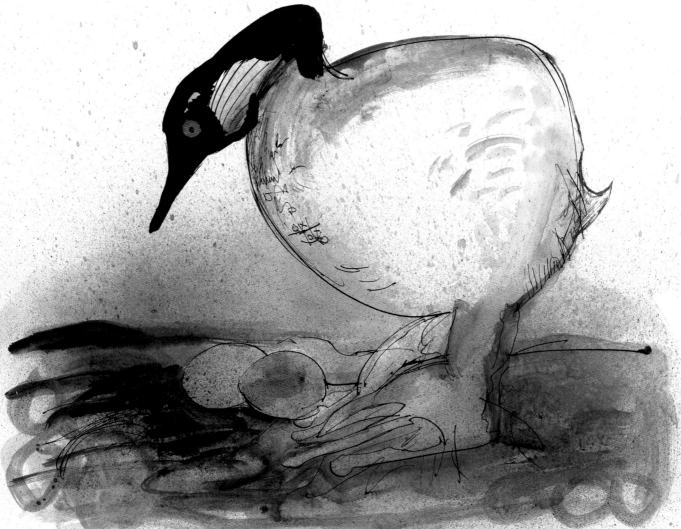

COLUMBIAN GREBE

Ralph STEADman 2011

9th July, 18:35. Ralph emails:
Something for the Weekend??!!!
RALPHZX

Ceri replies:
Is this the last cover of the *News of the World*??

Ceri's Diary: I laughed as soon as I saw the cuckoo alongside the parrot. Rupert Murdoch's English Sunday paper, the *News of the World*, had its last outing this weekend, with this seemingly inspiring Ralph to create an extremely topical boid, in the form of the Channel-beaked Murdoch Cuckoo. Just goes to show that it is not only animals that face extinction.

18:55, phone:
Ceri: The cuckoo was adopted by the Mascarene Parrot who took pity on such an odd sort of boid, and even though he's been around a while, he is reluctant to leave the parrot's side. Because he never leaves this branch, he relies on other creatures to tell him the latest news as he hates to be out of the loop. He loves to hear the latest gossip of who's done what to whom and where, when and why and takes a great delight in broadcasting this latest info to all and sundry, who are grateful that such a little boid has such a big voice.

Ralph: So if you have a tale to tell he's the man to see. And boy, has he told some tales.

Mascarene Parrot
Mascarinus mascarinus

Parrots (the Psittacidae) have suffered more than probably any other bird family at the hands of humanity, although the Colombidae (pigeons and doves) and Rallidae (rails) may argue that they have been treated just as badly. It's a close run argument, and not a fun one to have.

The Mascarene Parrot was an inhabitant of Réunion Island. Several specimens were captured and brought back to France in the late 18th century; it was considered extinct by the beginning of the 19th century. Little is known as to why the parrot died out, but hunting was probably a decisive factor in its extinction.

Channel-beaked Murdoch Cuckoo
Toichoruchus subtelephonus

The cuckoo is the first to spread the news on the island. If you want to know what may be going on then this is the boid to listen to.

MASCARENE
PARROT

CHANNEL-BEAKED MURDOCH CUCKOO
Ralph STEADman 2011

13th July, 19:07. Ralph emails:
OK Ceri
Here is something else gone but not forgotten...

Ceri's Diary: Gone but not forgotten. At least not anymore thanks to Ralph. Parrots constantly make me think of hunting, and the effect this has had on birds throughout the world over the centuries. It makes me so sad to think that this was such a normal way to study birds, and that it was also considered a pastime by many. There are still too many places in the world where hunting is considered a worthy activity, and birds are slaughtered as 'sport'. Sport is a game that should be played by two well-matched adversaries. Not by one party having a gun, a weapon or a trap and the other only a pair of wings.

But, as Ralph and I have been discovering, while we pick our course through the many islands of gone birds, there are a multitude of reasons other than hunting for the disappearance of many of them. We have to accept that wherever it happens, the accelerated rate of bird extinction is pretty much down to us. Our presence wherever we land invariably leads to pollution and environmental change of one form or another. Some say – so what? Why should we care? Ultimately that type of thinking leads to a world where people are all that is left. The last man standing is… man. I don't think that would be such a wonderful world to exist in. Count me out.

What we can do is learn. We can support conservation and address the balance.

Broad-billed Parrot
Lophopsittacus mauritianus

The Broad-billed Parrot was endemic to Mauritius. It was a very large parrot, but wasn't the greatest of fliers. Consequently it was easily hunted, and was last put in the pot at the end of the 17th century.

Spotted Wingless Strut
Strutapterus maculatus

Very little is known of the Spotted Wingless Strut's behaviour, other than it parades around in a haphazard fashion in its polka-dot plumage, imagining a world in which it was in charge.

THE BROAD-BILLED

PARROT

THE
SPOTTED WINGLESS
STRUT

Ralph STEADman 2011

15th July, 12:18. Ralph emails:
Not quite sure where I am going – but somewhere along the road – I may meet the Good Samaritan… Anyway – this one lives for now!!
Love
RALPH
PS – I will give you a good ole phone in a jiffy…

Two minutes later:

Ceri: Aren't YOU actually the Good Samaritan? Or should I say the Good Bird Samaritan? After all it is only because of you that birds like the Splatwink have been brought into people's lives. Without you, who would know of these funny little fellows?

Ralph: Between us we have managed to make them part of the public ether again. It was just that they had been lost and forgotten, and had to be found once more.

Ceri: Much like those Pale Blue Piddles that disappeared some weeks ago. Did they ever show up again?

Ralph: No they never did. Presumed missing in action. Do you think they could have become extinct? That would be irony in action. Extinct boids extincted.

Ceri: I'm not sure, but they did just vanish into thin air. Do you think maybe they were stolen? Maybe that terrible Rodrigues got his hands on them, and has them holed up somewhere.

Ralph: Not a chance of that happening. I have a Rodrigues-proof alarm system set up around the perimeter fence of the studio. He could never defeat that. Not even Queen Boidicea with all her armies could break in and capture the piddles. No, they did something of their own accord – and I don't like it.

Ceri: One day they might turn up again, but I'm not holding my breath.

Ralph: Quite right. You mustn't do that. Holding your breath can cause problems of the permanent kind.

Mottled Splatwink
Splatinicus maculosus

The Mottled Splatwink is one of those messy little blighters that seems to care very little about hygiene. It is believed that somewhere in the Splatwink's DNA there may lurk more than a little bit of chicken. But, unlike a chicken, it cannot lay anything but a stinky splat, and is not averse to leaving a splat here and a splat there – as can be seen with the freshly laid, reeking splat in this picture.

THE MOTTLED SPLATWINK

Ralph STEADman 2011

15th July, 17:21. Ralph emails:
Dear Ceri
Good to speak with you today rather than AT you –
or TO you, or anything else you!!
That strange American 'with you' doesn't sound
quite right… anyway – what I say is – whatever!!

Ceri's Diary: The Angered Maggot Sleet is a stumpy,
narky little creature, that needs some help with
anger-management. Its splat-chakra shows that all
is not well, and perhaps a little bit of therapy would
not go amiss. Yet another oddity we have unearthed
on our epic Boidyssey!

17:26. Ralph emails again:
I forgot to mention that today I got a postcard from
those damn Piddles… They are somewhere deep
within the Urinic Archipelago and have no intention
of returning. They have given me no forwarding
address or contact details, so I wash my hands of
those filthy creatures.

The postcard reads:

Hi Ralph,
The Altar piece of our whole world…The Urinic Circle.
We're travelling and not coming back for some time.
We're busy piddling about, as is our wont.

Angered
Maggot Sleet
Vermifrigipluvia fuminica

First discovered in Scotland, this species took its name
from the foul weather it was discovered in – 'it was
brewin' up a maggoty sleet'. The Maggot Sleet had
always considered itself to be the master of disguise and
camouflage, and consequently became incandescent
with rage when it was found. This wasn't too hard, as it
is not as good at concealment as it thinks it is; all the
Maggot Sleet does is stand stock still, close its eyes and
imagine that it has slipped from view.

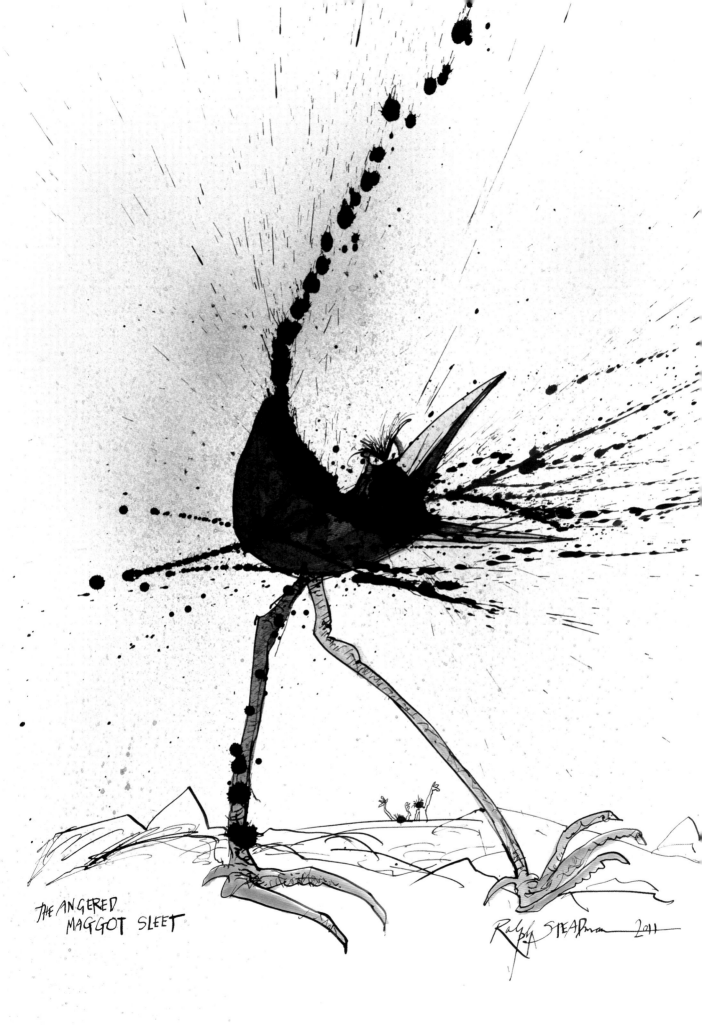

THE ANGERED
MAGGOT SLEET

Ceri's Diary: This picture's title is Boids Wot I Shot In My Goiden, and it reminds me of how so many birds were shot in the name of science, especially during the 19th century, when the common consensus was that the best way to study something was to shoot it and then have a damn good look. Nowadays we try to study by watching creatures live out their lives in front of us.

The first bird I noticed on this painting is the Paula, which immediately made me think this was a collection of Ralph creations. A Paula, indeed. What kind of name is that for a bird? Then I wondered whether this was confused with the now probably extinct Po'ouli, but on closer inspection I realised I actually do need some glasses. Ralph has written the name of the bird as the PALILA – not Paula as I first read it! I felt a bit silly, and looked again at the whole painting in a different light. I had better get this collection dead right!

After some research, ringing experts and spending time with Hawaiian bird tomes, I think I have got to the bottom of this picture. All the birds are real, although vulnerable, and are just about clinging on to life today. Some are endangered (the Alauahio, or Maui Creeper) or critically endangered ('Akohekohe or Crested Honeycreeper, and the Palila). If there was one group that took a pounding from the collector's guns it was the Hawaiian honeycreepers; these ones nearly crept past me, too. I hope that's it for problematic Hawaiian birds.

I've been genuinely confused by a Confusion of Boids, and how very confusing it has been. But I think I've finally cracked the code of this painting, although from now on I will always look at it and think of Paula the Palila.

Later, on Skype:
Ceri: I finally got to grip with your shot garden boids. That was difficult to work out. One minute I thought they were all made up by you, the next I thought some were real and others weren't, and now I've discovered they are all real, and its been a matter of working out which ones were extinct or living. I can't tell you how confused I was.

Ralph: You're confused? What about me? How do you think I felt having all these strangely named creatures surrounding me. They appear, and all I can do is draw them. The artist has just as much trouble as the writer!

Ceri: But did you have to pass the confusion on?

Ralph: As they say, a confusion shared... is more confusion.

Crested Honeycreeper
Palmeria dolei

Also known as the 'Akohekohe, this is a critically endangered species from Maui in the Hawaiian islands, whose habitat is under threat from wild goats and deer.

Pueo
Asio flammeus sandwichensis

'Some kind of goddamn owl' is the Pueo, the Hawaiian Short-eared Owl, which was originally worshipped as a God by the Hawaiians. It is happily still alive today.

'Apapane
Himatione sanguinea

The 'Apapane is one of the more widespread of the surviving native Hawaiian honeycreepers. Its red feathers were once an important adornment on the capes of the local nobility.

Maui Creeper
Paroreomyza montana

Also known as the Alauahio, this is another endangered Hawaiian species whose habitat is under threat from the impacts of introduced goats and deer.

Omao
Myadestes obscurus

Endemic to Hawaii Island, this bird survives but is considered vulnerable due to its limited range; it is also threatened by introduced mosquitoes, which spread avian diseases.

Common 'Amakihi
Hemignathus virens

This is one of the more common extant honeycreepers, occurring on several islands in the chain. Its big brother, the Greater 'Amakihi from Hawaii, was last taken in 1901, a victim of a temporary mania for converting forest into sugar cane fields.

Palila
Loxioides bailleui

Also known as Paula, the Palila is a critically endangered species that has fallen into sharp decline since 2005. Habit degradation and introduced cats are among the causes.

PUEO
— SOME KIND
OF GODDAMN
OWL !!

CRESTED
HONEYCREEPER

OMAO

APAPANE

MAUI CREEPER

AMAKIHI

PALILA

BOIDS WOT I SHOT IN MY GOIDEN.

Ralph STEADman 2011

8th August, Ceri's Diary: More Hawaiian creatures. I am starting to think that Ralph is deliberately confusing me with all the vowel sounds, and that some of the names that sound like they should be real birds are in fact pure-bred residents of Toadstool Island. I need to double-check my info. Perhaps Ralph cunningly draws them to appear as near-normal birds, but they are actually pulled from the recesses of the right-hand side of Ralph's brain, and are in fact a code for me to decipher, to prove I can work out the Real from the Ralph-real. Or am I getting paranoid? I like a challenge, though, and I nearly messed this one up, but I have worked out the truth behind this painting. The I'iwi exists today while the Ariapola'au is a boid. It's not so easy sailing in these Hawaiian waters, and I can't wait for us to move into less turbulent territory.

18:25, phone:
Ralph: The Ariapola'au used to copy the I'iwi and nest in trees. It had a terrible time doing this, as it suffers terribly from vertigo.

Ceri: That can't be very clever if you're a bird.

Ralph: Not really. Also it won't try to get up in a tree any more, as it's not very good at flying and can't get down very easily. Last time it did it got terribly stuck and had to wait to be helped out of the tree by some cranes – the flying variety of cranes, that is. They are always such helpful fellers. It now nests on the floor and is rather jealous of the I'iwi, which has none of the Ariapola'au's concerns about heights and flying.

Ceri: I have just been doing some research and the Hawaiian I'iwi is neither in danger nor is it extinct, and is also known as the Scarlet Honeycreeper.

Ralph: Well, that's good news isn't it?

Hawaiian I'iwi
Vestiaria coccinea

The I'iwi is still a relatively common bird in the Hawaiian islands, although it is largely restricted to upland areas, away from introduced mosquitoes (and introduced avian malaria).

Hawaiian Ariapola'au
Fictitius vertiginius

The Ariapola'au is a creature that likes to copy the ways and means of another bird, and it chose the I'iwi to be that role model. This trait is common among many of the smaller species of boid.

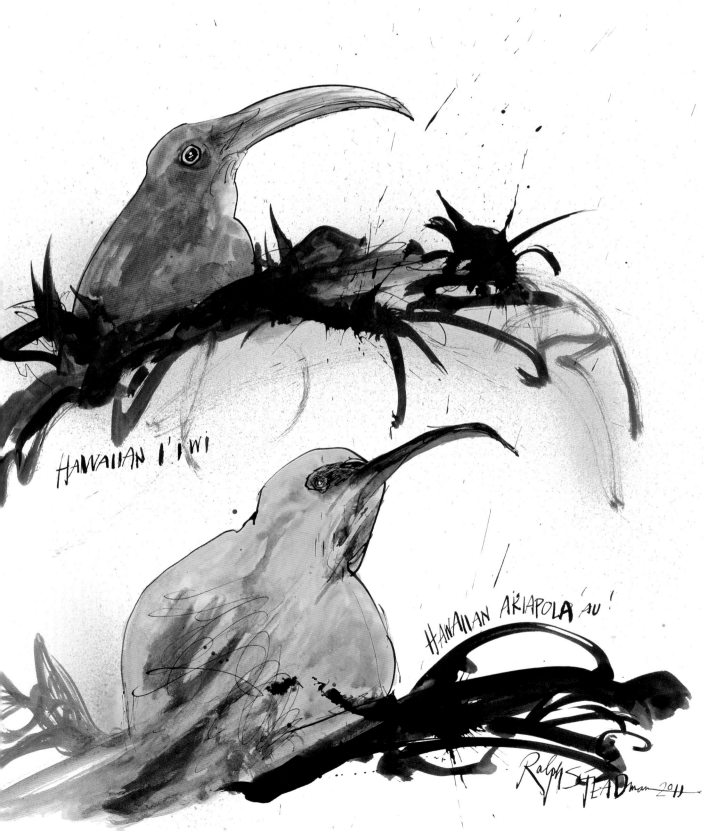

HAWAIIAN I'IWI

HAWAIIAN A'KIAPOLA'AU

Ralph STEADman 2011

Ceri's Diary: And just when I thought here we go again with another made up Hawaiian boid, the Lanai Oloma'o, I discovered that this was a real bird, which was last seen in 1931. Its extinction ties in with the building of Lanai City in 1923.

George Munro wrote on the progress of the city and the demise of the bird in 1944. It is a perfect summary of an oft-told tale:

It inhabited all the present forest, frequenting the low trees and under-brush and ... did not seek the highest dead trees to broadcast its few call-notes, which replaced the beautiful song of the other thrushes. From 1911 to 1923 this bird was under my observation as I frequently rode the bridle trails of the forest. It was at that time a common bird, and its call-notes could be heard constantly, especially in the north and south ends of the small Lanai forest. It declined from 1923 when the population of Lanai increased and the town of Lanai City was built. The people brought bird diseases with their poultry and these, evidently carried by mosquitoes, were fatal to the native bird population. I watched its decline till 1931. The few times I have been through the Lanai forest since 1931, the thrushes notes have been conspicuously absent.

Lanai Oloma'o
Myadestes lanaiensis lanaiensis

The Lanai Oloma'o (also called the Lanai Thrush) was once a common bird in the forests of this Hawaiian island. A sharp decline in the 1920s led to total extinction by the 1930s.

Greater Koa Finch
Rhodacanthis palmeri

The Greater Koa Finch was an endemic of the koa forest above 1,000 metres on Hawaii. The last specimens were taken in 1896, and it was never seen again. The extinction happened just ten years after the bird was discovered; although the cause is unknown, habitat change and predation by introduced species must have played their part.

Kona Grosbeak
Psittirostra kona

The Kona Grosbeak was endemic to the mountainous forests of Hawaii. It was always considered a rare bird, and was last collected in 1894. The reasons for extinction are unclear but habitat change is again relevant.

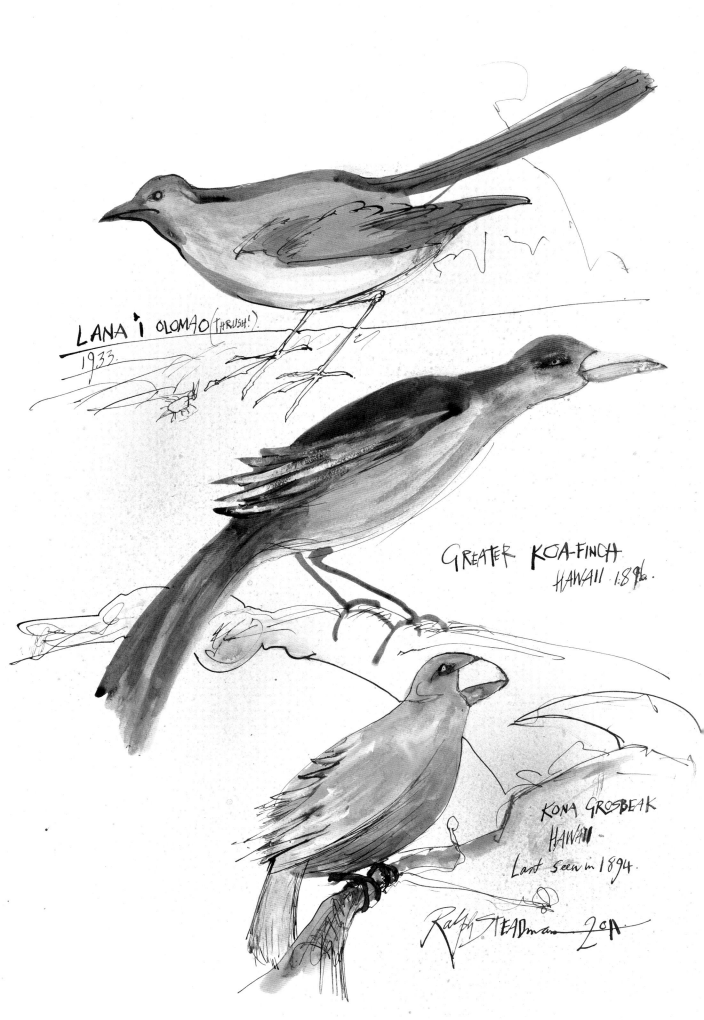

LANA'I OLOMAO (THRUSH!)
1933.

GREATER KOA-FINCH
HAWAII 1896.

KONA GROSBEAK
HAWAII
Last seen in 1894.

Ralph STEADman 20A

24th August, phone.

Ralph: There are just so many birds that have become extinct that came from Hawaii.

Ceri: It is often termed the World's Capital of Extinction, and the figures unfortunately stack up to prove this. Over 50% of the islands' 140 native bird species have become extinct. As we can see from your paintings that includes some amazing birds. Even your made-up ones add to the picture. Who is to say that they couldn't have existed in Hawaii?

Ralph: Why does Hawaii have such problems?

Ceri: There are several possible reasons. One major reason was Captain Cook's boat *Discovery*, which came to Hawaii in 1778. It was infested with cats, rats, mongooses and birds. Unknown diseases harmless to their carriers provoked major problems for the local residents, as the mammals ran amok through the unsuspecting Hawaiian birds, which had no reason to fear the new invaders until it was too late. Genetic processes like inbreeding and loss of genetic diversity may have played their part, too.

Ralph: That sounds like a serious business.

Ceri: I think that scientists don't yet have the answers as to why species go extinct, but modern methods are taking them towards certain conclusions, which are not fully clear. There's still work to do on this.

Lanai Hookbill
Dysmorodrepanis munroi

George C. Munro was the only man who ever described a living Hookbill, and who also believed it to be an actual species. For years, it was thought to be a hybrid, but in 1989 an examination of the skull and mandible of the only specimen proved beyond doubt that this was a unique species. Munro would have been pleased to have been proven correct. Finally the Hookbill officially existed, even though it no longer exists. Work that one out, if you can.

Kioea
Chaetoptila angustipluma

The Kioea is another little-known bird from the Hawaiian Islands. It is known from four skins, which were taken in the 1840s and 50s. It was a resident of the high plateau between the mountains and the forest. The reasons for its extinction were probably habitat change and introduced fauna. It was last seen in 1859.

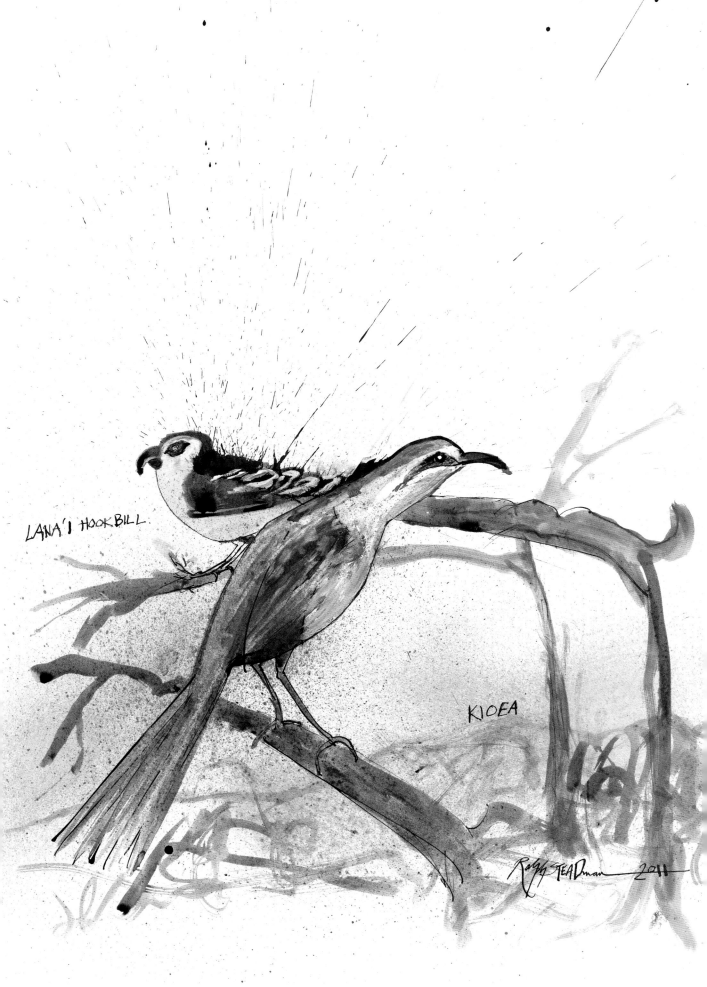

LANA'I HOOKBILL.

KIOEA

Ralph STEADman 2011

Laysan Rail

Porzana palmeri

The Laysan Rail was an inhabitant of Laysan Island in Hawaii. It can thank guano collectors and the destructive rabbits they introduced for its extinction.

Hawaiian Rail

Porzana sandwichensis

The Hawaiian Rail was found in the upland forest of Hawaii, and maybe on Molokai as well. The last sighting was towards the end of the 19th century. The probable cause of extinction was a full house of cats, rats, dogs and humans.

Bishop's 'O'o

Moho bishopi

Bishop's 'O'o was endemic to the Hawaiian forests. There were reports of sightings until 1915, with an uncertain reported sighting in 1981. Habitat destruction, rats and disease have probably done for the 'O'o.

Hawaiian Crow

Corvus hawaiiensis

The Hawaiian Crow is not an extinct bird, but it is well on its way to becoming one. Although there are around 90 birds in captivity, the crow has not been seen in the wild since 2002. No wonder Ralph's bird looks at us with such a baleful and miserable look.

Ceri's Diary: Guano is bird excrement. It is considered to be a fantastic fertiliser. In the 1890s, guano collectors set up a station on Laysan to harvest guano from seabird colonies on the island. They also planned to open a meat cannery, and brought along rabbits and guinea pigs for it. The cannery failed, and the rabbits escaped and did what rabbits do, breeding ferociously and destroying the rail's habitat. Attempts to take the rail to other islands to save it from extinction nearly worked, but in 1929 a gale killed the birds introduced to Pearl and Hermes Reef and to Eastern Island in the Midway Atoll. Then those introduced to Lisianski Island died out due to – can you believe it – the introduction of rabbits! Didn't anyone learn anything?

The last remaining birds on the islands disappeared during World War II, when a US landing craft introduced rats to Midway, which had a flourishing population of rails. The rats took over the island, and the birds were gone by the end of the war. Ironically, by around the same time the rabbits on Laysan had been exterminated, the vegetation had returned to normal, and a perfect habitat for rails had been restored. Unfortunately there were none left to enjoy the scenery.

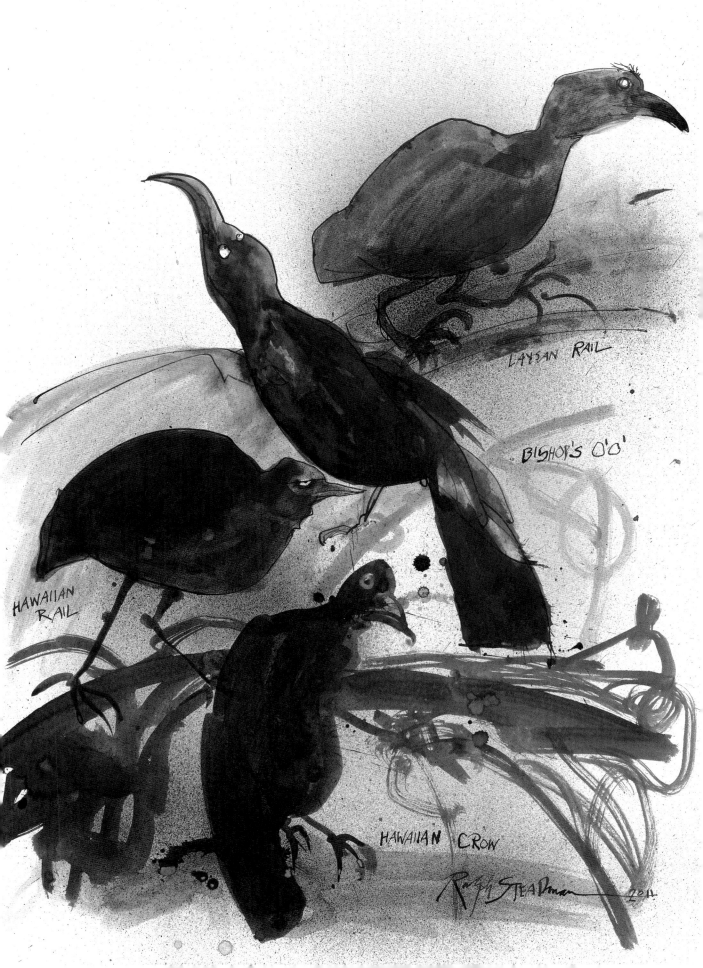

LAYSAN RAIL

BISHOP'S O'O'

HAWAIIAN RAIL

HAWAIIAN CROW

Ralph Steadman 2011

24th August, phone:
Ralph: It's all about the way the front bird stands. And the way he looks at you. I love his poise.

Ceri: There is a certain coquettishness in the bird with its head tilted jauntily and its ever-watchful eye fixed firmly at the viewer, while the other bird seems to be looking protectively over its mate.

Ceri's Diary: So many of the birds in this book have become extinct in remote, far-away lands. Damage done in distant places can be ignored as it doesn't immediately affect us. It's not been done on our doorstep, so is it really a concern? The answer, of course, is 'yes', especially today as the world gets smaller. The Canary Islands are a European holiday destination, visited by hundreds of thousands of sun-seekers each year. When a bird becomes extinct in a place that is familiar to many, the extinction becomes so much more poignant. It just shows that we can never be complacent. Extinction can happen anywhere, at any time. The world's ecosystems are in a fragile state, and we need to look after them more than ever.

Canary Islands Oystercatcher
Haematopus meadewaldoi

The Canary Islands Oystercatcher was a resident of Fuerteventura, Lanzarote and some of their offshore islands. Anyone who has heard the familiar sound of an Oystercatcher will know just how loud the piping call can be, as it runs around searching for morsels in the sand. The Canary Islands Oystercatcher was apparently much louder and ran everywhere, often refusing the option of flight, even when necessary. It had disappeared from the islands by the 1940s. High-rise hotels can't be blamed for this one. Its demise was thanks to hunting, habitat change and possibly predation by cats and rats.

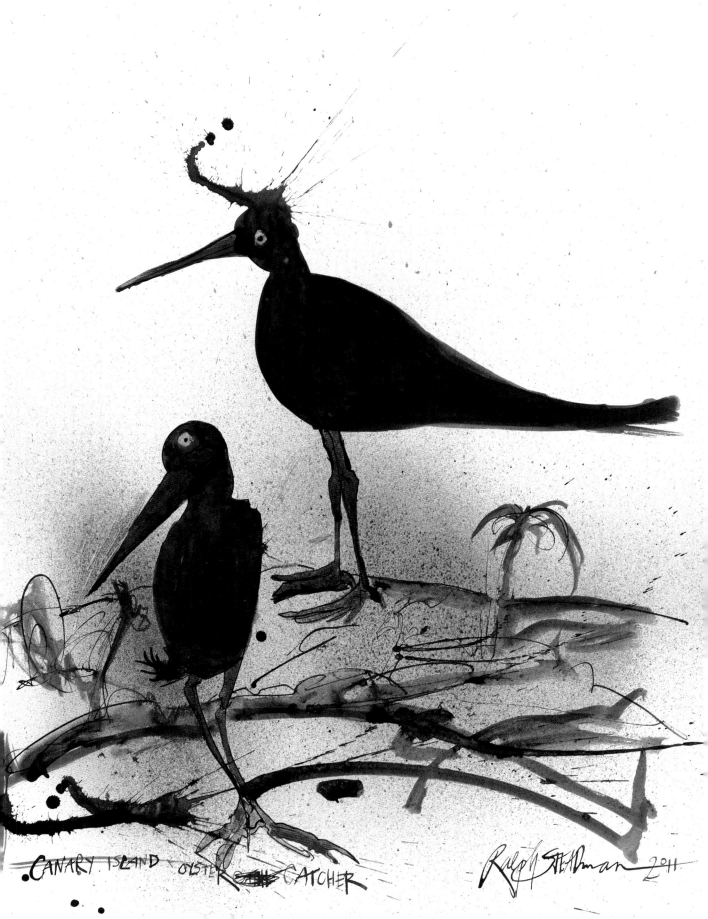

CANARY ISLAND OYSTER CATCHER

Ralph Steadman 2011

25th August, Ceri's Diary: This crazed and delirious creature has just appeared in my inbox. I wonder if he has been bashed on the head or whether that is how his bonce normally is? He certainly looks as though something bad has happened to him. Or perhaps he realises he has just been Ralphed, and is coming to terms with his existence? I get the feeling that he is on his way to somewhere. Maybe Toadstool Island?

24th August, phone:
Ceri: I heard it said that the White-winged Gonner spent a long time trying to find his way to Toadstool Island.

Ralph: He's never had a decent sense of direction, but he got there in the end. And he does have musical sense. Can hold a tune perfectly. Like all boids can.

Ceri: Maybe he could run the Dawn Choral Society on the Island. He wouldn't be short of singers, as it's in every bird's DNA to chirp up and sing a favourite song. His could be called 'I'm a White-winged Gonner and I wanna be a Gonner from here'.

> I'm a White-winged Gonner who upped and went
> To Toadstool Island, I was heaven sent
>
> To join the Confusion was no delusion
> Enough of seclusion, time for inclusion
>
> A happy conclusion, and no illusion
> These boids of profusion would mean no exclusion
>
> To join up with their ranks
> I gave heartfelt thanks
>
> To Ralph who had drawn me into this world
> Allowing my plumage to be boldly unfurled
>
> For all of this island to finally see
> That the Gonner no longer would indeed be...
>
> The last living boid in purgatory.

Ralph: He's quite good at putting a song together. I like that little ditty. I might pick up my ukelele and see if I can find the right chords to go with it. Altogether now, 'I'm a White-winged Gonner...'

The White-winged Gonner

Vamusus leucopterus

He's not got a bad sense of timing. And he likes a bit of word play, too. Not bad at all for a Gonner.

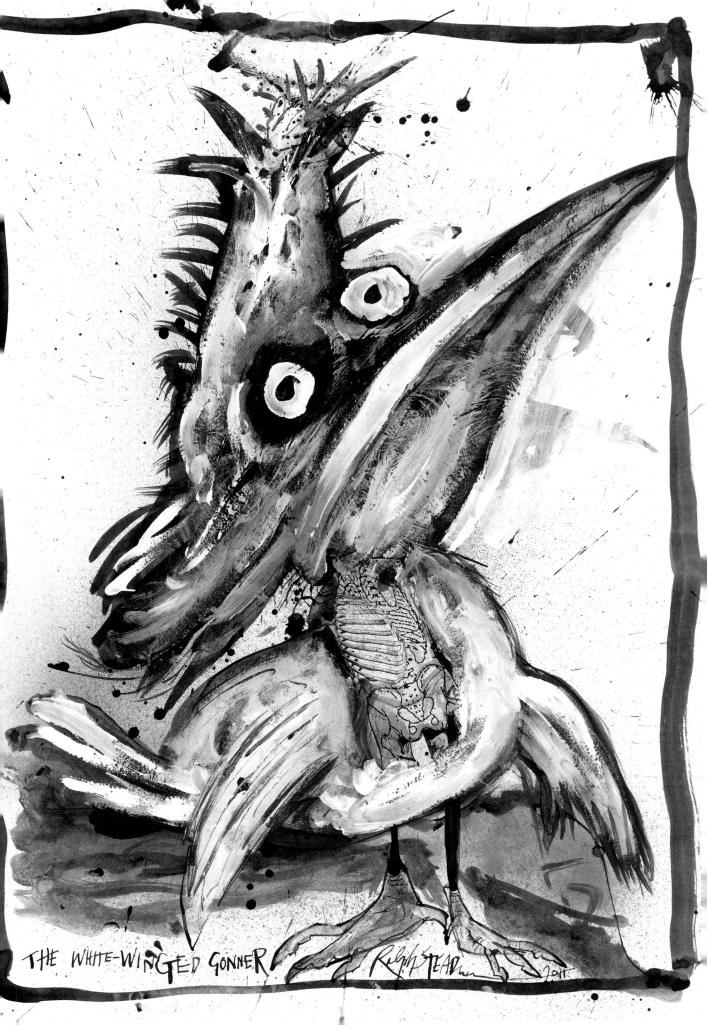

THE WHITE-WINGED GONNER

Most of the Yerks and Bindle Parrots come from Rhyl in North Wales. They are Welsh birds… OK

I have a couple of others which I will send your way shortly…

Ceri's Diary: Even though Ralph is the man responsible for depicting these birds, one has to remember their rarity. Just because we know of them, it doesn't mean that Ralph has been able to draw them. We have to track down these boids as we travel upon sea after sea, and not always with success. Several boids have been impossible to find, untraceable and universally lost. Take the Bindle Parrot, for example. Yes, it may come from Rhyl, but you try and find one.

It is a legendary creature, and we have constantly dipped on seeing it. Dipping is a birding term for attempting to see a bird, usually a rarity, but failing. You might miss the scarce bird by moments, and on arrival someone will usually pipe up 'you should have been here five minutes ago, it's been displaying beautifully for hours!' Bindle Parrots are like this for us. We continually dip every time we try to see it; if this carries on it may become our 'bogey' bird – one that we consistently fail to see.

Sometimes the worst thing is to get a fleeting sighting of a bird, too brief to confirm exactly what it was you saw. It would be bad form to claim a proper sighting of such a bird. Hence, the Bindle Parrot remains undrawn.

Tanna Ground-dove
Gallicolumba ferruginea

Spittle's Yerk
Yerkus spittlei

He's a little guy, the Spittle's Yerk. But he feels quite big and important sat next to the Tanna Ground-dove, because now that Ralph has painted him he is probably just as well-known. Up until this moment, the dove was known from a single painting by Georg Forster, which he sat for in 1774 at home in Vanuatu. The probable cause of the dove's extinction was predation by introduced rats.

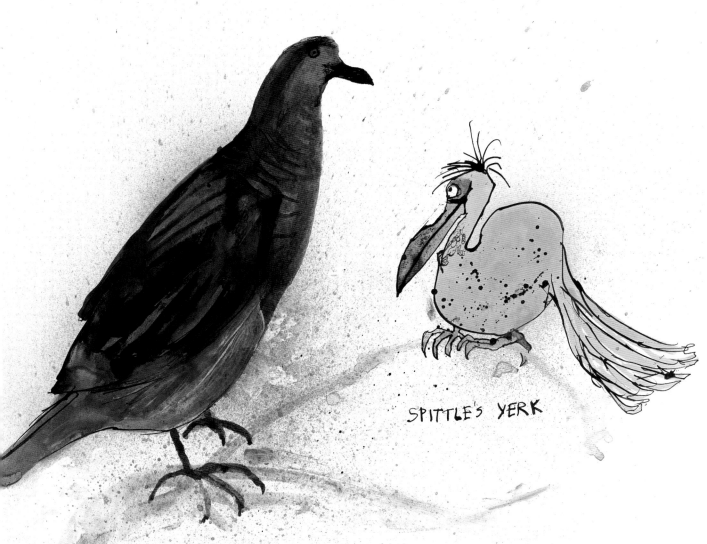

TANNA GROUND-DOVE.

SPITTLE'S YERK

Ralph STEADman 2011.

2nd September, 16:13. Ralph emails:
Here is one that got away!! He is still around in Turkey – and bloody well looks like a Turkey!! He doesn't sound Northern – but he could be BALD!!! Serves him right!!

Ceri's Diary: Ralph was then told about these birds by a friend when he was on holiday in Turkey. After he heard of their plight, he painted their portrait.

Tristan Reid contacted me some time ago. He is another who went on holiday to Turkey and was shocked at how many birds at risk there were in the country. He wanted to do something about it. To raise awareness for these birds, Tristan decided to tattoo his body with the endangered species of Turkey. He has called his project Giving My Right Arm. Tristan told me that he would love to find a way to be involved with *Ghosts of Gone Birds*, and could I think of a way in which he could help? So I have sent a photo of Ralph's latest Turkish creation to Tristan, to see what he makes of it.

4th September, 20:56, Tristan Reid emails Ceri:
Many thanks for the fantastic image of the ibis by Ralph Steadman; he has captured the character of this charismatic species! As it happens, this bird is on my list to be tattooed onto my right arm...

Ceri: Just an idea that springs to mind, but why not use Ralph's ibis image? I would love to film the tattooing as well...

Tristan: I think Ralph's piece would look better on a flatter area as opposed to my arm; so I have an idea! I would be really pleased to have his design tattooed onto the front of my shoulder/chest, which could link up with my left arm work. I think this is exciting. It would be great to link it in with my campaign and *Ghosts*, and of course your film. What do you think?

Ceri's Diary: Perfect. We've put two and two together and came up with TATTOO! What an image to have emblazoned across his chest. Maybe I should get one too...

Northern Bald Ibis

Corvus sylvaticus

The Northern Bald Ibis (actually *Geronticus eremita*) is not an extinct bird, but it is one that is desperately in need of help. There are a number of projects helping the ibis to survive, as it teeters on the brink of oblivion.

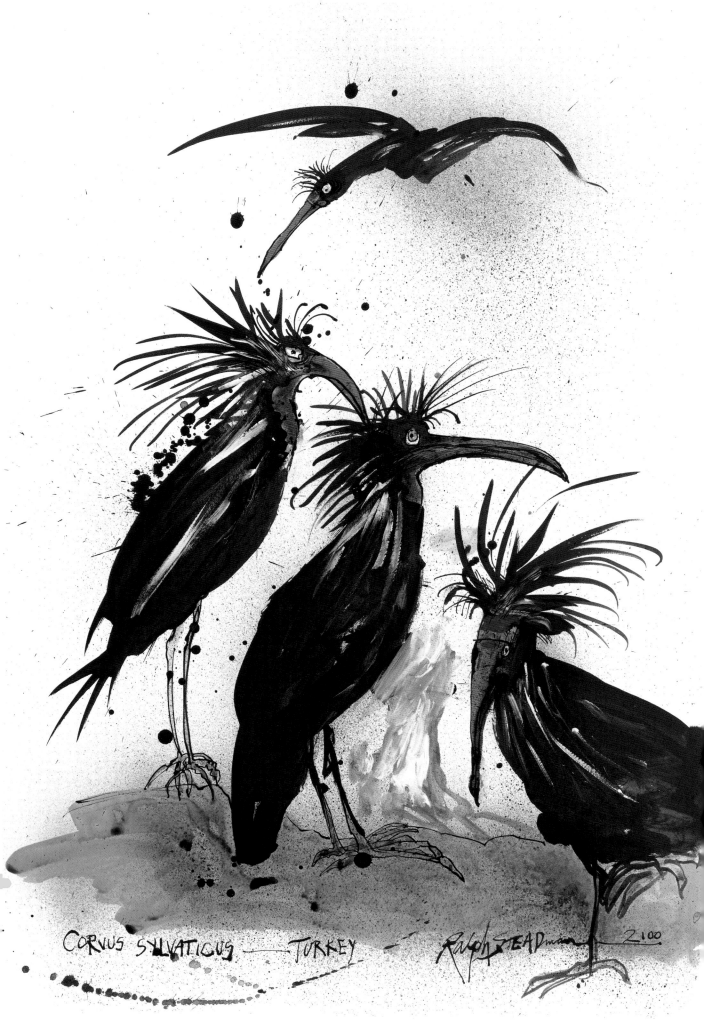

CORVUS SYLVATICUS — TURKEY

Ralph STEADman 2100

18th September, 18:26. Ralph emails:
I haven't done it yet but tomorrow I intend to portray the White-winged Feathered Dinosaur! Meanwhile, more showed up in my garden. They seem to be attracted to me.

Later, on the phone:
Ceri: So what do we think the Lesser Peruvian Blue-beaked Blotswerve was swerving out of the way of in Peru?

Ceri's Diary: It could well have been swerving out of the way of guano collectors. Between 1848 and 1875 over 20 million tonnes of Peruvian bird poo was consumed by Europe and North America. And when I say consumed, I don't mean eaten. It was used for fertiliser. The sale of guano was an incredibly lucrative business, with it becoming the greatest source of income to Peru. Wars were fought over it and it sparked many diplomatic arguments.

It is the anchovy-rich waters that provide the impetus for this potent poo, which is still farmed today. Each seabird is a guano factory. Today, however, there are efforts to sustainably manage the industry. This means monitoring and protecting the birds, and the marine ecosystem that they rely upon.

Ceri: Although the Guanay Cormorant was the bird of choice for the guano collectors, the Blotswerve may also have been popular, due to the purity and sheer strength of its guano.

Ralph: Where there's muck there's brass as they say. And that would explain why the Blotswerve looks so nervously over his wing. Maybe this pressure around his toiletries made him get out of Peru and head for Toadstool Island.

Ceri: I heard that he often refers to Peru as Poo-ru. At least on Toadstool Island he knows his privacy and dignity can be maintained properly.

Lesser Peruvian Blue-beaked Blotswerve

Maculoswervus peruvianus minor

The Blotswerve is another flightless bird, though it is able to march at high speeds that outstrip many runners. It was built to walk, and raised a lot of money for sickly boids when it became the first of its kind to cross the Andes, as seen in Ralph's portrait of its triumphant achievement. In fact, when it had completed its task it carried straight on to Toadstool Island.

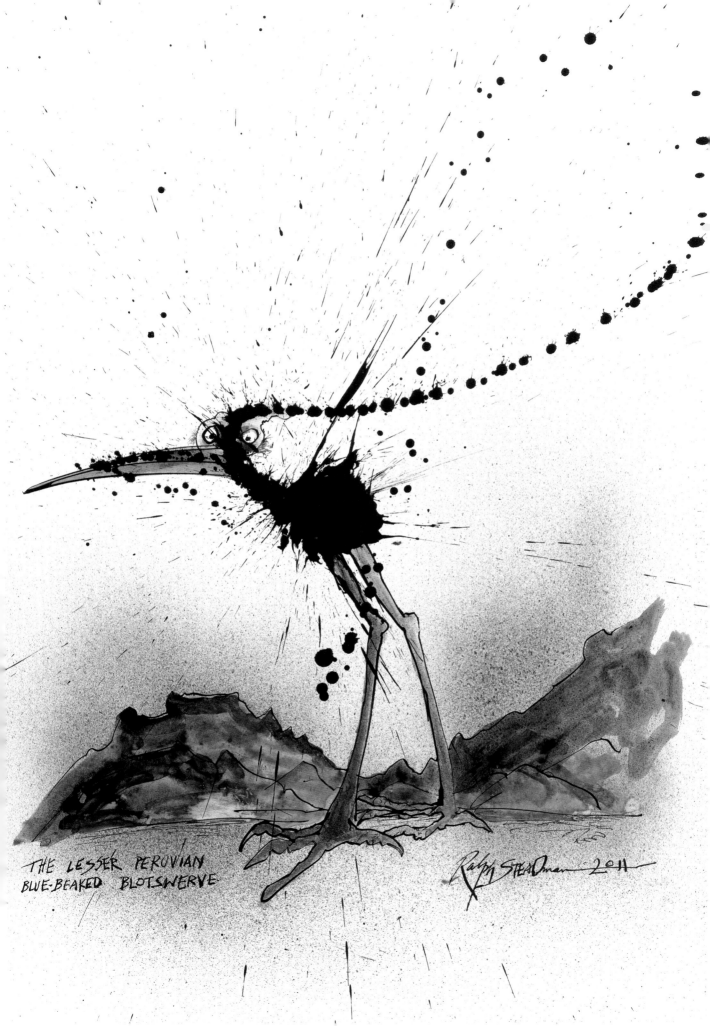

THE LESSER PERUVIAN
BLUE-BEAKED BLOTSWERVE

20th September, 13:05. Ralph emails:
Dear Ceri
The White-winged Feathered DINOSAUR has been
sadly overlooked!! Here's one now...

Ceri replies:
I was wondering when you would do him! I have
been waiting ages...

Later, on Skype:
Ralph: Nice white wings, but useless for flying...

Ceri: This is a real discovery you have made here,
Ralph. The White-winged Feathered Dinosaur could
be one of the most important creatures that you
have found – probably as important as *Archaeopteryx*.
This is the Granddaddy of all the boids, who single-
handedly created the gene pool for all of the
flightless birds that there have ever been. So by
that fact alone, he can definitely be blamed for the
demise of a great many of his avian descendants.

The trouble was that in his day there were no cats,
rats or sailors for him to need evolve wings to
escape from. One blow from his swishing tail would
see off most potential predators, allowing him to
be the king of all that he surveyed. Just looking at
him, it is easy to see that he hasn't an inkling of his
impending fall from grace and disappearance from
this world. But if it could happen to him it could
happen to anyone.

Ralph: From what I've learned no boid is safe. Terrible
things keep on happening, and we are running out
of time to tell the tales. We have to make sure
people learn of all the things that have happened to
birds throughout time.

White-winged Feathered Dinosaur
Dinosaurio fluffinus

The battle rages as to whether the White-winged
Feathered Dinosaur is in fact the oldest of all the
boids. The other contender is, of course, the Orange-
beaked One-wing Jurassic, who reckons he is 20,000
years older. Neither of them has a birth certificate,
and though they would like to arm-wrestle over the
argument that's going to prove a little tricky to do
with wings.

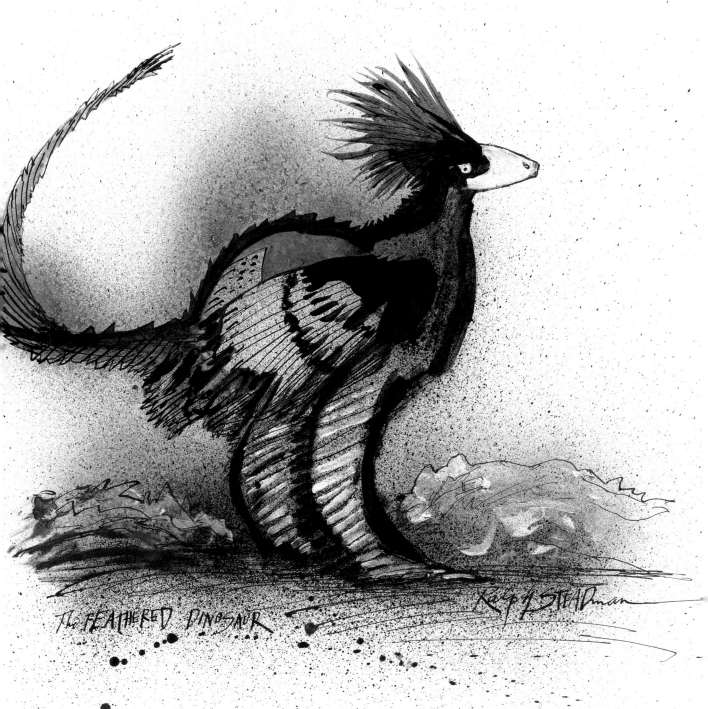

The FEATHERED DINOSAUR

21st September, 15:54. Ralph emails:
I think change is a bad move!! Extinct Boids knew that instinctively.

Ceri: Do you think they should have let their instincts get the better of them? That may have saved them?

Ralph: I don't know!! You know everything!! You'll be telling me next that there is no such thing as a Needless Smut. But you would be wrong, because there is still one living example – at least! – In the Marine Arcade in RHYL!!! And of course on Toadstool Island.

And you were completely unaware that I spotted a Nib Cluster frolicking in the vegetable garden only this morning trying to make out with a Careless GONNER in season. If I hadn't shooed them off we would have been overrun with flocks of Inky Nibblers making that awful scratching mating call at inoffensive Bay Windas that never do nobody any harm – except those damned Winda Cleaners that love to rub them up the wrong way… think I spotted a Loof at 8.30 am from the Swimming Pool.

Ceri: You seem to be inundated by boids these days! I hope you have a pen and paper to hand in case these disappear from view and are never seen again. Flighty creatures indeed.

Tristan Moorhen

Gallinula nesiotis

The Tristan Moorhen was endemic to the volcanic island of Tristan da Cunha and was seemingly abundant in the mid-1800s, but it was extinct by the end of the century. A motley selection of reasons for its extinction included habitat damage by fire, hunting, and predation by cats, rats and pigs. This practically flightless bird was last reported in 1881.

P.S. Tristan da Cunha was a very nice man…

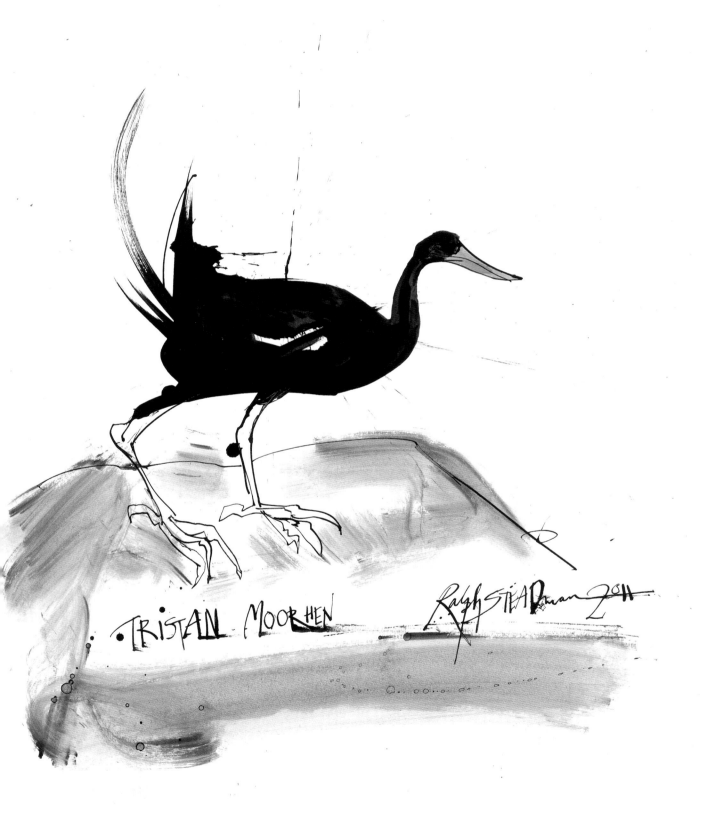

TRISTAN MOORHEN

21st September, 11:31. Phone:
Ralph: I can't stop the birds. They are everywhere and won't leave me alone.

Ceri: You should be able to stop soon, as the show is nearly upon us and HMS *Steadmanitania* will be sailing into its final port of call. The exhibition opens on November 1st so I will need to collect the pictures in the next couple of weeks. We've still got to work out how we are going to display them. We have a separate room that we've earmarked for your work, and as the room is rather high at about twenty feet, we were thinking that we could hang the birds from floor to ceiling. We also had the idea of attaching binoculars throughout the space so people can do some birdwatching with your pictures, using them to view the highest-hanging birds, up near the ceiling. Could be quite fun. It's also going to be interesting to see what people make of all the birds that you have created. I think they'll be bowled over. How many do we have now? It must be nearly a hundred.

Ralph: But what if the birds continue to appear and I just can't stop?

Ceri: Let's cross that bridge when we come to it.

Ceri's Diary: Deep thinking going on here, as I sit in the crow's nest looking out over our latest port of arrival. I am observing our newest case study, the Hawaii Mamo, which hopped into view this morning. Its appearance has set me thinking about extinction and whether birds feel the pain of their impending doom. It surely can't be easy to realise that your time is up and that the end of your lineage has been reached. Was this bird alone at its time of realisation? I presume so. Is the other bird below it actually a figment of the last Hawaii Mamo's imagination in this, its final moment upon the earth? A last visitation of what could have been if there had been more time to reflect and realise that the numbers game was just about up? I'm afraid we'll never know, but it is nearly time for this bird to let go of its perch and head off on its final flight to Toadstool Island.

Hawaii Mamo
Drepanis pacifica

The Hawaii Mamo was last seen in 1899. It was often hunted and trapped for its plumage by Hawaiians, as the Mamo's bright yellow feathers were among the most prized of all, but habitat destruction and introduced diseases were probably the ultimate causes for the bird's extinction.

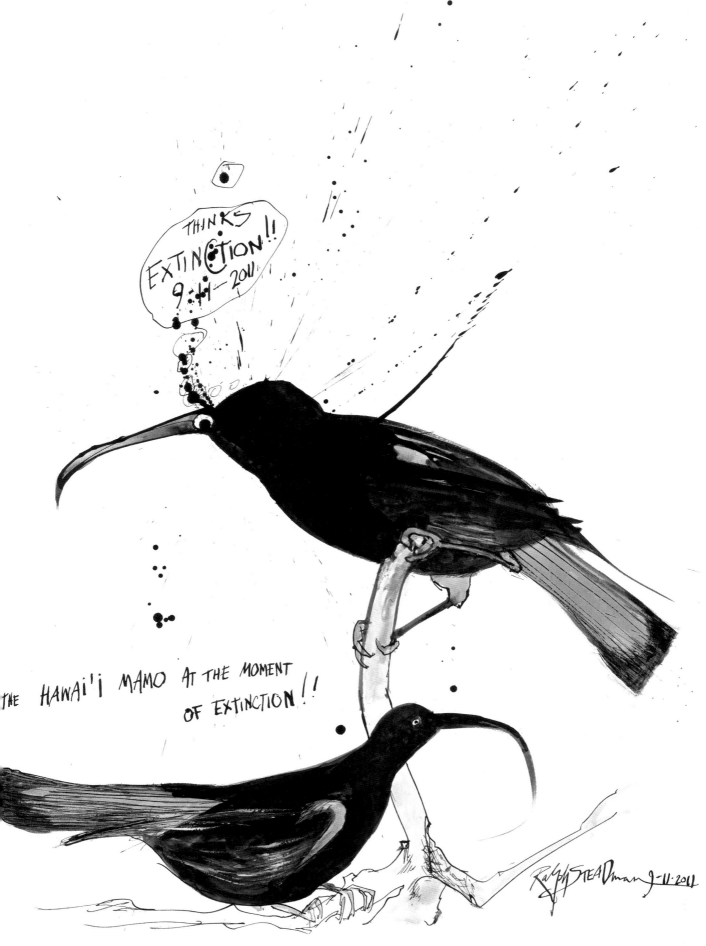

September 25th, 18:40. Phone:
Ceri: Today's picture is an odd one! What's all this about?

Ralph: It's the man who hated birdshit. And boy does he hate it. He lives on Toadstool Island, and all day long he is rained upon by the birds' business.

Ceri: What does he do on the island?

Ralph: He is actually the Governor and tax-collector of Toadstool Island. There has to be someone in charge, after all.

Ceri: We had decided that the Needless Smut was in charge of the boids, but now there is an actual Governor of the island as well? Does that mean the Smut is in effect the boids' union leader? I presume the Smut works in tandem with the Governor to keep the island working properly. And how does the Governor collect taxes? What do the birds pay with?

Ralph: Keep up Ceri, politics can move quickly, and now you see how rapidly things can change with the flick of a brushstroke. The Smut is now the leader of the TUB – the Trade Union of Boids. Between them they bring a certain disorder to the island. The boids pay taxes with guano, of course. Pay attention, isn't it obvious? Remember the Lesser Peruvian Blue-beaked Blotswerve and all his problems in Peru? Here the birds don't mind so much, as they deposit what they can afford and find it quite funny to leave some of their payment on the Governor, knowing how much he hates birdshit.

Ceri: But the sound of falling guano is the sound of falling money, I presume. So he has to put up with it. So where do they keep all the guano? Do they sell it?

Ralph: Guanotanamo Bay is where it's kept. They intend to sell it one day, but for the moment they keep it in reserve.

Ceri: And the Governor's cat doesn't cause a problem for the inhabitants?

Ralph: The cat's in its third life, having discovered it's not worth trying to attack and eat boids. But just in case the cat reverts to type, the Governor keeps it on a long lead, to help it avoid toying with another of its lives. After all, there is no such thing as a cat-master, as the Governor well knows, and cats will rule their domain if you let them. So prevention is the best solution.

The man who hated birdshit

Homo sapiens guanophobes

Every time he looks up he gets one in the eye.

THE MAN WHO
HATED -er-
BIRDSHIT....

28th September, 18:26. Ralph emails:
Noon on Wednesday – is our best-laid plan – and our egg!! Hope the ideas for hanging are going well – I was asked if we have an Infantry of ALL works that will be going off with you. I believe you know exactly what we produced… I said that I rely on TRUST – like all those Extinct Boids!! And anyway – you are not a sailor with a ship's cat – and I do not smell a rat!! See you Wednesday!!

Ceri's Diary: So it is settled then. I will go next week to collect the whole kit and kaboodle from Ralph and bring them back to town, to prepare them for their first public appearance *en masse*. There are more than a hundred pictures in all, and we must make sure we don't leave any behind in Ralph's studio as time is tight.

We also still need to work out exactly how we are going to exhibit the collection. Are we going to hang them all? As the show draws closer I am worrying more and more about this, as they will be unprotected and we will have to keep our eyes on them at all times. The other option is to display them in a series of folders, but that won't have the impact of lining them up, row by row, from floor to ceiling, surrounding and enveloping the viewer. Let's get them to town first and work out the options later.

Tahiti Rail

Gallirallus pacificus

The Tahiti Rail was an inhabitant of Tahiti and possibly the nearby island of Mehetia. Very little is known of the bird, and although it was reported as abundant in 1844 it had disappeared by the end of the century, though it potentially survived until the 1930s on Mehetia. There is one drawing, made by Georg Forster on Cook's second Pacific voyage in 1773, although a recent drawing has been unearthed, drawn by Ralph Steadman from his first Boid voyage, which has taken him to such far-away places as Snodland.

Snodland is in Kent, and was probably named after a Saxon named Snod.

Fragment of Anglo-Saxon poem:

"Probably" he said
While snodding his head
"Snodland's the best
If you needed a rest"

Ceri's Diary: The White Gallinule again appears – the gallinule confusion goes on. There is something about boids that sends the human mind into meltdown. Maybe it is because these gallinules all seem to have more than one name; they have persuaded Ralph to keep on drawing them as they pour forth from his studio. Purple Swamphens, Lord Howe Swamphens, various gallinules – they're all the same thing. Still, I'm getting to learn a lot about them now. For example, I've learned that the Réunion Gallinule is, in fact, extinct. Hooray! Not that I'm cheering for extinction, but it feels like a right result to get a new extinct gallinule into the melting pot (careful with these analogies, Ceri!).

1st October, 12:06. Ralph emails:
Those birds keep coming – LOOK OUT!! Here they come… but keep your eye on the PONCE!!

(Sung to a tune of your own making)

Cats, Rats and Sailors!
Oh, they'll never fail us
On them you can always rely,
The bird will die!

Cats, Rats and Sailors!
They always regale us
With tales of species killed
And bird blood they've spilled.

Cats, Rats and Sailors!
Oh, they'll never fail us
They are a Boid's worst friends
As on them death depends!

Ceri: The Guadalupe Ponce is a funny bird. He sits there all hunched-up. A strange, timid-looking creature with his nervously crossed feet. What does he do with his life?

Ralph: He shivers… that's all he does. He shivers. No one knows why. It's a long-standing condition. Probably incurable… but he quite enjoys it.

Réunion Gallinule
Porphyrio caerulescens

Little is known of the Réunion Gallinule, other than there are reports of how good it was to eat. This culinary fact plus introduced rats ended its existence, probably by the end of the 17th century.

White Gallinule
Porphyrio albus

Still from Lord Howe, still probably extinct.

Guadalupe Ponce
Freezus shivericicus

A strange creature, hard to talk to on account of his unexplained and continuous shivering.

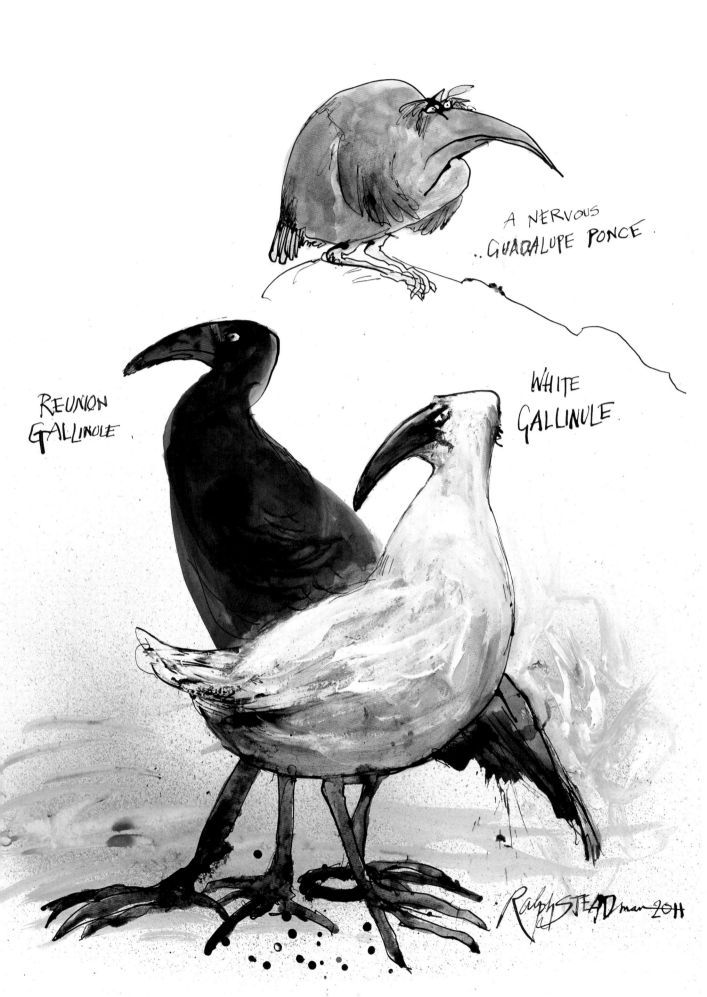

A NERVOUS
.. GUADALUPE PONCE.

WHITE
GALLINULE.

REUNION
GALLINULE

October 5th, Ceri's Diary: Three weeks until *Ghosts* opens. I am at Ralph's collecting the pictures for the show. We are looking through all the artwork; each triggers memories of the last few months, getting to know Ralph and these boids. They are all old friends. I notice that Ralph wrote 'extinct' in the titles of all the early birds, and then stopped. Why? Perhaps because he set out to only paint a few birds and it served as a reminder of the subject. But when he decided to take on a large chunk of the extinct world he needed no such prompting, the titling was forgotten, and what we have now is a monument to extinction. As we go through the boids I discover some that I have never seen before. The Tahiti Rail, the Oceanic Eclectus Parrot, the Kakawahie, the Lesser Blotted Kamao, the Guadeloupe Amazon Parrot, the Oahu Nukupu'u and the Lesser 'Akialoa. Oh, and surprise surprise... there is one more White Gallinule. And today they are all flying the coop.

Ceri: Do you realise how many White Gallinules you have done? They are meant to be extinct.

Ralph: Maybe they're not any more. By constantly drawing them, perhaps we have brought them back into existence...

Ceri: And how come there are so many other birds I have never seen before?

Ralph: Birds can be very secretive. They must have been in hiding.

It's an auspicious moment as we check that we have all the paintings, and then we bundle them together, ready for their chauffeur-driven journey to the big smoke and their London debut. The huge array of work fits into two large portfolios, and then into my car. I have some real VIPs on board. I have never driven so carefully.

Oceanic Eclectus Parrot

Eclectus infectus

The Oceanic Eclectus Parrot was seen and drawn on Vava'u, Tonga in 1793, but it was never reported again. This parrot seems to be perched on a leg of some sort, or is it just a human-looking branch? Let's hope so. It probably died out sometime in the late 18th century due to the usual predatory assassins, introduced cats and rats.

Oceanic Eclectus Parrot

Ralph STEADman 2011

October 6th, Ceri's Diary: I am at home now, surrounded by art. I keep looking through the pictures... these are the painted equivalent of birdsong. They are alive, and have been brought back to this world by Ralph to sing their songs.

Having them with me gives me time to take in the birds I have not seen before. Like the Kakawahie, which sounds like a great Ralph-made-up bird, but it is (or was) as real as I am. There is an evocative feel about this painting, which is often apparent when Ralph paints a pair of birds together. This may well have been the last pair of their species, and we may be witnessing the last relationship within the Kakawahie family. Looking at these birds brings me great joy, but also leaves me with a heavy heart at the future that was awaiting this couple.

There is also a sense of sadness that we have reached the end of the road with these birds. They are soon to fly out into the glare of the public eye, and no more will be appearing. I am incredibly proud of what we've achieved, as behind the play, the chaos and the fun this year there is the underlying message of *Ghosts of Gone Birds* – we have lost too many species, don't let us lose any more. And Ralph has made this point absolutely perfectly by drawing so many diverse creatures. Bring on the public!

Kakawahie

Paroreomyza flammea

The Kakawahie was endemic to the highland forests of Molokai in Hawaii. It was once a common enough bird, but it started to die out in the 20th century, with the last sighting of it in 1963. Habitat destruction, rats and mosquitoes waved goodbyee to the Kakawahie.

KAKAWAHIE
(Molokai Creeper)

Ralph STEADman 2011

7th October, Skype:
Ceri: Sometimes worlds' collide. The real world and yours. It's happened here.

Ralph: He's a real bird, isn't he?

Ceri: Actually Ralph, I think 'he' is a 'she'. The Lesser-blotted Kamao is one of the most feminine and dainty looking birds that you have done. And technically, no, it's not a real bird, for the following reason. There is a Kamao from the Hawaiian Islands, which is now probably extinct. But this being a lesser-blotted version, it becomes a mixture of bird and boid, a blurring of realities, mixed together to make a true confusion. Does it matter? I don't think so. The more we go on, the more I am finding it hard to distinguish between the worlds that we're moving in.

Ralph: Now I'm confused. I remember doing the Kamao. I don't know how it turned into a lesser-blotted one. Still, that must make it much more rare.

Ceri: That's true, and maybe these birds are starting to do things behind your back. I was wondering if the Kamao had bred with something like the Lesser-blotted Bitwing, but this bird looks too calm to have that crazed painter of a bird for its father.

Ralph: Maybe the Kamao sat for the Bitwing in his studio and this is the result, if you take my meaning! Our first experiment into the breeding possibilities between bird and boid has produced this creature. Do you know what this means?

Ceri: No, I don't.

Ralph: Neither do I! Fascinating isn't it?

8th October, Ceri's Diary, 9:00. I'm in Carlisle today to film Tristan having Ralph's ibis tattooed on his body. Birds inspire incredible loyalty.

12:00. Tristan is in the chair at Immortal Art Design, and I am filming the process. Everything is worked out in fine detail – and there is plenty of fine detail in the picture. I watch Richard Batey work so precisely on reproducing Ralph's line – I have seen some shoddy tats in my time, but this is not going to be one of them. It is artistry at work, and this is a first for me, filming a tattooist at work. I get some pretty good footage of Tristan gritting his teeth but on the whole he seems pretty relaxed. After several hours it's done. It looks a bit sore but is superbly executed. Ralph, Tristan and the endangered birds of Turkey are linked inextricably forever.

Lesser-blotted Kamao

Myadestes microblottus

A loving liaison between Bird and Boid.

LESSER-BLOTTED KAMAO

Ralph Steadman 2011

11th October, 16:52. Ceri emails:
We are just making a checklist of all the birds we have for the show. Do you have a photo to hand of the Guadeloupe Amazon Parrot? Can you send him over?

Ralph replies:
HERE HE IS!! Suddenly a huge green hairy arm came out of my screen and shouted Guadeloupe Baby!!! And that was the last I remember – Sorry about that!!

Ceri's Diary: Looking at this parrot, I can't help but think about the thorny subject of hunting. Hunting for food is something I am able to understand in days gone by, and where there is a shortage of food, but what I can't understand is hunting as sport. As ridiculous as it seems, hunting as a 'relaxing' pastime continues to this day. Persecution of birds of prey is often linked to the protection of game birds, which are bred to be shot by the wealthy. A lucrative business to be in, and many wonderful birds have been killed to protect wage packets. There are problems with hunting across the world, nowhere more so than in Malta. Having seen the hunting situation there first-hand, I can categorically state that it is the most barbaric sight I have witnessed in my life. In one week during the autumn hunting season I saw enough murder in the Med to last me a lifetime. Before my eyes I saw both common and rare birds shot at; Lesser Spotted Eagles, Short-toed Eagles, Eleonora's Falcons, Marsh Harriers, Honey Buzzards, Little Bitterns, Night Herons, White Storks, Black Storks, Hoopoes, Swallows, House Martins, Bee-eaters, Wheatears… just some of the birds that the hunters successfully went after. Maltese hunters consider it a traditional and inalienable right to do this. Birds wiped from Malta's breeding list include the Peregrine, the Barn Owl and the Kestrel.

In spring, the favourite birds to kill are Turtle Doves and Quail, which are both in sharp and undeniable decline. But the Maltese government allows thousands to be shot every spring, as this is the best time of year to shoot them as they pass through Malta, on the move to their breeding grounds in the north. The sad reality is that every dead, shot Turtle Dove or Quail could equate to maybe five, ten or more birds that would have existed if the birds had escaped the guns and gone on to breed.

Bullfighting was a tradition that many Spanish people said would never die. Now look what's happened. It is dying off, banned outright in some parts of Spain. Hunting of birds is equally barbaric and should be consigned to history. Hunters of the world, put down your guns now.

Guadeloupe Amazon Parrot
Amazona violacea

This amazon parrot hailed from Guadeloupe. It was considered very rare by the end of the 18th century as it was hunted heavily. It became extinct soon after the last reports of its existence in 1779.

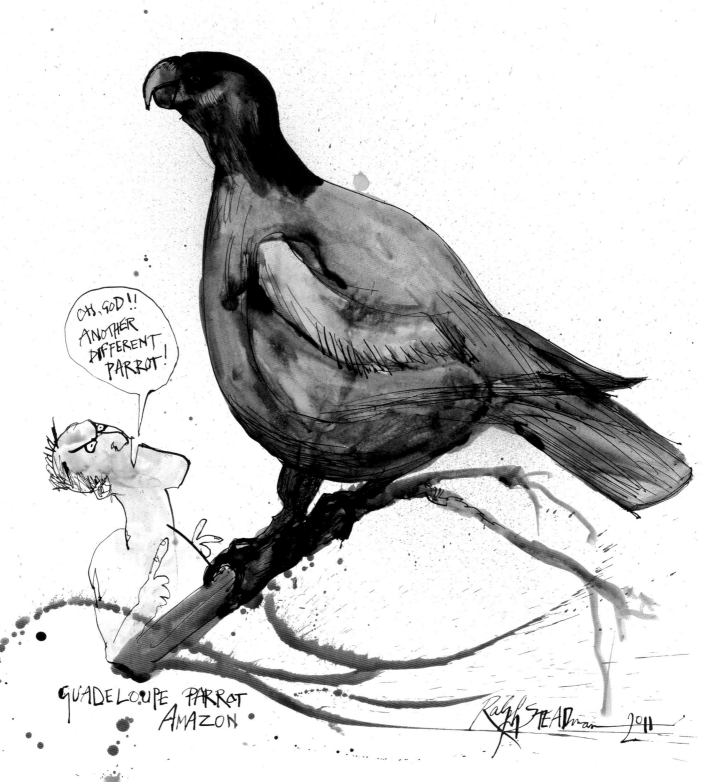

23rd October, Ceri's Diary: Whenever I go out birdwatching, the birds that always confuse and trouble me the most with identification have to be the warblers. I get agitated as I try and separate a Wood from a Willow, a Willow from a Chiffchaff, a Chiffchaff from a real rarity like a Dusky. Every time Ralph sends through something with a Hawaiian flavour I get the same sinking feeling. What is it I am looking at? A real bird? Or a made-up one with too many vowel sounds? After all, he has taken me for a ride a couple of times, making up birds that sounded appropriate with apostrophes in all the right-looking places. So nervously I hazarded a guess that the Nukupu'u was fiction and the 'Akialoa was real. They both turned out to be genuine birds. God damn you Hawaii! You don't make it easy for a novice like me. Bring back the warblers!

30th October, Ceri's Diary: We are in the venue now and hanging the art. Scaffolding has been erected in Ralph's room and the boids are going up. After a lot of thought we have decided to be brave and hang all of them unframed; this provides the greatest impact. We have to rely on the visitors not to damage the art! Plus we will have someone in the room constantly to make sure nothing untoward happens.

31st October, Ceri's Diary: It's taken a couple of days but all of Ralph's art is in place, and looking beautiful. There is an echo in the room because it has such a high ceiling. It feels church-like. Acoustically it's odd, but it really adds something to the atmosphere. I am sitting in here alone and feel quite moved by what is hanging around me.

Oahu Nukupu'u
Hemignathus lucidus lucidus

The Oahu Nukupu'u was endemic to the mountain forests of Oahu in the Hawaiian Islands. It was common until about 1860 but had disappeared from the face of the earth by 1893. Habitat loss was probably responsible for finishing the bird off.

Lesser 'Akialoa
Hemignathus obscurus

The Lesser 'Akialoa was another bird that was a) once common and b) endemic to the island of Hawaii. It was a familiar species until 1895, but was last sighted in 1940. Habitat change was a probable cause of its extinction.

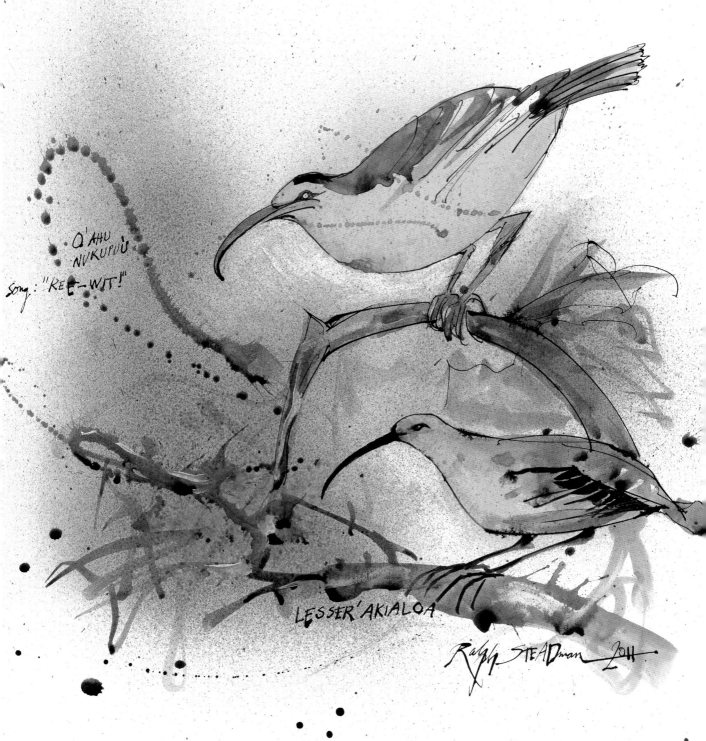

O'AHU
NUKUPU'U

Song: "REE-WIT!"

LESSER 'AKIALOA

Ralph STEADman 2011

1st November, Ceri's Diary, 08:00. This was one of the last birds that we hung last night. Here we have another case of gallinular repetition. Having already painted the Purple Gallinule, Ralph has now done it by its other name of the Purple Swamphen. What I find interesting is that all the gallinules/swamphens he's painted have individual characters. That's why I have no problem seeing them time and again.

Ceri: Do you know that this is the second time that you have done this bird? The Swamphen?

Ralph: Really? One thing's for certain, swamps ain't what they used to be! Not like in *Great Expectations*. When Magwitch meets Pip in the churchyard on the Kent marshes … That was a swamp. Just the thought of that place scared the hell out of me as a kid.

Ceri's Diary, 08.35: Just listened to Radio 4's *Today* Programme, which carried an interview with Ralph and me, chatting about the boids. What a start to the day.

Ceri's Diary, 10:50. In ten minutes the doors open for the press launch, and we are hoping that a few people will turn up. As for tonight I have no idea whether twenty people or two hundred people will show, although we are continually getting requests for the guest list. It is now in the lap of the gods.

11:00. Quite a lot of press have arrived and the early signs are that the show is being appreciated. Fingers crossed for some decent coverage. I always say that when you don't get press it doesn't matter and when you do get it you realise the difference it makes!

12:00. Ralph arrives, and this really makes people sit up. We enter his room and suddenly there are photographers everywhere, their cameras flashing like crazy. Ralph is enjoying playing up to the crowd, and proves to be a wonderful showman. I stand to one side and take in the sight of Ralph in his aviary, busy giving good copy. I remember the first birds that he created – the egret, auk and moa. What an adventure we've been on since then. Now it's for the press and the public to make up their minds.

Ralph meets Tristan Reid.

Purple Swamphen

Porphyrio porphyrio

The Purple Swamphen – AKA the Purple Gallinule – is NOT an extinct bird. It is still alive and still squawking in various locations around the world.

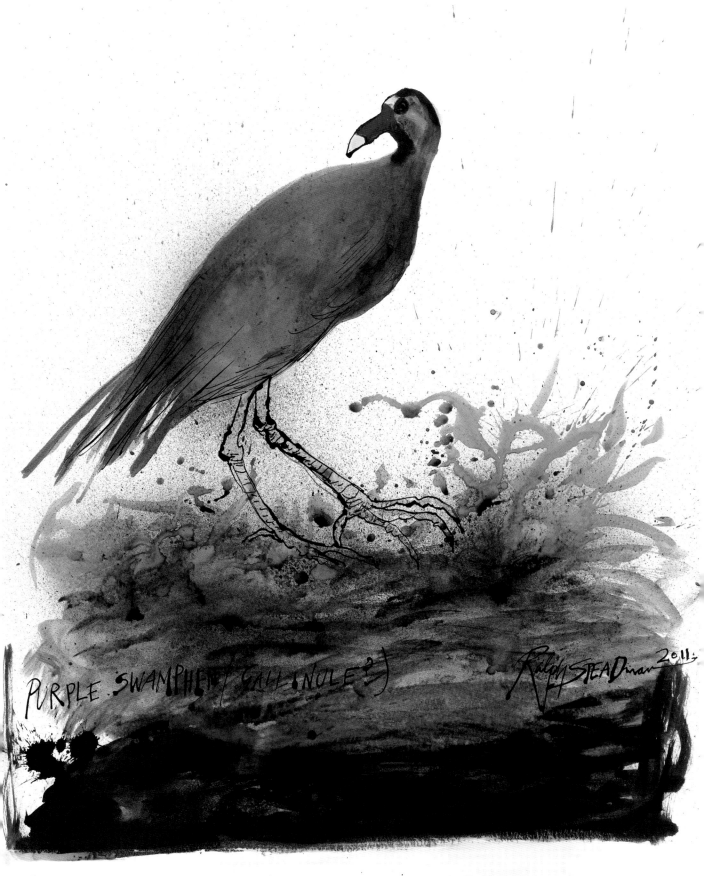

PURPLE SWAMPHEN (GALLINULE?)

Ralph STEADman 2011

Ceri's Diary: And last but not least, here is the final picture on the pile to be hung. Please welcome the third appearance of the White Gallinule. It's a 3-2 win for the extinct White Gallinule over the very much alive Purple Gallinule. Yet again, though, it is a wonderful drawing of the bird, accompanied by a strange predator. I'm not quite sure what it is but it looks grumpy enough to mean business. Meanwhile we are ready to open the doors and to see what reaction the show receives. It's showtime!

1st November, Ceri's Diary, 17.55: There are queues outside, waiting to get into the show. It's going to be OK. It really is. The art is on the walls, the sculptures are on their plinths, the drinks are ready to be served and it is reckoning time.

18:00. People flood in. I didn't know we knew so many people. It is chaotic, and how full is Ralph's room? People are clamouring to get in, and yet are being respectful of the delicacy of the art on the walls. There is such a buzz on seeing people using the binoculars to study Ralph's art. The audience is with us. This is more than we could have hoped for.

2nd November, Ceri's Diary: Reviews abound in many newspapers, and photos of Ralph in his room have featured in several of them. All complimentary – the whole show has been a resounding success in the press. This is more than we could ever have hoped for. As I drive up to the show I notice that there are people already queuing to get in.

23rd November, Ceri's Diary: The last three weeks have been a blur for us. The reaction has been fantastic, and we have had close to 10,000 people passing through our doors. And these have been people who have come to *Ghosts* not because they are 'bird fans' in particular – it has been a real cross-section of the public. It's been great to hear the words 'I had no idea…' when people realise how many birds we have lost over the years. The binoculars have been really well-used in Ralph's room – it has been the bird equivalent of the Rothko room at the Tate.

White Gallinule

Porphyrio albus

Back for its third appearance …

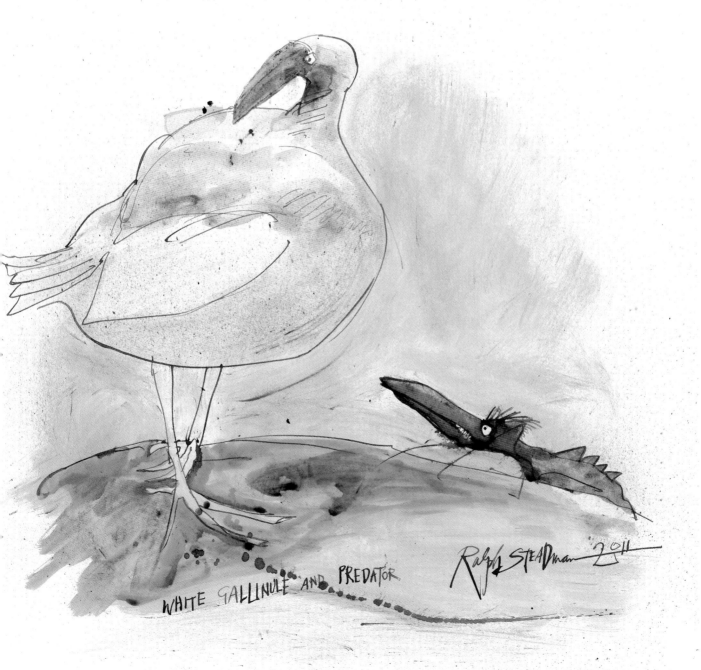

WHITE GALLINULE AND PREDATOR

Ralph STEADman 2011

10th December, 19:06. Ralph emails:
I Started Agin!!

Here's one now and a pal!!
Love
RALPHZXXX

Ceri's Diary: I didn't expect this. The show has been over for a couple of weeks and Ralph and I have been talking about getting things moving on creating an extinct boids book. I thought we had enough images, but Ralph has obviously decided otherwise. So here we go again – stoke the fires, all aboard HMS *Steadmanitania* and let's cast away, we're travellin' agin! And immediately off to starboard is a Tahiti Sandpiper, and it is being watched by, er… a Yooo-eeee Bluebreast, or what is also known as a Ghosted Waver. Apparently. Bless you Ralph! I have missed this beautiful madness.

Later, on the phone:
Ceri: What's happening here? I thought you had finished drawing birds.

Ralph: I don't know. They were sat there, so I had to draw them. It was the only way to make them go away.

Ceri: I think that maybe you don't want them to go away and you're leaving food out to attract them to your studio. I reckon you've become a bird lover.

Ralph: It seems that way. There are just so many I still haven't done and I like what I can do with them. I like birds! I like drawing them. There, I've said it!

Tahiti Sandpiper
Prosobonia leucoptera

Very little is known about the Tahiti Sandpiper. Johann Forster took one specimen and Georg, his son, made a painting in 1774. Apparently a bird of the highland streams of Tahiti, its demise was probably due to introduced rats.

Yooo-eeee Bluebreast
Pectocaeruleus yoooeeeenius

The Yooo-eeee Bluebreast is a siren-like bird that lures potential invasive species onto the murderous rocks surrounding the island. A bewitching "cooo-eee, yooo-eeee", repeated over and over again, works every time.

A GHOSTED-WAVER
OR YOOO-EEEE !
BLUEBREAST

TAHITi Sandpiper.

Here's a little Dickie Bird and I have just begun the Jail Bird!!

Ceri's Diary: Over the year, this project has altered its course many times. Ralph started off creating one extinct bird, but when his imagination ran away to far-off islands he discovered this flock, and then found the perfect place for them to live, survive and exist with a purpose on Toadstool Island. We have conjured up roles for them to play on there, but that has grown necessary as the island has come to life. Most of their roles actually involve serious issues that have made extinct birds extinct. They protect their island from the perils that have threatened them for centuries. Persecution, hunting, habitat change and introduced species. Funnily enough, they are role models we can learn from. The majority of boids are striving to stop everything that has happened to the birds of our world from threatening them again. Perhaps this time they can be left in peace.

On the phone:
Ralph: A little dickie bird told me that I should do the Dickie Bird! After all, he gets mentioned so much in our language that it was about time he finally got drawn. Portraits of him are few and far between. He has never been drawn from life nor been represented officially, so I decided to change that.

Ceri: He looks a bit bemused and confused to me.

Ralph: Well considering that he has never sat, or in this case never stood, for a portrait before, he wasn't sure how to pose for me and he found it hard to take instruction, as I don't like to contrive posture when I am making a social document like this. But he was very well behaved, and kept quiet while I drew him. Which is more than could be said for the Lemon Tweet, who would not shut up!

Ceri: Did you know that dickie bird is rhyming slang for 'word', so 'not a dickie bird' means silence. So not a dickie bird came out of the Dickie Bird's beak.

Dickie Bird
Confusornis subrichardi

Nested Lemon Tweet
Sherbetum citrumdabus

The Dickie Bird looks like a confused but happy sort of creature. He is a little away with the fairies and in something of a daze. Perhaps this is why the Lemon Tweet is looking up in a kind of fear, just in case Dickie steps the wrong way and destroys its nest.

A DICKIE BIRD.

Ralph STEADman 2011.

12th December, 18:53. Ralph emails:
No proper specimens – at the moment – though I have heard tell down the valley the *Carcerem boidus* is in feather!!! Can't fly yet though as it is stuck in klink!!

Ceri's Diary: Why is this bird doing bird? What did he do to end up in this situation? He has that 'lorks above, butter wouldn't melt in his beak' look about him. 'I'm innocent guv! Honest... strike a light, there I was just minding me own business...' He has all the hallmarks of a great 1960s British cinematic comedy about him, and could be peering out at us from a film poster of the time, having been banged up with Peter Sellers, Wilfrid Hyde-White and Lionel Jeffries in a prison movie classic.

Later, on Skype:
Ceri: It has been an extraordinarily productive period since the Egret first landed among us. Are you surprised at how this year has turned out?

Ralph: Yes I am, and I never expected it. It all just happened, and I had no choice but to draw these creatures. I had been lonely before they turned up. They brought something that I didn't expect. I don't know whether you brought the birds or they brought you, but this has been one of the most wonderful projects I have worked on. And soon we will have a book to show for it. A record of all the birds we have discovered. Unequivocal proof of what we have found.

Ceri: No one will be able to deny the existence of these creatures then. The birds inspire our dreams and have created such adventures for us. The places that we have visited because of them have been remarkable. How often while looking for these creatures have we walked down a dead-end road, thinking we have made a wrong turn, only to continue walking as far as possible and to then discover a wonderful and previously unseen bird? Sometimes they just appear, but often we have had to seek them out. We could not have made up this story if we had tried.

Ralph: That's the point. We never tried to do anything. It all just happened.

Jail Bird
Carcerem boidus

There's always got to be one bad egg, and this is what came out of it.

A JAIL BIRD —
(12 YEARS MINIMUM)!

Ralph STEADman 2011

Ceri's Diary: I constantly think about the subject we are tackling with Ghosts and what Ralph has done over this year, and I still find it difficult to comprehend why humanity has destroyed so much on and of this world. I had often thought that environmental concerns were a relatively new subject, as we work out how to halt our interference in the natural order of things. But I've found that there have been champions over the centuries who have fought to maintain our world's status quo, and who have strived to point out the dangers of 'progress.' Today I came across a wonderful quote by Alfred Russel Wallace, who independently discovered the principles of natural selection in 1858, even though Darwin took the plaudits with the 1859 publication of *On the Origin of Species.*

Wallace called it right, and his words struck a chord deep within me. Having visited the Malay Archipelago and seen the array of animals that lived there, he made this observation:

Should civilised man ever reach these distant lands... we may be sure he will so disturb the nicely balanced relations of organic and inorganic nature as to cause the disappearance and finally the extinction of these very beings whose wonderful structure and beauty he alone is fitted to appreciate and enjoy.

Jeepers, Mr Wallace. In four sentences you have encapsulated the issue. Thank you for this chilling prophecy. Christmas food for thought...

And then...

24th December 2011, 17:04. Ralph emails:
A Christmas Chicken!!

Ceri's Diary: What a year it's been with Ralph. I'm looking through all the boids, and know this is their very first Christmas. Please raise your glasses to them all.

Merry Christmas Boids!

Yuleiptopede Nativitaurus Willychick Tweet

Supernoeliticus nonsensicus

We have Santa, and the boids have the Yuleiptopede Nativitaurus Willychick Tweet. It is the bringer of the boidies' presents, and spreads good cheer across the island.

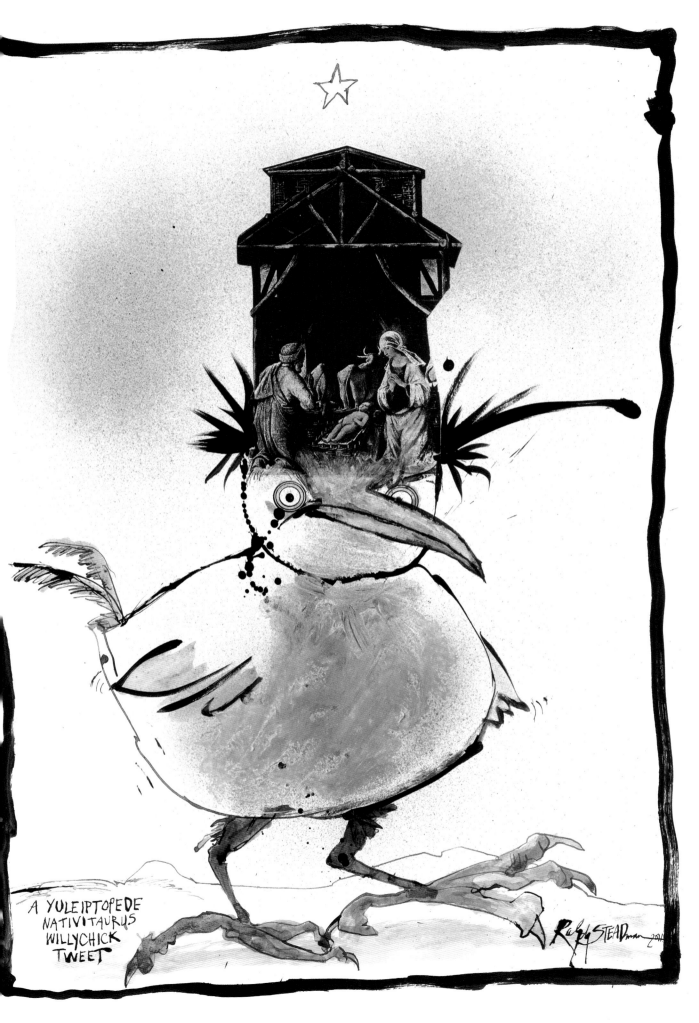

A YULEIPTOPEDE
NATIVITAURUS
WILLYCHICK
TWEET

20th January 2012, 13:09. Ralph emails:
WEIRRD Spotted winged thing seen – I reckon it doesn't exist!! Could be wrong!!!

20th January, 17:54. Answer-machine message from Ralph:

Hi Ceri, It's Ralph here. I'm just fed up with this electronic nonsense. It's not really that good… phone's the best. I tried to buy an old magazine online but could I? No. I couldn't get my right password.

Anyway, I just thought I would give you a ring. I thought, I know, I'll ring Ceri, he'll pick up the phone… but no, he won't. It's obviously that kind of a day. NOBODY is doing anything important, or they're doing something far more important than to use the phone, or they are occupied doing something that they perhaps oughtn't be doing but are doing, or doing something that they must do and, therefore, are getting on and DOING it! That's phoning! Good for you! So, I'll speak to you later, lots of love…

(pause)

I've done too much stuff Ceri, it's ridiculous! Anyway, the Long-legged Shortwing is a nice one. I'll send it soon when I have put it on film. Speak to you soon. Lots of love… bye.

Ceri's Diary: Ralph told me that when he painted the Shortwing he went to lunch, leaving it unfinished with only one trailing leg. The straight leg magically dripped into place while His Nibship ate. These boids are starting to control their own destinies!

Long-legged Shortwing
Brachypteryx longicrurus

One look at this poor creature explains why the Long-legged Shortwing would struggle to survive in our world today. Ridiculously stumpy, bright-yellow wings would draw attention to the bird's inability to fly, and its miserable demeanour and resemblance to a swotted wasp means it would struggle to get help if it needed it. Luckily this matters not a jot on Toadstool Island; even though it's a solitary creature that ploughs its own furrow, the Shortwing has plenty of good friends – the boids always stand by each other. Every boid is sacred.

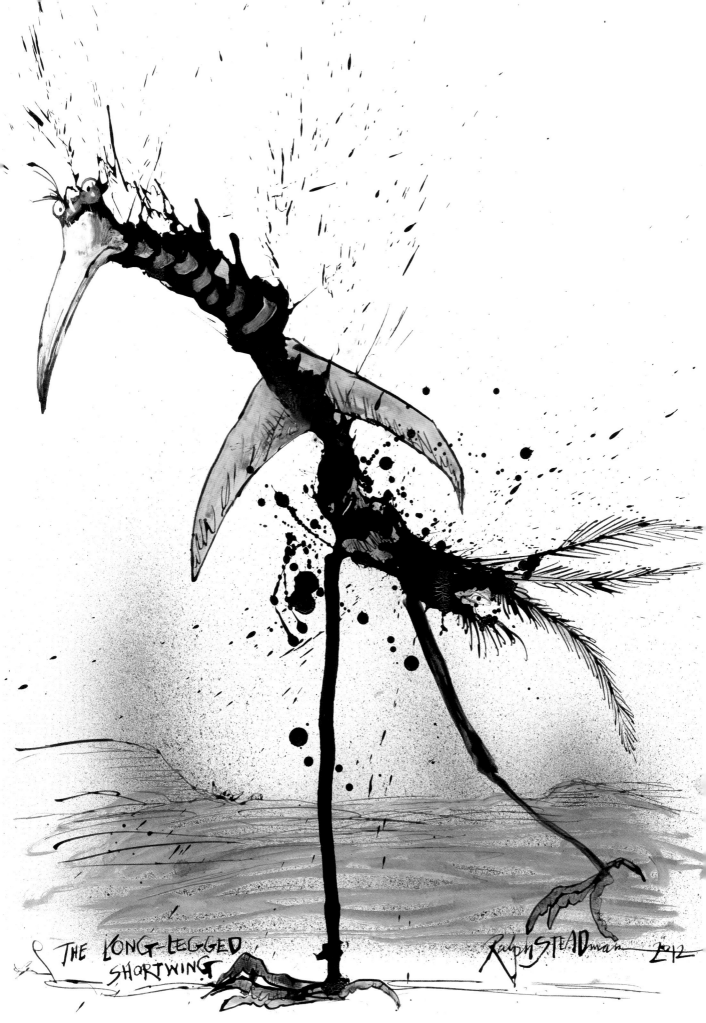

THE LONG-LEGGED
SHORTWING

Ralph STEADman 2012

Passenger Pigeon
Ectopistes migratorius

The poor Passenger Pigeon was once one of the most numerous of all birds, and probably the only bird to have ever had a flock with around a billion participants, one of which was recorded in the 19th century. By the turn of that century the population of this bird had been decimated, through hunting on a colossal scale and habitat loss as the great eastern woodlands were felled. By 1909 the only living examples were housed in Cincinatti Zoological Gardens – one male and two females. Two passed away leaving just one lonely female, Martha, who lived until 1914, when she passed away taking the species with her.

Orange Thronk
Thronkus oranginus

Pink Twisted Thrisp
Thrispus twistus

Branch Fling Schwing
Flingschwingus ramus

Hangers-on (for dear life).

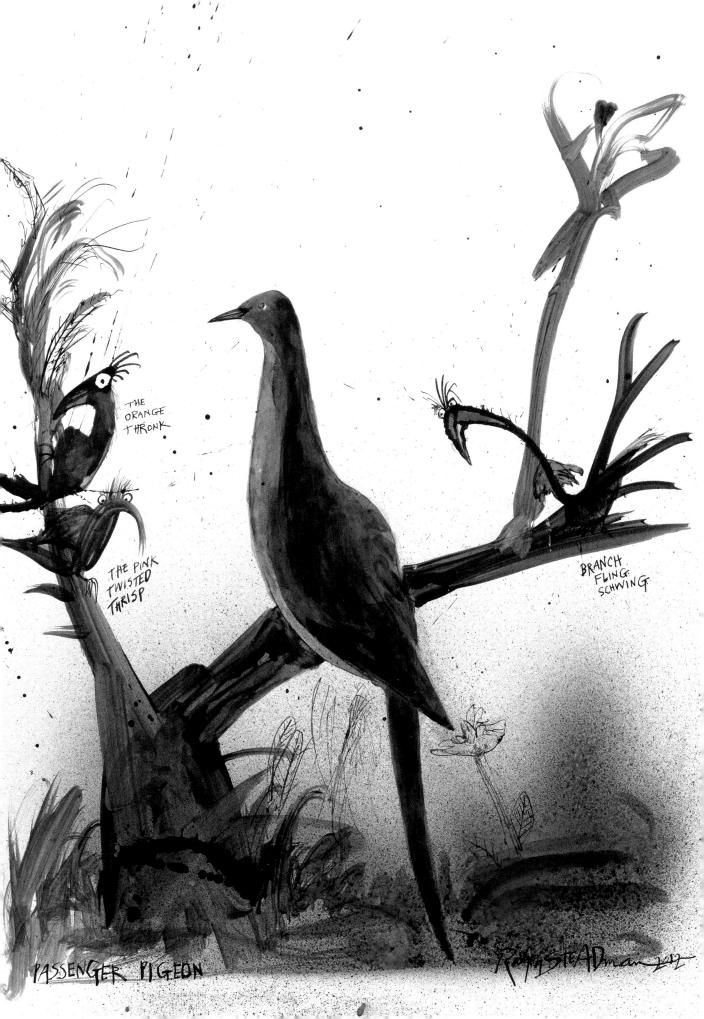

THE
ORANGE
THRONK

THE PINK
TWISTED
THRISP

BRANCH
FLING
SCHWING

PASSENGER PIGEON

Ceri's Diary: I am in Spain on holiday, and we have started compiling the boids for the book. We are missing one or two of the latest images, and Ralph is busy taking photos of them so we can slot them into place. But as always there is the odd surprise, like this latest creature.

27th January, 13:53. Ralph emails:
Dear Ceri
You just don't pay attention!!! Now you notice we are missing birds. Your head has gone all Spanish. Are you some kind of Conquistador?? Or a failed Toreador, maybe??

I have attended Bullfights too – and I have sad pictures of dragged dead Bulls!!

Have you ever dragged a dead Bull – very heavy…!!!

I cannot do a butt dick with my new camera!! I should have stayed old and reliable. We have located the extinct birds you have no photos of but because I got this spiffy new camera – all the mechanical crap you can imagine has broken loose in Loose!! The fan is clogged up with filthy brown slush, and I just wish I had left stuff as it was. Screw progress!! I think gizmos have feelings and they feel rejected when ignored. We located the 'missing' pictures – but I cannot copy them to file because my sodding new improved equipment won't let me!!

Hope you are having a lovely warm time – even in Spain… meanwhile, as you sun yourself in foreign climes, this filthy Pink Rotten Scrawl came into being… OK.
See you in your own time!!!
Love RALPHZXXX

Ceri's Diary: I found this quote yesterday, by Robert Lynd. It shows how birds can be much more advanced than us:

There is nothing in which the birds differ more from man than the way in which they can build and yet leave a landscape as it was before.

Pink Rotten Scrawl
Miserabilis miserabilis

The Pink Rotten Scrawl is the real old misery of Toadstool Island. He moans about everything, and is constantly having a go at the Dawn Choral Society about the times of their get-togethers. Even though he's a bird he has never understood the principle of 'early bird catches the worm'. Singing first thing in the day is not something that appeals to his miserabilist sensibilities. He and the White-winged Gonner, who now runs the Society, have feuded ever since the Gonner arrived and reminded everyone of their early morning duties.

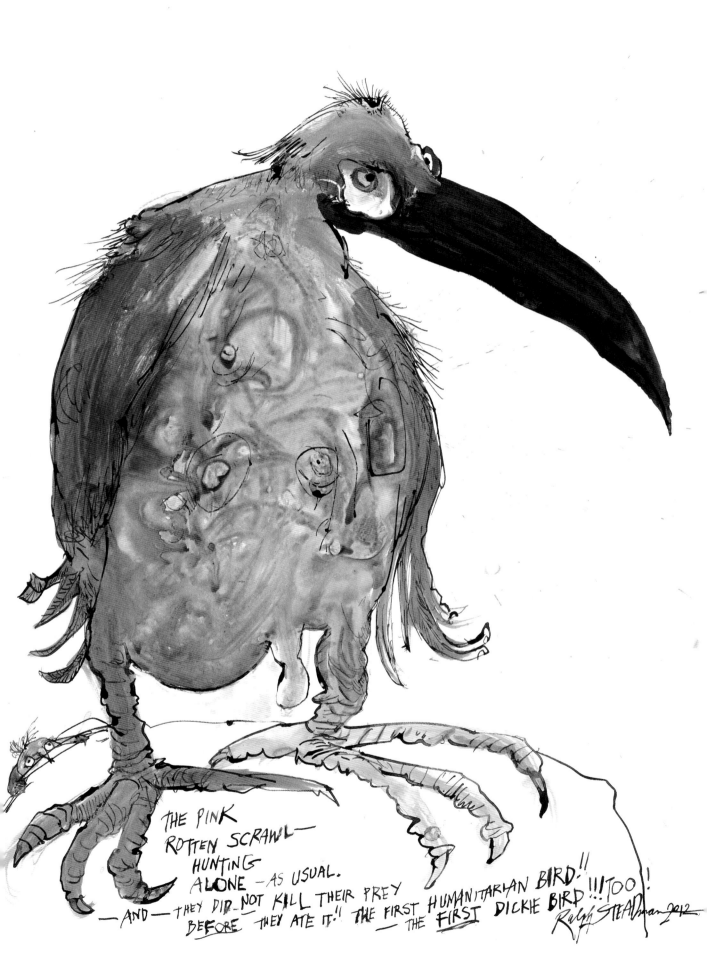

THE PINK
ROTTEN SCRAWL—
HUNTING
ALONE—AS USUAL.
—AND—THEY DID NOT KILL THEIR PREY
BEFORE THEY ATE IT!! THE FIRST HUMANITARIAN BIRD!!
— THE FIRST DICKIE BIRD!!!TOO!
Ralph STEADman 2012

And at the mere mention of the word random,
The Random Blotted Slumley appears. It looks like
a member of the Salvation Army Band – it just
seems to be missing its instrument. Apparently the
Slumley is quite musical and likes to bang the drum;
he is the percussionist in the Dawn Choral Society.
After all, music is second-nature to most birds.

Random Blotted Slumley
Capus handi

The Random Blotted Slumley is a reluctant friend of
the Pink Rotten Scrawl, purely because they are so
grumpy that no one else will hang out with either of
them. Their days always start with a bicker together to
get the blood flowing through their wings, which, let's
face it, have seen better days.

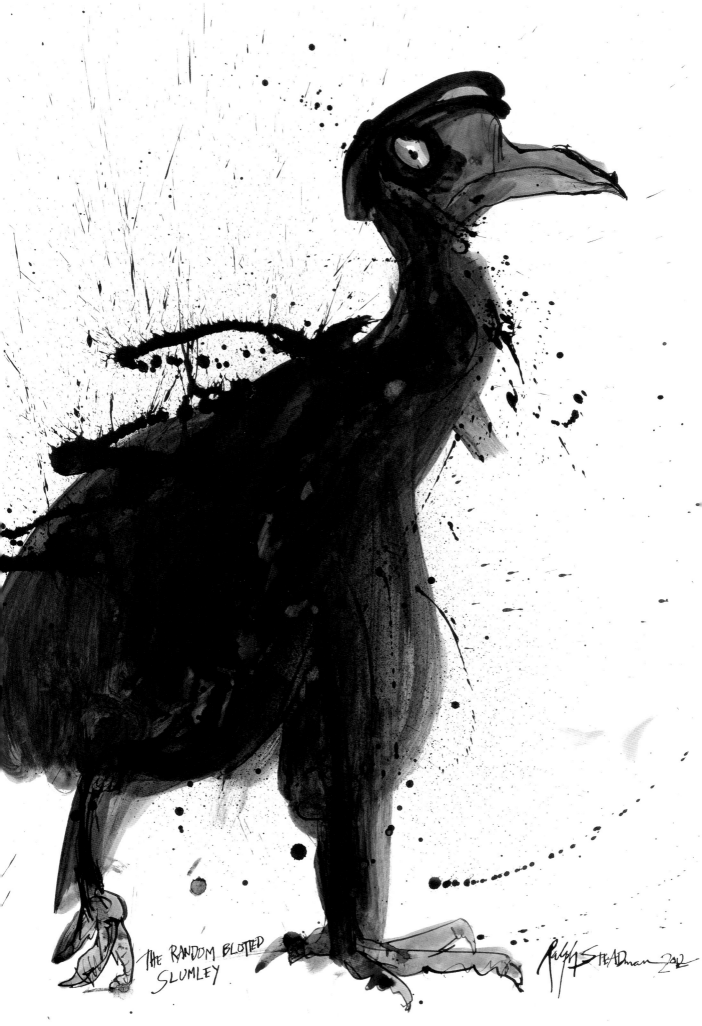

THE RANDOM BLOTED
SLUMLEY

28th January, 18:15. Ralph emails:
Here is some BOID here… an alternative solution
fusion with a mission - an addition wishin' it was
fishin' for trout wi' nothin' but the woid of a stupid
BOID!!!

Ceri's Diary: I know now that we are nearly at the
end of our journey on board the *Steadmanitania*. It
is time for Ralph to think about putting his pen
down and letting the birds and boids free. But just
when I think it is over he sends me a new creation
that can't possibly be left out of any book. What
bird tome would be complete without a Splattered
Shag inside, for God's sake? So here he is, existing
perfectly happily in front of me. Perhaps not even a
speck of a thought in Ralph's mind an hour or so
ago. And now I can't imagine what the world was
like before this bird had been drawn into being.

Ceri: This looks like a guano-chucker to me! Is that
guano that the bird is covered in?

Ralph: Yes, of course. That's what Splattered
Shags do. They self splatter. And don't let it cover
your Meccano in guano. That's no way to play. Well
worth avoiding that kind of behaviour.

Ceri: I heard that the Splattered Shag has a very
important job for such a newbie boid, in that it
looks after the island's guano reserves at
Guanotanamo Bay. On arrival he was put in place
by the Governor, which is high praise indeed for
such a newly formed creation. He immediately
earned the moniker "Stinky" for obvious reasons.

Ralph: Where there's muck there's a Splattered Shag.

Splattered Shag

Phalacrocorax splatterinisi

The cry of "It don't matter if I self-splatter, it's better
for me than throwing hot batter" is often heard well
before the Shag is seen.

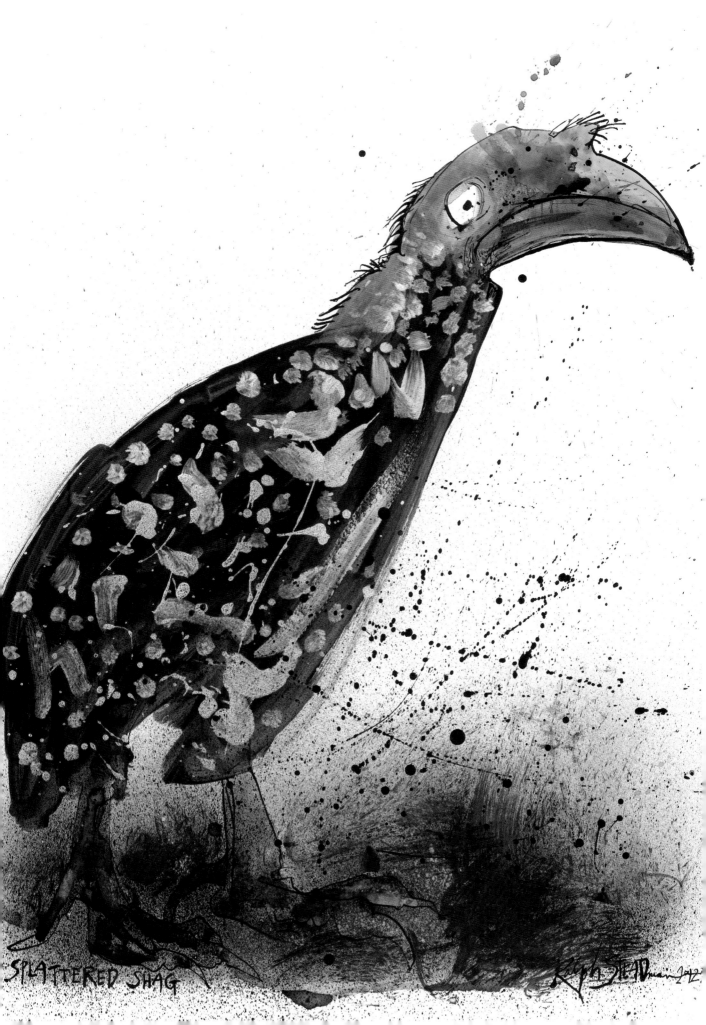

SPLATTERED SHAG

30th January, 18:35. Ralph emails:
Dear Ceri
I came across this little Weirrdo and thought to send him along to show you that I am still doing strange things and that there is no let up on the bird front. I hope you make it back from Spain tomorrow as we have much to do!! Meanwhile here he is... a Desert BLUEBEAK – a very serious kind of study!!
Bon Voyage!!

Ceri replies:
Weirrd seems to be the norm these days!! And actually, what's even slightly weird about a Desert Bluebeak? I don't really see the abnormal in these creatures anymore. It all seems quite logical to me. Have we messed with our minds???

Ceri's Diary: Yet again Ralph pulls a trump card! Where does he find these creatures to draw? I am sure that birds continually come to Ralph now and befriend him. He told me the other day about a Goldfinch that had got trapped in his greenhouse, and was flapping about in a terrible panic. Ralph managed to approach it, talk to it, calm it down and pick it up, which is no mean feat in itself, and was able to release it outside. He said it was a magical experience the moment he let it go and it flew free. He's definitely a birdman now.

Later, on the phone:
Ceri: This Desert Bluebeak makes me think about all the birds I have missed seeing back when I wasn't interested in birds. I have been lucky enough to travel a lot with my film work, and have ended up in extraordinary places. I once had to spend time in the Namib Desert, and I remember seeing a black bird of prey but I had no bird knowledge at the time, or binoculars, and I really wish I had had more of an understanding back then. Was it a Black-chested Snake Eagle, which I have since discovered lives in that region? I will simply never know.

Ralph: I spent a long time in Hawaii and God knows what I could have seen if I had had the interest in birds that I have now.

Ceri: Interestingly, there are species that you could have seen that may now be extinct. That makes it more poignant doesn't it? To think that some of the birds you have seen in your lifetime may now have gone.

Desert Bluebeak
Caerulearostra deserta

This solitary beast prefers the land of sand to more populated areas, although it loves to pop down to the oasis to see who's about and to catch up on the latest gossip from the rest of the island.

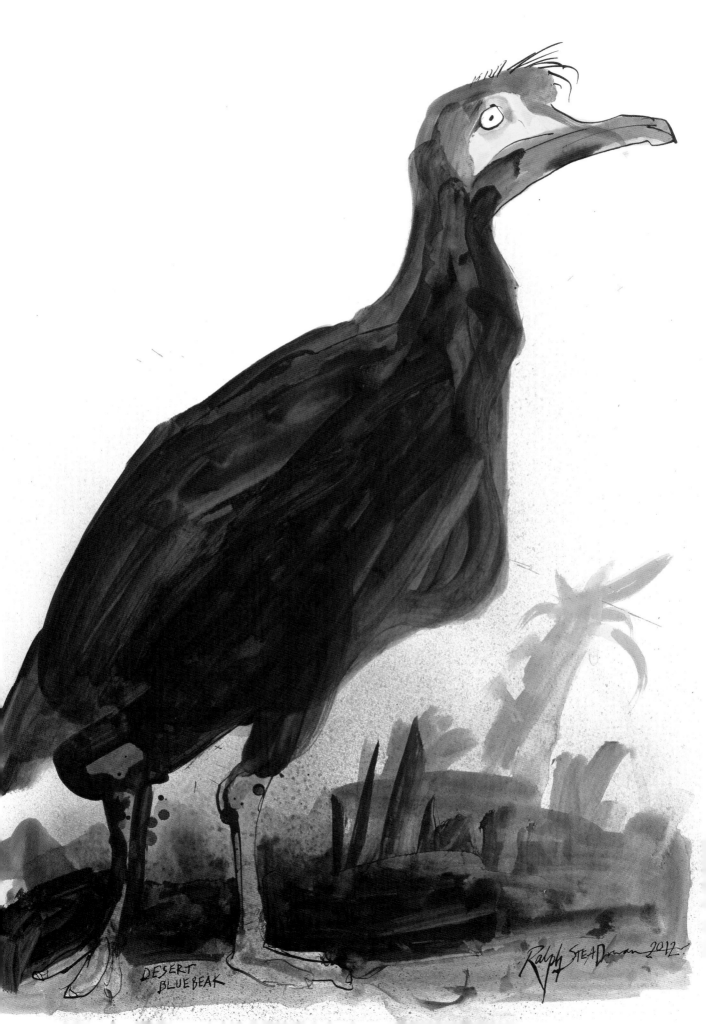

DESERT
BLUEBEAK

Ralph STEADman 2012

Ceri's Diary: The journey is often as important as the destination, and that has never been truer than in the case of this voyage of the *Steadmanitania*. The destination has actually *been* our journey, as we constantly discovered new islands along the extinction trail. In our time together we have discovered places we never knew existed, learned facts we wish we had always known, and discovered the truth that the birds on our planet need our help. We have stumbled upon wondrous creatures deep within the Urinic Archipelago, and some that got away, such as Red Wowlets, Sanctimonious Godnoses, the Ooshut Doorbang and the Groglicks.

21st February, 17:33. Ralph emails:
Ceri, I have done the Pink-headed DUCK – so that's a bit of luck – it can go in the buck!!!!

18:01. Ralph again:
Deah Ceri
Wot I fort wos dat dis is de weigh ta go!!
Capisch?? Pusunnily, I um no' a snobb bu' I fink sum peeepul r !! Speeek wiv yer suuwn… BLYMEE!!
Sorry me Onglish noot gut…
RALF

P.S. – in arf diffikult trie in ta rite rong!!!!
Warmest RALPHZXXXX – speek ta ya tummorrer!!

Ceri's Diary: The Pink-headed Dukk, sorry, Duck, is one of the best examples of a modern day 'twilit' bird. More than any other, it symbolises a probable extinction that many people do not wish to accept has happened. People keep going in search of this creature, so far to no avail. .

There always seems to be a sadness associated with finally declaring a bird extinct. And yet we still don't seem to be able to stop extinction in its tracks.

Pink-headed Duck
Rhodonessa caryophyllacea

This bird, a resident of the wetlands of India, Bangladesh and Burma, was always a rarity. The Pink-headed Duck was last officially seen in the late 1940s, until a very recent but unconfirmed sighting in Burma. If it is still persists then its numbers will be very small indeed. But there is still the slimmest of hopes, and we hold onto that. There are many who carry a torch for the Pink-headed Duck. Let's hope those candles don't burn out. The reasons for its extinction or near-extinction are habitat loss and possibly overhunting on its wintering grounds.

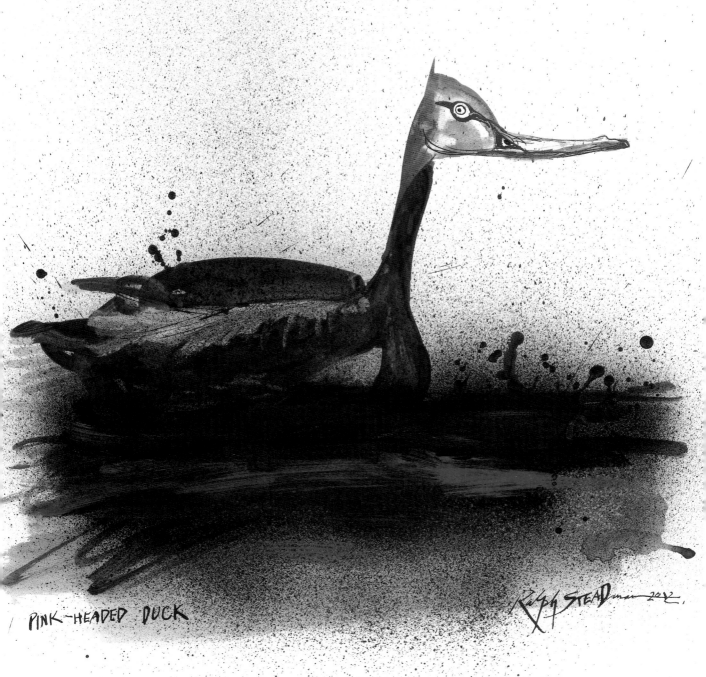

PINK-HEADED DUCK

Ralph STEADman 2012.

Ralph: I now know that dreadful people exist in this world, and there are terrible things happening daily to birds. We need to tell people about these things, they need to know. I never had a clue what was going on until you came along, and look at us now. Birds are everywhere in our lives and we must help them.

Ceri: The best way is to get our findings out there and hope that more people will want to join in and help protect our new avian friends. All we can do is present the evidence we have discovered on our travels together, and show your drawings to as wide an audience as possible. It is time for your art to be seen and heard.

Ceri's Diary: Art has the power to connect and inform people like no other medium. It provokes curiosity within the viewer, which in turn can generate engagement with the subject, leading to further investigation, research, belief and support for the focus of the work. Art is capable of waking people up and stimulating action within them. That is what *Ghosts* set out to do, as well as putting emotion back into conservation and revealing that it has a warm and beating heart.

Ralph's work most certainly has a giant thumping heart – it is bringing a new audience to the subject of extinction. Undoubtedly many people will feel inspired enough to pass on the tale of our ever-disappearing birds. And every single one of us has the power to make a difference, simply by talking to each other. Let's talk... bird talk.

So here we have the last collection of birds created by Ralph for this book. The Elephant Bird, recently coated in guano by the Splattered Shag, is accompanied by three mad little fellers, the Green Twot, the Yellow Twet and the Pink Twit, a distant cousin of the Wizened Twit that we saw hanging out with the New Zealand Quail. These three love to play a form of 'Dare' by running in and out of the footsteps of the Giant Elephant Bird. It's a game that is lost by getting crushed by the Elephant Bird's footfall. I believe the Twot has been flattened the most regularly, but they still play the game.

Giant Elephant Bird
Aepyornis maximus

The Giant Elephant Bird was one of seven or eight species of elephant birds that were once indigenous to Madagascar. Standing at more than three metres tall, it was the heaviest bird ever known, possibly weighing as much as half a metric ton. It also laid the largest egg of any vertebrate, past or present, larger even than those of dinosaurs. The probable causes of its extinction were over-hunting, habitat loss and possibly longer-term climate change. The birds may have clung on to the end of the 17th century.

Green Twot
Twotus viridis

Yellow Twet
Twetus flavus

Pink Twit
Idioticus rosea

Thrill-seeking adrenaline-junkies.

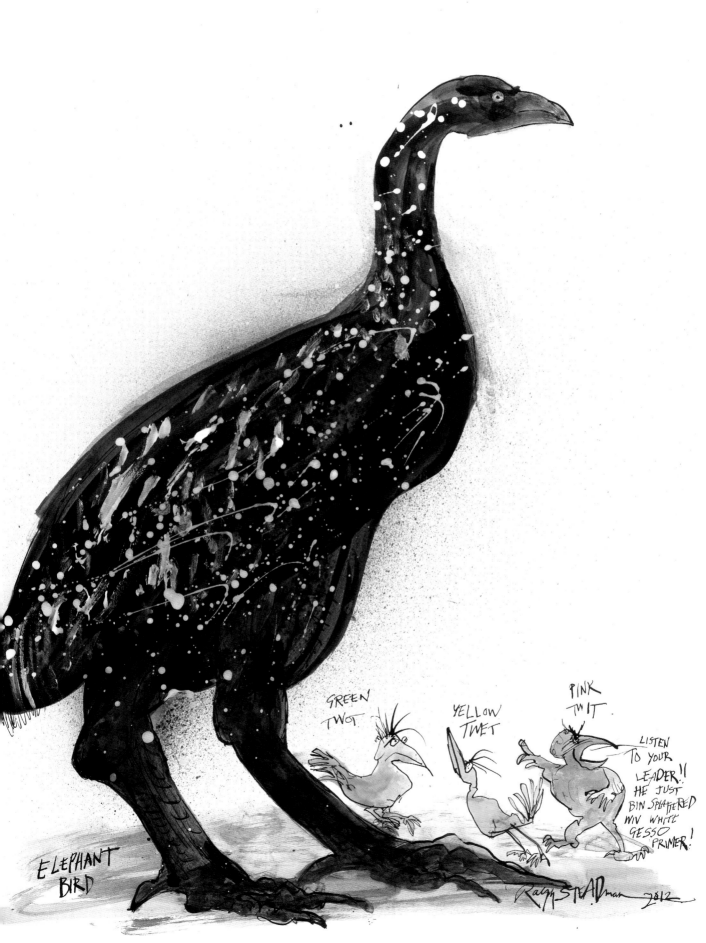

23rd February, 17:33. Ralph emails:
Here is a birrd wot nearly got away, but at the moment I have it trapped in the Toolshed. He can stay there till the morrow – I will measure it from tip to tail and put it into the Pantheon of bad-tempered SOB's!!!

Ceri's Diary: I have realised that I have taken the world for granted too much over the years, and I would like to give something back. Perhaps by tackling the subject of extinction we will find other people who've found that there is a world out there that gets too easily forgotten. I want to be a memory-jogger and urge people to rediscover nature, which is in need of our love and attention.

Ralph meanwhile has become quite the bird expert, and happily converses with his local birds every morning whilst taking his constitutional swim. The birds come to see him daily and have become part of his life. For both of us they have filled a space that perhaps neither of us knew was there, and one that will never be empty again.

We have travelled so far together, becoming firm friends and like the birds I have no idea what life was like before Ralph appeared in it. He has proved to be a wonderful partner in our global quest to understand the world of extinct birds, and we have raised as many answers as questions.

As we pull into port for the last time I know we have learnt so much as we've dived deep into the mysterious waters of extinction. Of course, it is not just birds that are facing extinction crises. But like the canary in the coalmine, birds are the greatest and earliest indicators of problems in our environment, and ultimately a problem for birds will become a problem for all. Isn't it time we started listening to the advice that birds are trying to give to us?

And so, here we are, the last boid in the book, and what a strange fellow he is too. The 'Smy Egg is the most infuriating creature that an egg-laying bird has ever had to deal with. One look the wrong way and it will leap onto any unprotected egg, encase it with its bandy legs and lock its joints into place, rendering it practically immovable. Many birds are delighted that someone else is doing the egg-sitting (the Egg Sitter was its old folk-name), as just sitting there can be a lonely old business, but the 'Smy Egg loves doing it, and can remain still for days or weeks. More often than not the egg will hatch but occasionally it doesn't, which causes a problem for the 'Smy Egg as it's joints seize up and it must hobble around trying to loosen its grip on the unhatched egg. Eventually its legs unlock and it is free, but as soon as it sees another egg it jumps on. And so the cycle continues, with the occasional egg being left behind... leaving just one question...

'Smy Egg

Mea ovum

Never an egg-borrower or lender be.

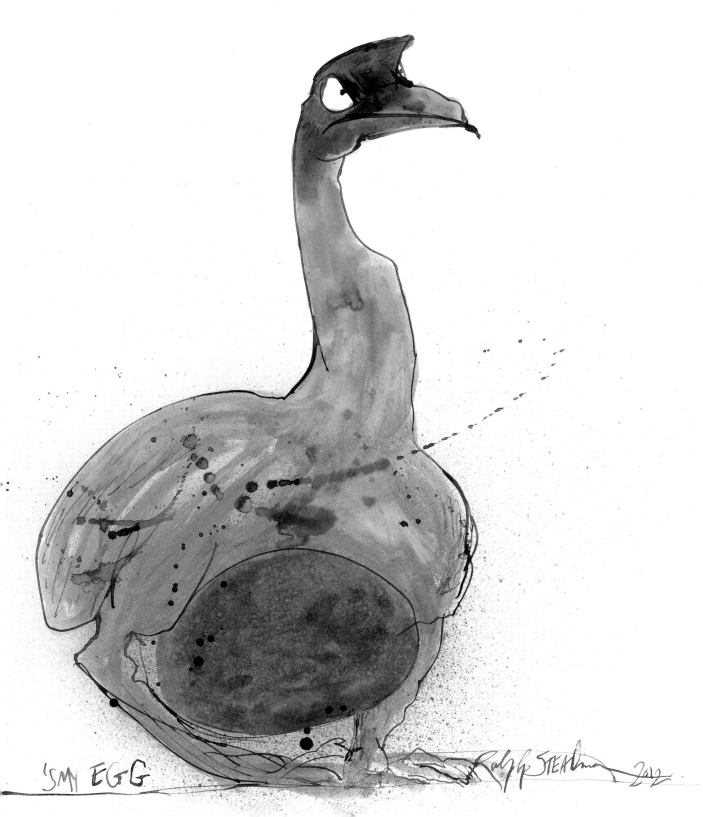

'SMY EGG

WOT CUM FOIST?

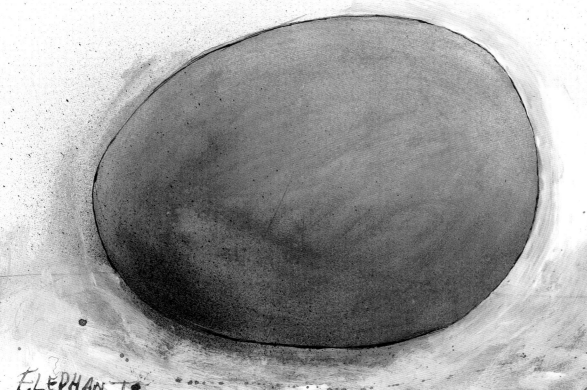

ELEPHANT
BIRD EGG

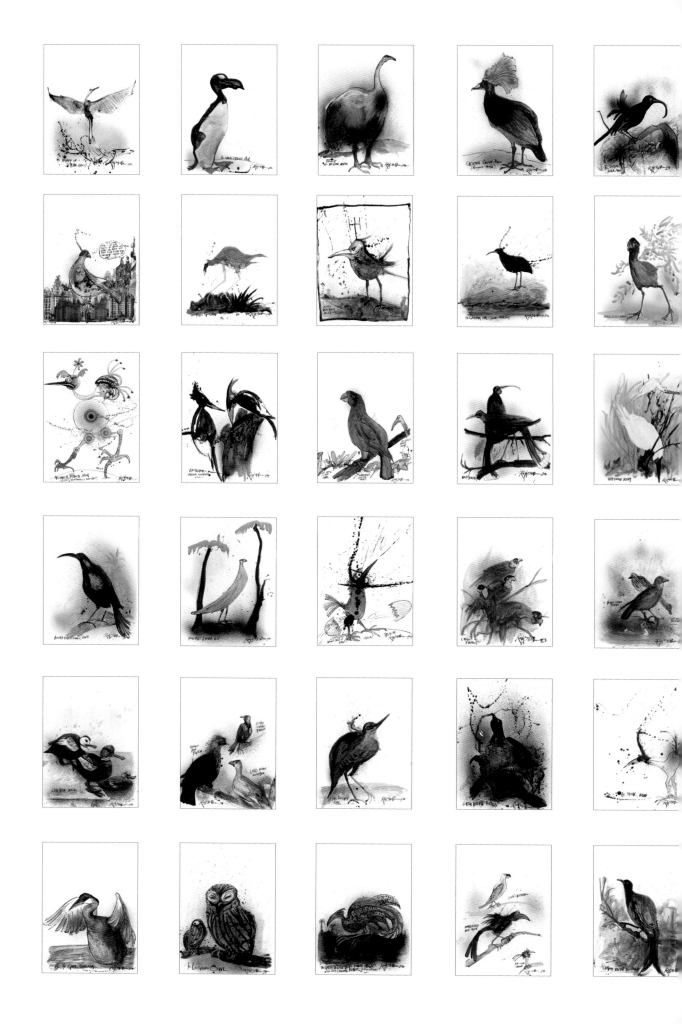

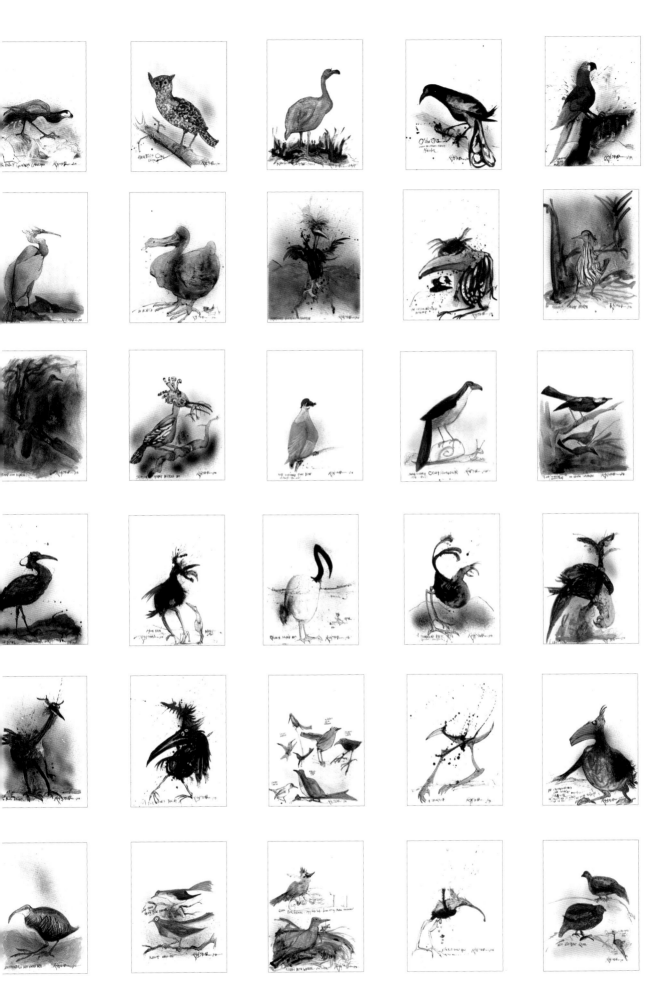

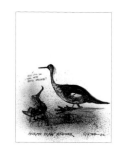
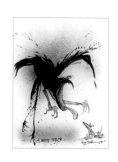
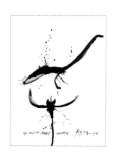
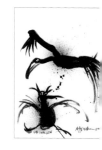

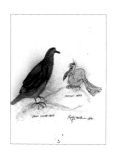
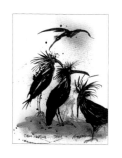
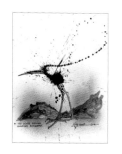
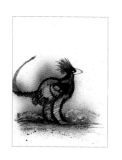
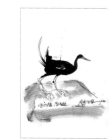

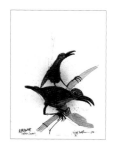
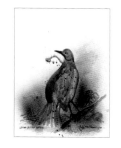
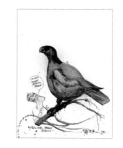
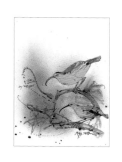
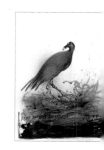

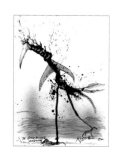
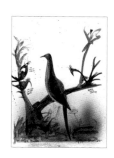
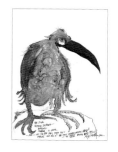
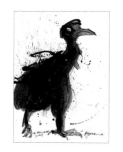
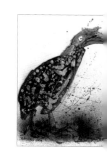

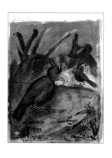

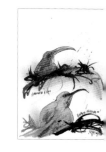

TRUBBLE

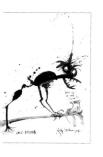 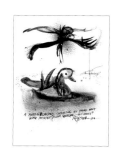 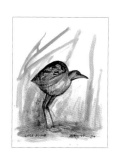 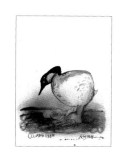 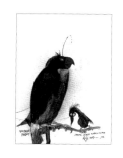

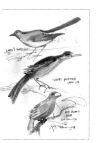 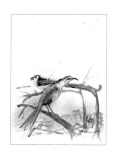 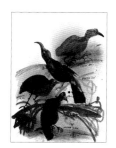 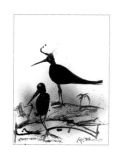 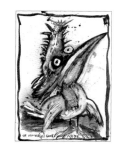

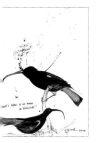 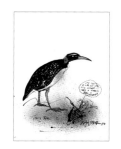 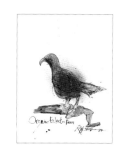

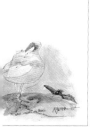 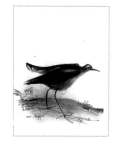 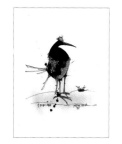 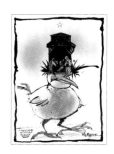

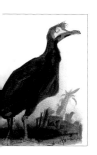 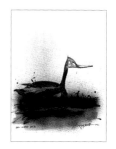 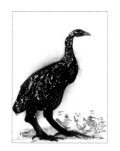 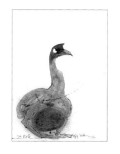

Acknowledgements

Thanks to:

Jackie Ankelen
Anna Steadman, Sadie Williams

Chris Aldhous, and the GOODPILOT team;
Pete Hodgson, Pierre Humeau,
Paul Beer, Arita Celma

Bloomsbury People – Jim Martin, Marina Asenjo,
Nigel Redman, James Watson, Elizabeth Jenner,
Jasmine Parker

Kirsten Canning and Michael Barrett at
The Press Office

Nat Sobel and Adia Wright at Sobel Weber
Associates, Inc.

Jealous Studios – Dario Illari, Ellie Phillips,
Matthew Rich, Adam Bridgland

The Rochelle School – Mike Carney, Paddy Gould

Jimi Goodwin
Keith Newstead
Tristan Reid
Errol Fuller
Julian Hume
Immortal Art Design – Richard Batey,
Robert Richardson
Mathew Clayton
Dr Clemency Fisher
Pete Gamby and Opticron

BirdLife International – Jim Lawrence, Marco
Lambertini, John Fanshawe, Ade Long, Martin Fowlie.

Jeff Barrett and the Caught By The River crew;
Robin Turner, Andrew Walsh, Danny Mitchell
and Carl Gosling

Lady Catherine Saint Germans and the
Port Eliot Festival

Photo credits
All photos ©Ceri Levy, © Stan Gruel or ©Good Pilot Ltd,
apart from Keith Newstead (Jim Lawrence) and Ralph with
Tristan Reid (Nicola Boulton). Cover photo ©Jim Martin.